1994

1994

Berenice Abbott / Photographs

BERENICE ABBOTT

PHOTOGRAPHS

Foreword—Muriel Rukeyser

Introduction—David Vestal

SMITHSONIAN INSTITUTION PRESS

Washington and London

Produced for the Smithsonian Institution Press by
TENTH AVENUE EDITIONS, INC.
625 Broadway, New York, NY 10012
Editor in Chief: Clive Giboire
Managing Editor: Rose Hass
Editorial Assistant: Peter Wagner
Art Assistants: Romeo Enriquez & Mark Muday

Library of Congress Cataloging-in-Publication Data
Abbott, Berenice, 1898-
 Berenice Abbott photographs / foreword, Muriel Rukeyser : introduction, David Vestal.
 p. cm.
 Includes bibliographical references.
 ISBN 0-87474-211-0 (alk. paper)
 I. Photography, Artistic. 2. Abbott, Berenice, 1898-
 I. Title.
 TR654.A198 1989
 779'.092—dc20 89-21993
 CIP

The paper used in this publication meets the minimum requirements of the American National Standard for Permanence of Paper for Printed Library Materials Z39.48-1984

Printed in Hong Kong
96 95 94 93 92 91 90 5 4 3 2 1

To the memory of Elizabeth McCausland

CONTENTS

PHOTOGRAPHY AS A MEDIUM IS SO YOUNG THAT IT IS TRULY a prisoner of time. Its uses are so vast that we cannot speak of more than any one at a time.

I am speaking now of the interpreter who expresses our time or a phase of it . . . the artist, if you will. Our technical conditions decree how far we can go. We cannot photograph the same subject in the 30s that we can in the 40s—or 60s.

In my own case with New York City—the contrasts, the fast changes inspired me. The look of a vibrant city needs detail, texture, perspective. The people decorating this tableau would be very desirable too, but our time capsule did not permit this. Why? Film was 10 to 20 times or more slower! In many of my shots I was lucky to halt some motion at 1/5 second. Faster film would have permitted a wider range of subjects and speedier motion.

The medium is young to the degree that the general public does not yet read the photograph as is its due. A glance usually suffices. But readers are needed here too, as in all other visual media. It might be said that a subject is not photographed until made as well as possible at any given time.

Photography's future is tremendous!

Berenice Abbott

F O R E W O R D

THESE FACES LOOK OUT AT US WITH THE CLARITY OF EXTREMES.
They are human faces, yes; but they are also human bodies looking out at
us, with their pride, their deep gifts, their magnetic strangeness asking for
response. They are also buildings, streets, shop windows, a cart, and a
clock, all seen by this photographer as human faces, with their expressive
power entire. They are also a penicillin mold and a bouncing metal ball,
watched with the attentiveness and grave joy that let them speak to us.

What makes the distinctness and excitement here? What kind of artist has
given us these?

Berenice Abbott is one of those extraordinary master-artists who is an
inventor, too. In the notebooks—not yet published—we find a woman who
is as practical as Ben Franklin, working out the steps and adjuncts of her art
and the daily life connected with it—cameras, fixtures, clothes—while she
discovered ways of showing the human being and the human city. She
presented us with Atget, the very character of Paris in his years; we see
him in this gallery of persons, wearing the new overcoat of suffering. We see
Joyce in the elegance of his great fertility, and again Joyce, and his wife, and

his daughter Lucia, not yet in the sanatorium. All these people, faces like magnets—Gide, Cocteau, Margaret Anderson, Leadbelly in his bronze loud tones, the Princesse Murat—look out at us in a kind of roaring. The qualities in these complex looks, people who show us the moments of their perception, are revealed because Berenice Abbott perceives them.

She does not have to be introduced to the young, who take these photographs directly, in excitement receiving.

But there are those who lived through the period when the pictures were made and never recognized what had happened. I think of the magazine editor before whose office I waited until Berenice Abbott came down with the series of big "science" pictures still under her arm (the series from which the penicillin mold is the single one included here). She came out with her clown look, the pure child in grief. "He turned them down. But he said they had very little grain," she told me in wry despair; another picture editor who could not see. Look at that penicillin until it opens you, brilliant and round, producing its droplets. Also, the picture has *no* grain. It is made with an invention of Berenice Abbott's.

"We need a light as good as the sun," she said. "Greater than the sun."

She made a picture of a clock face. "A most human face," she said.

These have been called marvelously objective pictures. I myself do not know what this means. They are extreme works of art, carrying the artist and the object and ourselves to us, carrying poetry and the big concepts she has always undertaken: a road down the length of the Atlantic coast, the cycle of the year in one spot in Maine, pictures of things seen with such concentration that they can be called "science" pictures; New York; and always portraits. The last three groups are represented in this book; we see the human face when all those people were young and in Paris, and after that Berenice Abbott's concern beyond "all those people" to focus on everyone whose face and body speak—to focus on a burnt-out man facing a thousand magazines all false. Studies of Sloan and Hopper in their studios, yes; but also the ferry pier; also rock face with holes drilled for dynamite, all overlaid with ice, a foundation; also the strong magic of the chicken sign, the hardware

store; the "fiery parcels" of New York, evening advancing; the narrow vertical Exchange Place, and the people of those years crossing their streets in the lost sunlight.

There is a pride and sadness each time, in a moment of entire and silent declaration. How is it possible that this book was not with us years ago? It is that the time has finally come around to this artist, explorer, discoverer, and these forms pour through her self to us.

The last section, these *things* and forces—ripples of water, shallow-edge waves; surface of bubbles, very physical; the prism declaring its effect on life like Cocteau; light bent, motion of a bouncing ball in a perspective of vanishing arches. These orbits; and a final movement-forward, seen as a locomotive and the span of a bouncing ball. Magnets here like faces. Actually, forces like faces.

I think that the witnesses of this art, coming to it for the first time, will see that Berenice Abbott has given us the vision of a world in which all things look at us, declaring themselves with a power we recognize. A power that is related to something in the human face.

MURIEL RUKEYSER

I N T R O D U C T I O N

BERENICE ABBOTT WAS BORN IN SPRINGFIELD, OHIO, IN 1898.
She went to public schools in Columbus and Cleveland, and to Ohio State
University. In 1918 she left for New York to study sculpture on her own—
not with any teacher. She has always been independent. She moved on to
Europe in 1921, still studying sculpture; first to Paris, then to Berlin, then
back and forth. From 1923 to 1925 she worked as assistant to the American
photographer in Paris, Man Ray.

During her years of portrait photography in Paris, 1925 to 1929, she
established an enviable reputation, which was solidified in 1926 by her first
one-man show of photographs: *Portraits Photographiques*. She photographed
everyone who was anyone, and did it superbly. The pictures are both beauti-
ful and honest—a rare combination in portraiture. "Successful" portrait
photographs tend to be one or the other, not both. The most celebrated
portrait photographers are often those most skilled and shameless in flatter-
ing—that is, obliterating—their victims. The person is erased and replaced
by a fantasy. You won't find much flattery in Abbott portraits. She has
concentrated on finding the best in people and trying to understand exactly
who they are.

She first saw photographs by Eugène Atget in 1925. Nearly forty years later she wrote, in *The World of Atget*: "Their impact was immediate and tremendous . . . a sudden flash of recognition—the shock of realism unadorned. . . ."

She soon met Atget. In 1927 he came to her studio at 44 rue du Bac to be photographed, wearing a huge new overcoat. When she had made the first prints of his portraits, she went to show them to him, but found his apartment empty. Atget had died. His old friend, the actor André Calmette, inherited his photographs.

In the fall of 1928 Calmette sold Atget's work to Berenice Abbott; he saw that she loved those photographs. How right he was. She took care of the work for forty years and did all she could—it was a great deal—to win recognition for Atget. Thanks to her, he is securely recognized as one of the great photographers.

Eminently successful in Paris, she may have become homesick. In 1929 she left Europe; in the *New Yorker's* words, "taking herself and her talent back to New York and the Hotel des Artistes." Once there she discovered a passion for New York. Professionally, she photographed a series of American businessmen for *Fortune,* and, on her own initiative, began to document New York City with her camera. Later she photographed scientific subjects for *Life*: the three preoccupations represented in this book are not new.

In 1930 she had a one-man show of her photographs at the Contemporary Art Club at Harvard, the first of many. She has exhibited almost continuously in the United States ever since. The same year, she arranged for the publication of one of the first books of Atget's work, and furnished most of the pictures. *Atget, Photographe de Paris,* with a preface by Pierre MacOrlan, was published in New York by E. Weyhe.

Another phase of her career began in 1934 when she began to teach photography one evening a week at the New School for Social Research in New York. She continued to teach there until 1958.

Photographing New York City took first place from 1935 to 1939 when she supervised and photographed a document, "Changing New York," for the Federal Art Project. This culminated in 1939 in the book, *Changing New York,* with photographs by Berenice Abbott and a text by Elizabeth McCausland, published by E. P. Dutton. More than half of the places photographed on this project have since been demolished.

In 1954 she was photographing Route One along the Atlantic coast and discovered the state of Maine. She bought a house there in 1956 and moved into it permanently twelve years later.

In 1958, still in New York, she began work on a huge project for the Physical Science Study Committee of Educational Services, Inc. The photographs of physical phenomena were largely produced then.

Berenice Abbott is a photographer with sensibility. She's aware, receptive, sensitive, and has common sense. Her work is refreshingly straightforward—strong, clear pictures with art but without pretense. Berenice has no use for purple prose or precious prints. She belongs to no school or movement.

She wrote down some of her beliefs so clearly that it would be foolish not to quote her. The article, "It Has to Walk Alone," appeared in *Infinity* magazine in 1951; parts of it were reprinted by Nathan Lyons in his 1966 book, *Photographers on Photography*. She tells what she's up to in a few essential sentences:

"Photography can never grow up if it imitates some other medium. It has to walk alone; it has to be itself.

"If a medium is representational by nature of the realistic image formed by a lens, I see no reason why we should stand on our heads to distort that function. On the contrary, we should take hold of that very quality, make use of it, and explore it to the fullest."

That is what Berenice Abbott does.

DAVID VESTAL

17

FACES
OF
THE
TWENTIES

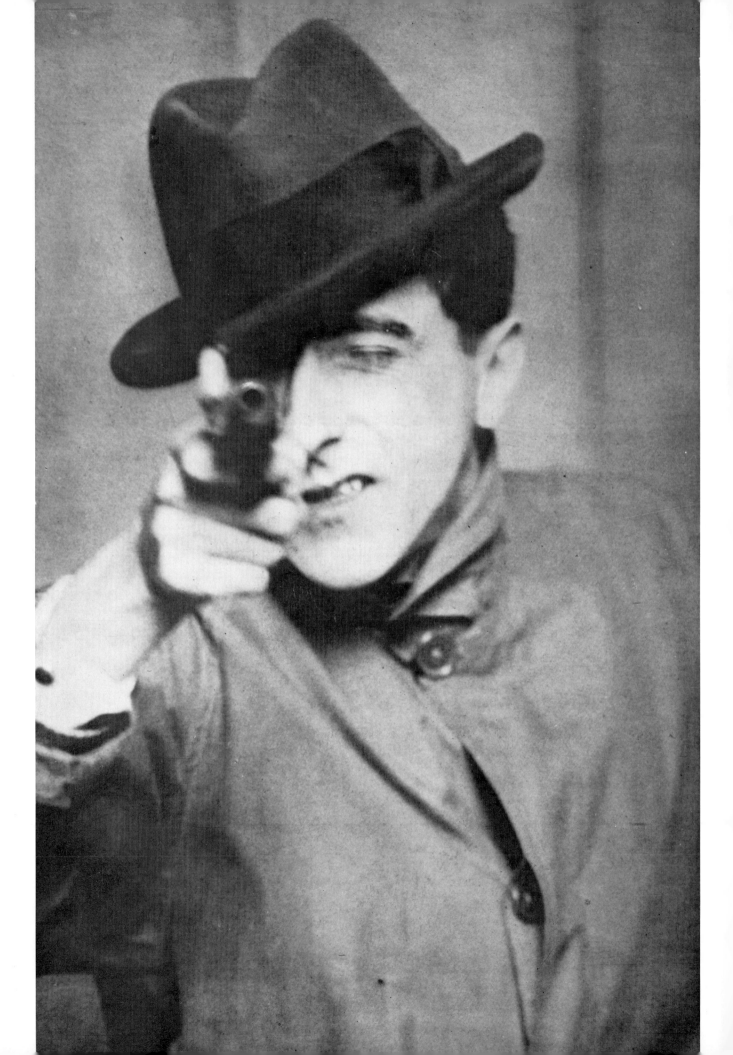

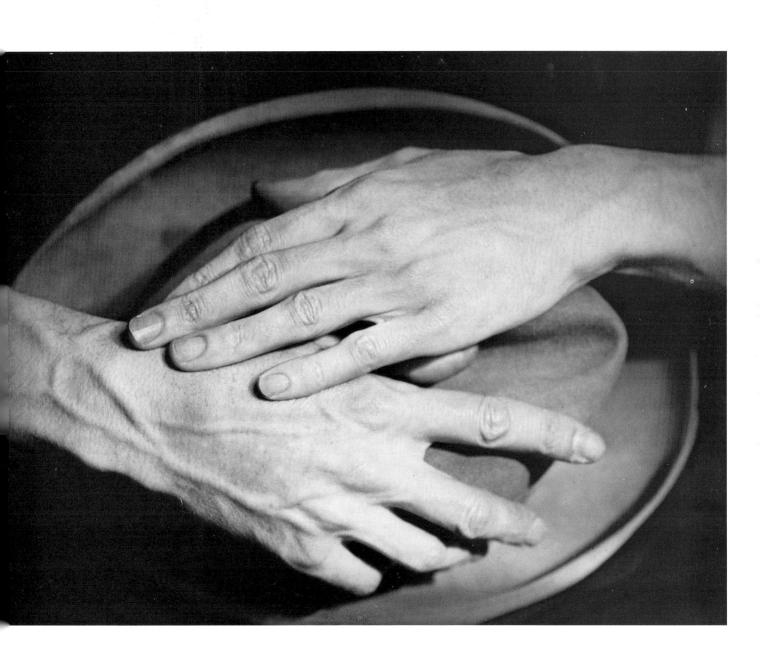

Jean Cocteau, writer and artist (left); his hands (above)

Jean Cocteau

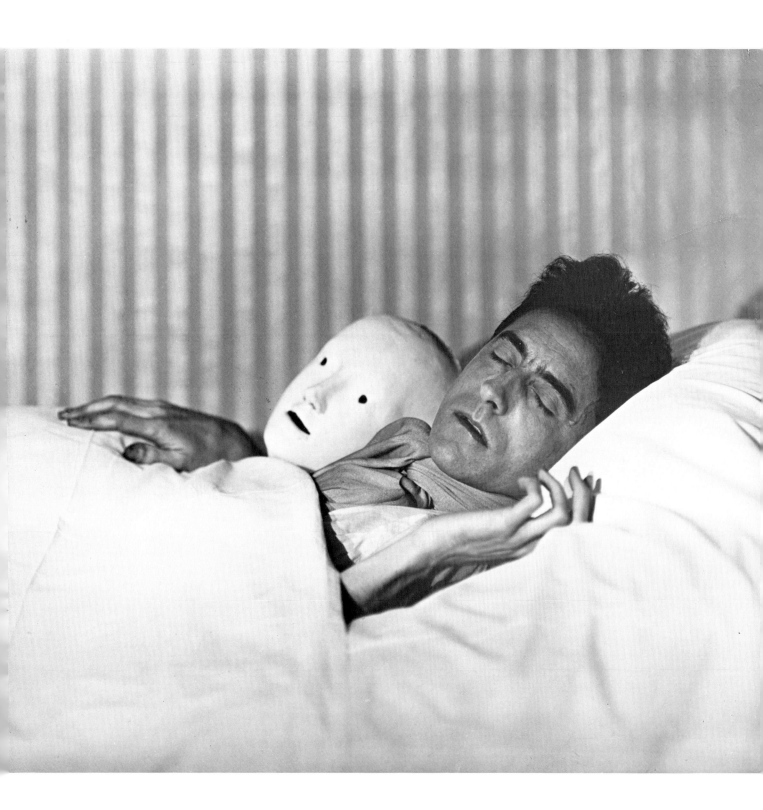

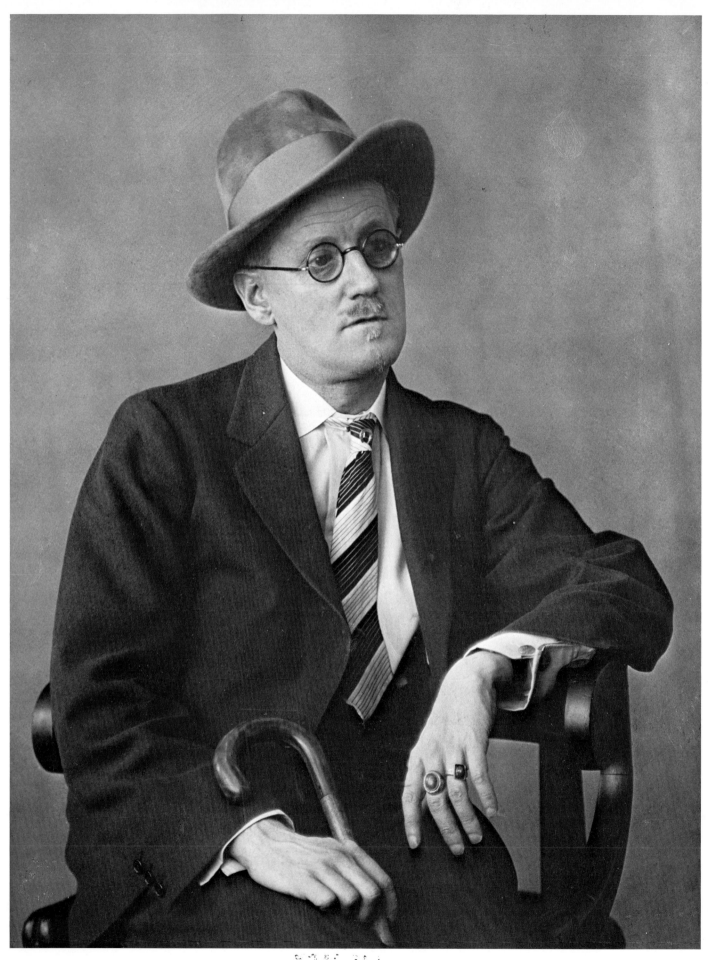

24

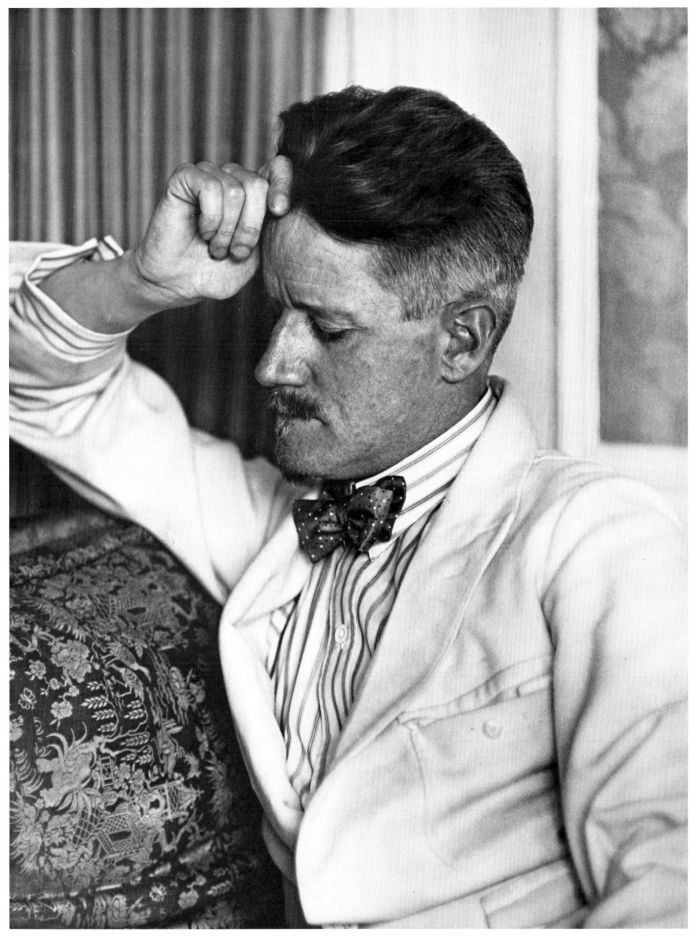

James Joyce, writer (above and left)

25

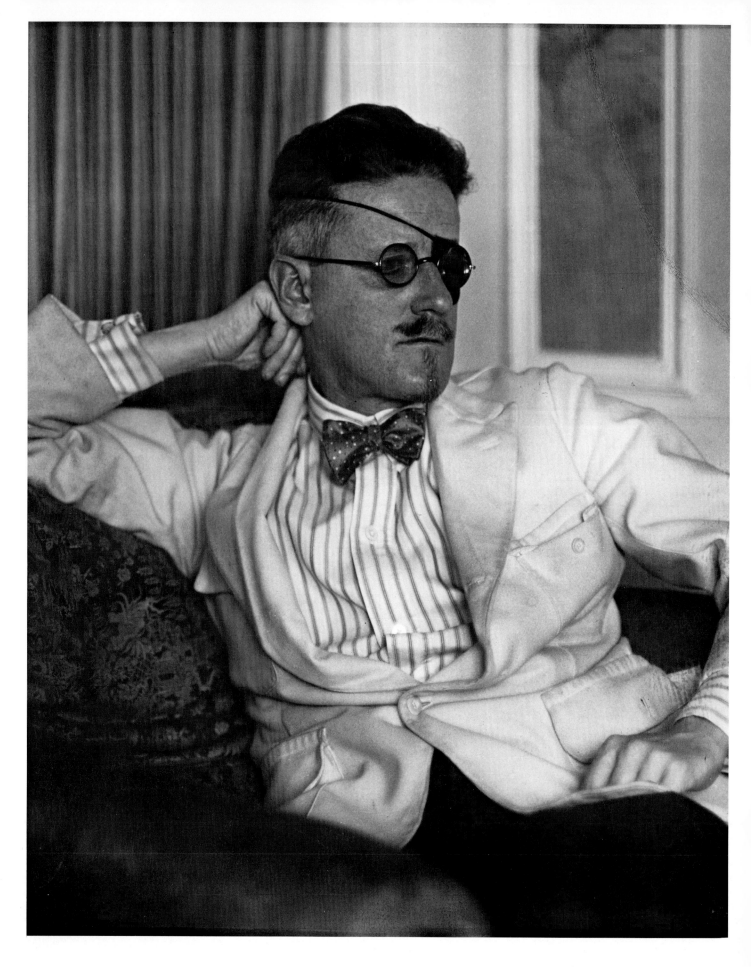

James Joyce (above and right)

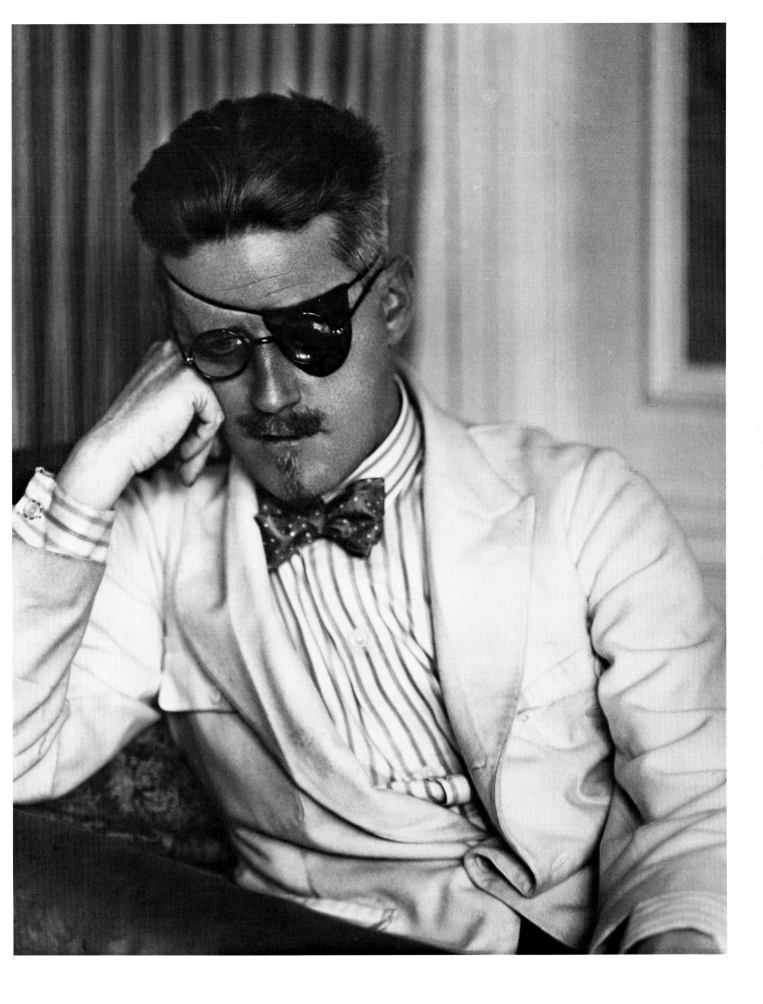

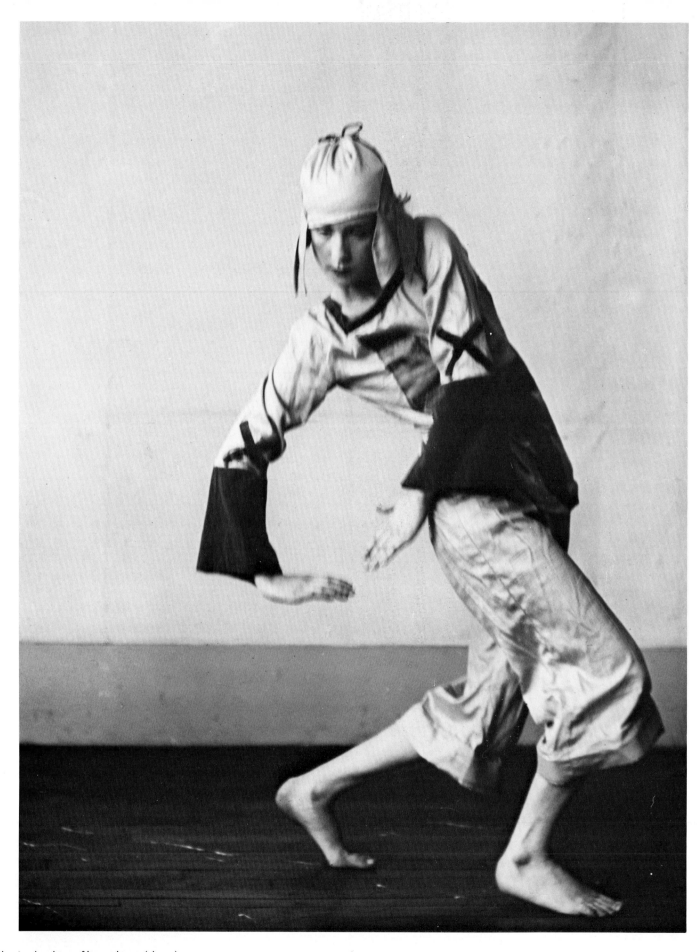

Lucia, daughter of James Joyce (above)

Nora, wife of James Joyce (right)

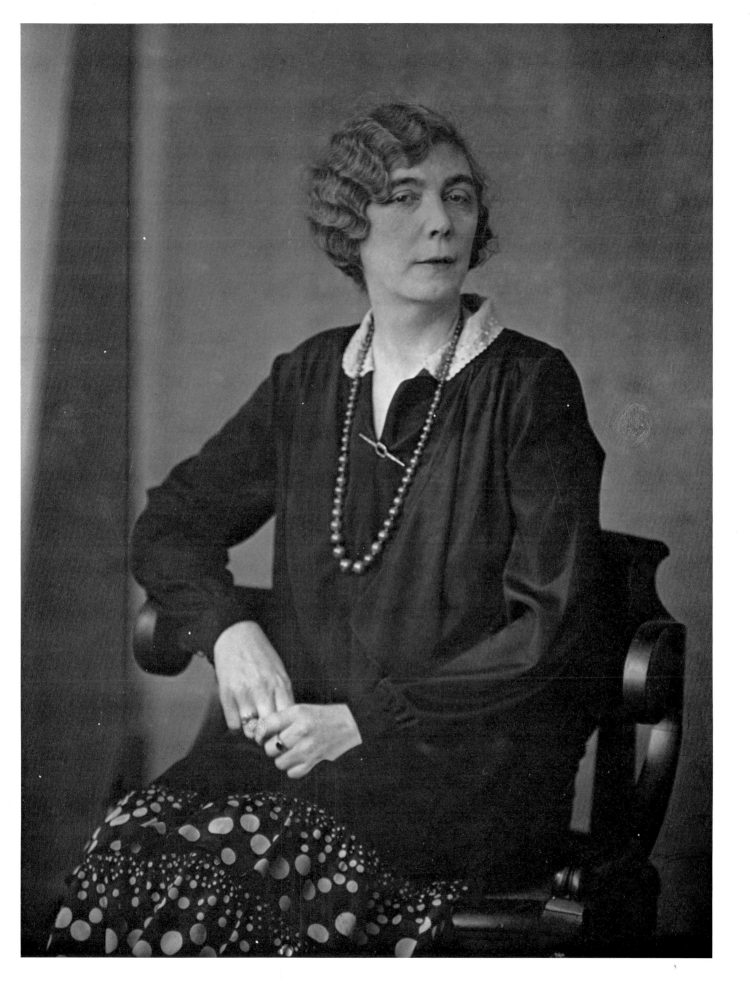

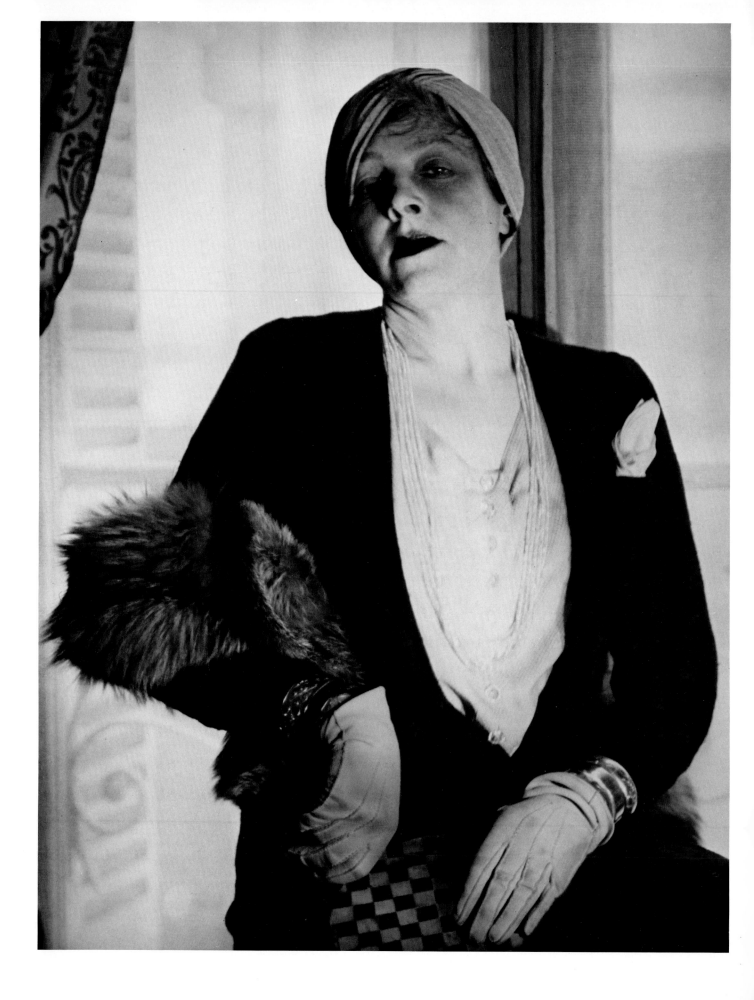

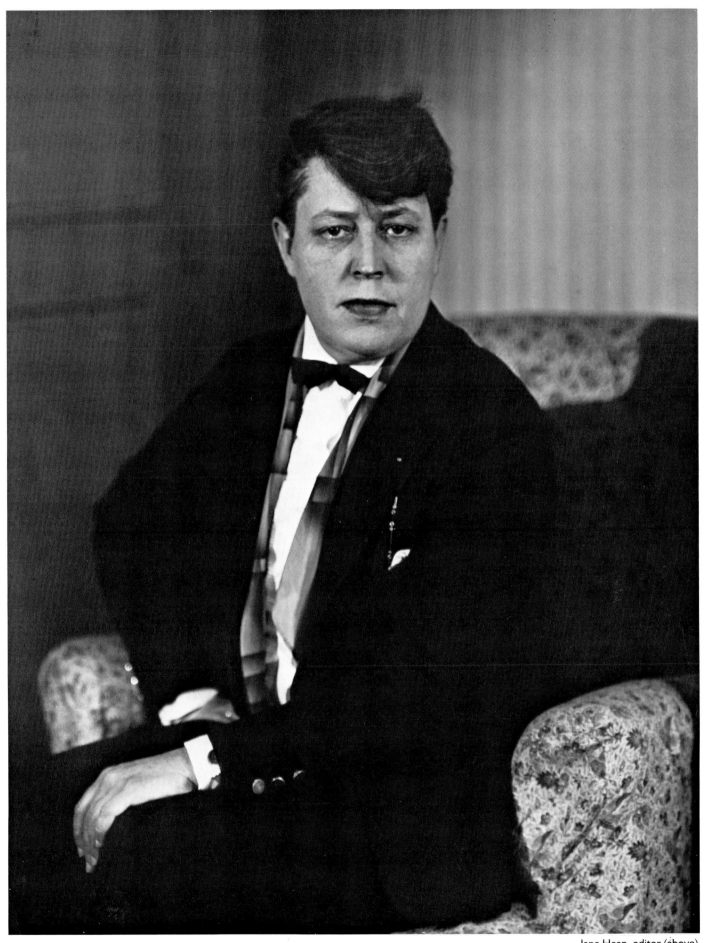

Jane Heap, editor (above)

Margaret Anderson, writer (left)

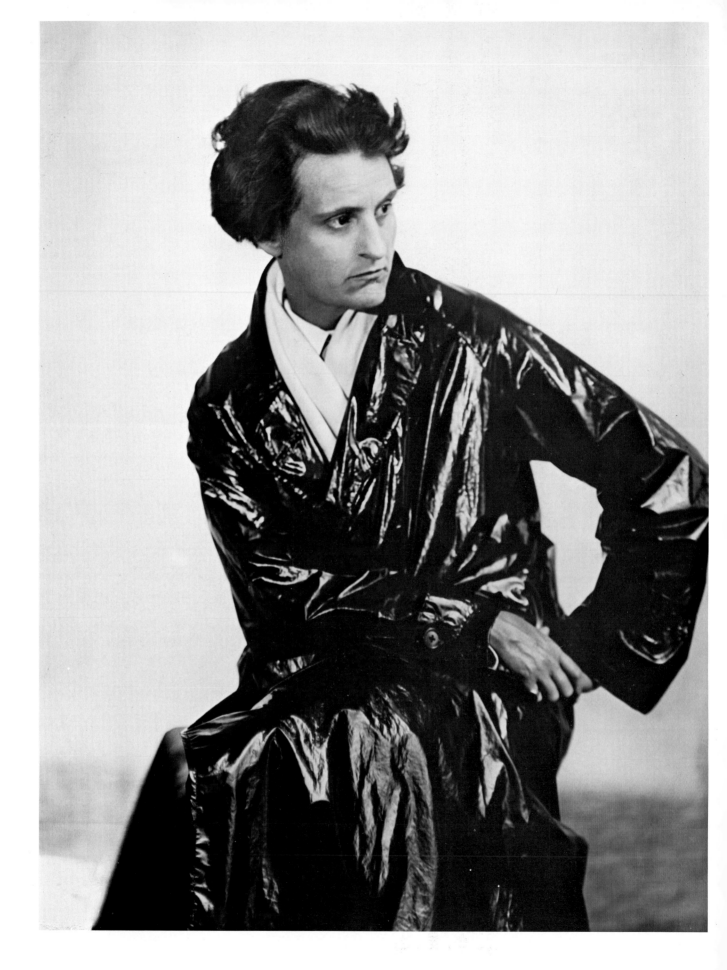

Sylvia Beach, publisher and bookseller

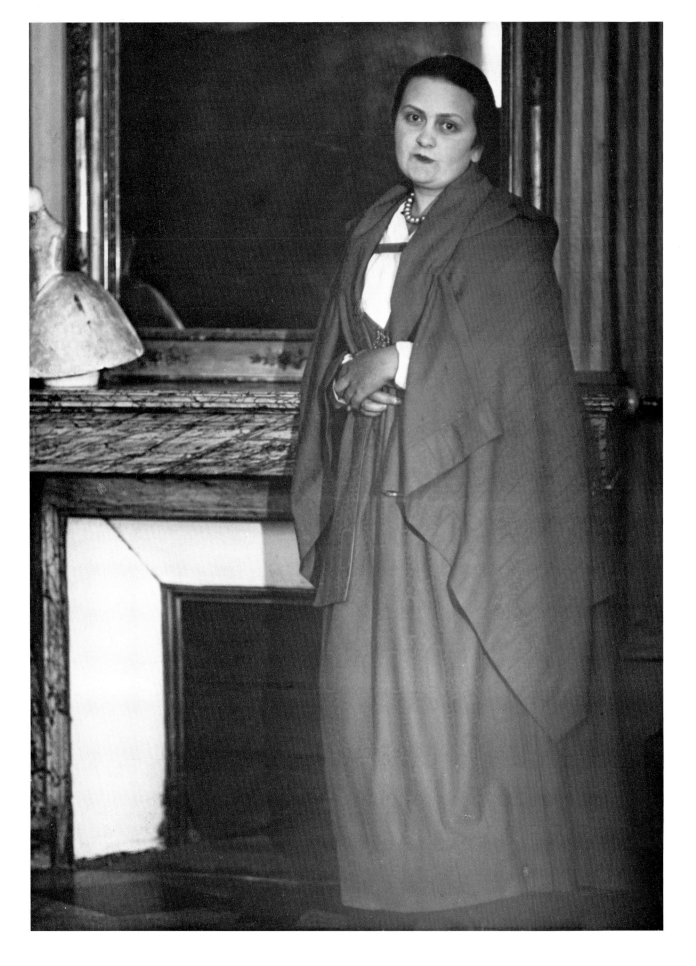

Adrienne Monnier, writer

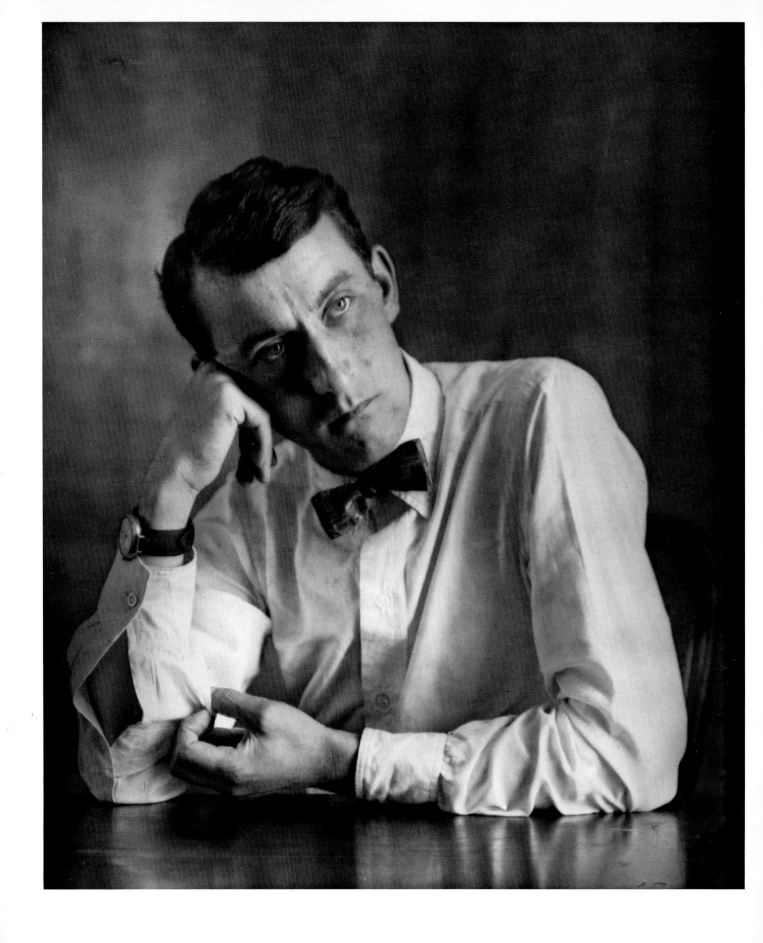

Robert McAlmon, writer and publisher (above)

Peggy Guggenheim, art patron (right)

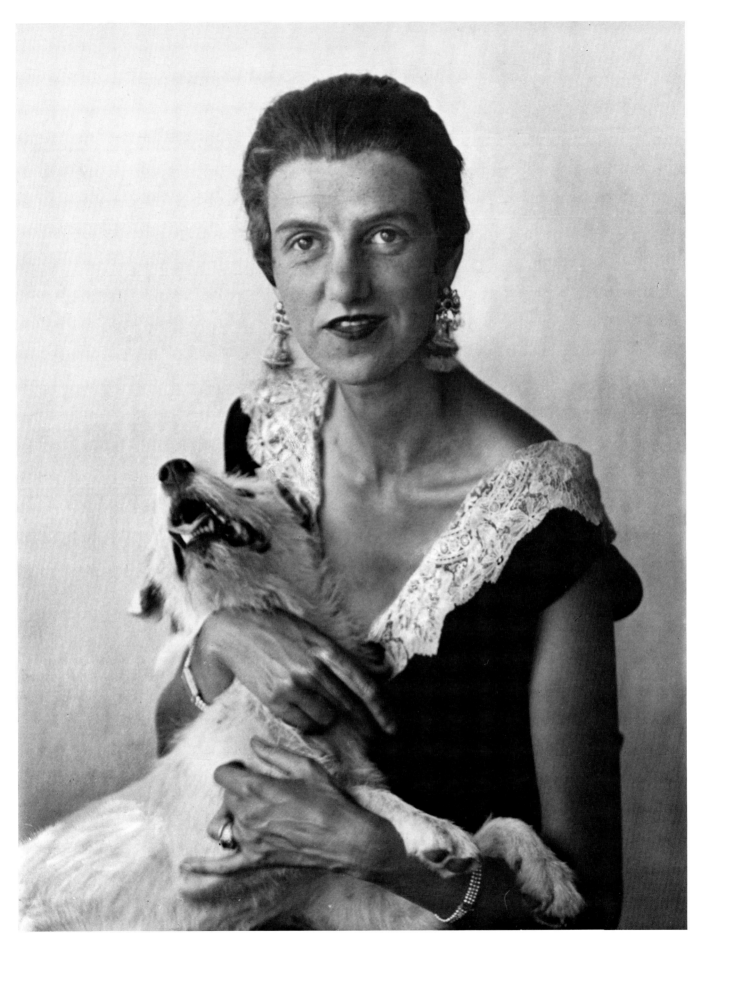

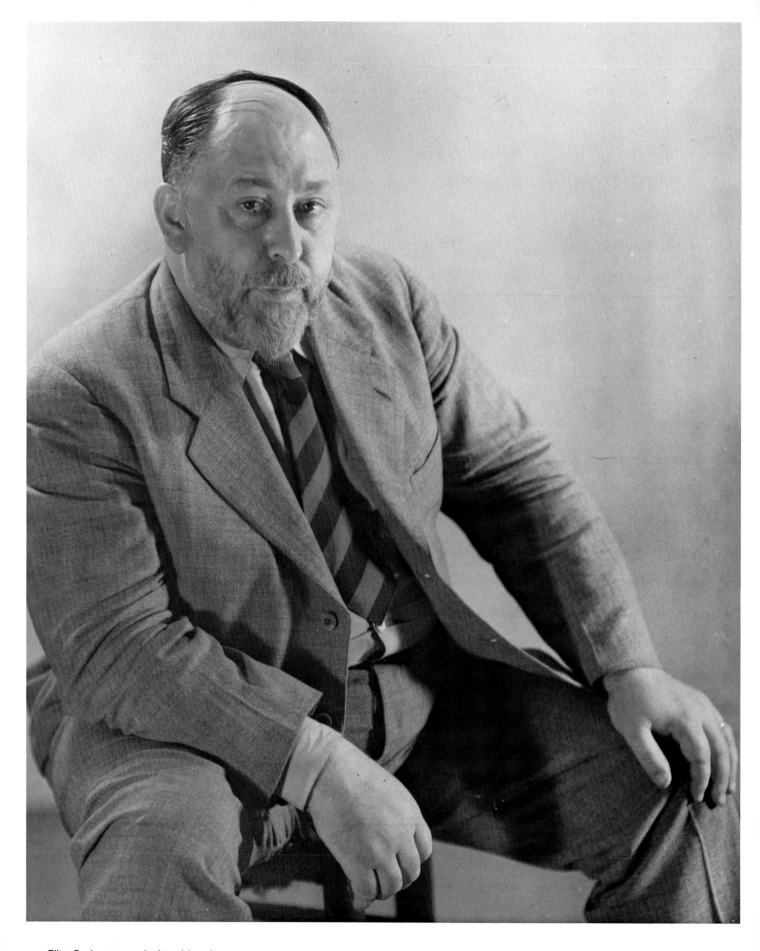

Elliot Paul, writer and editor (above)

George Antheil, composer and musical director (right)

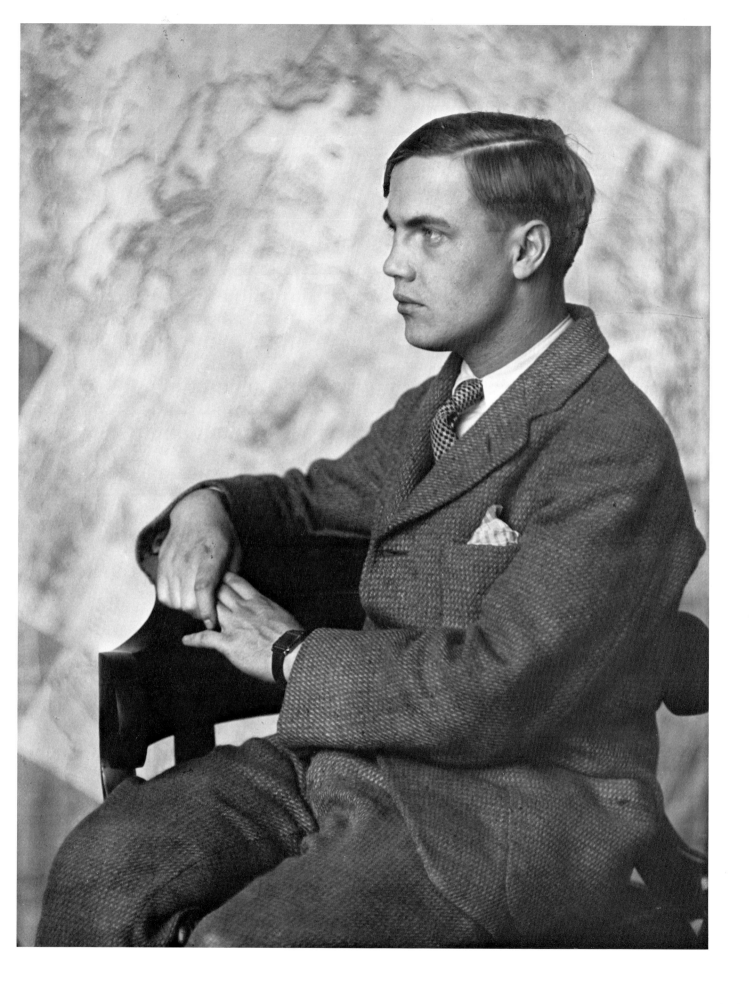

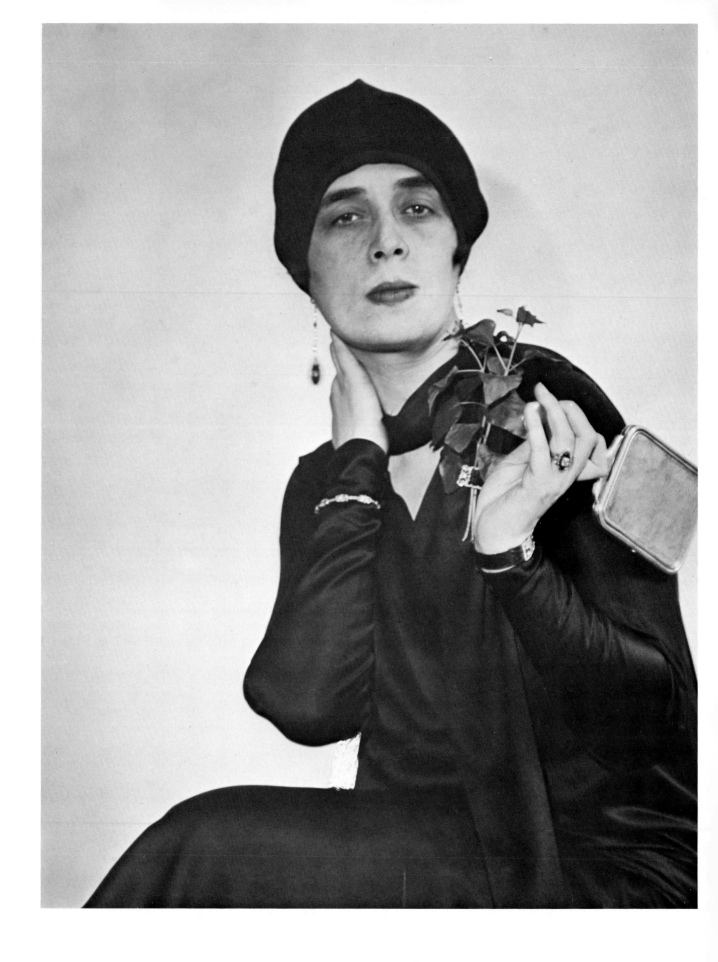

Princess Marthe Bibesco, writer

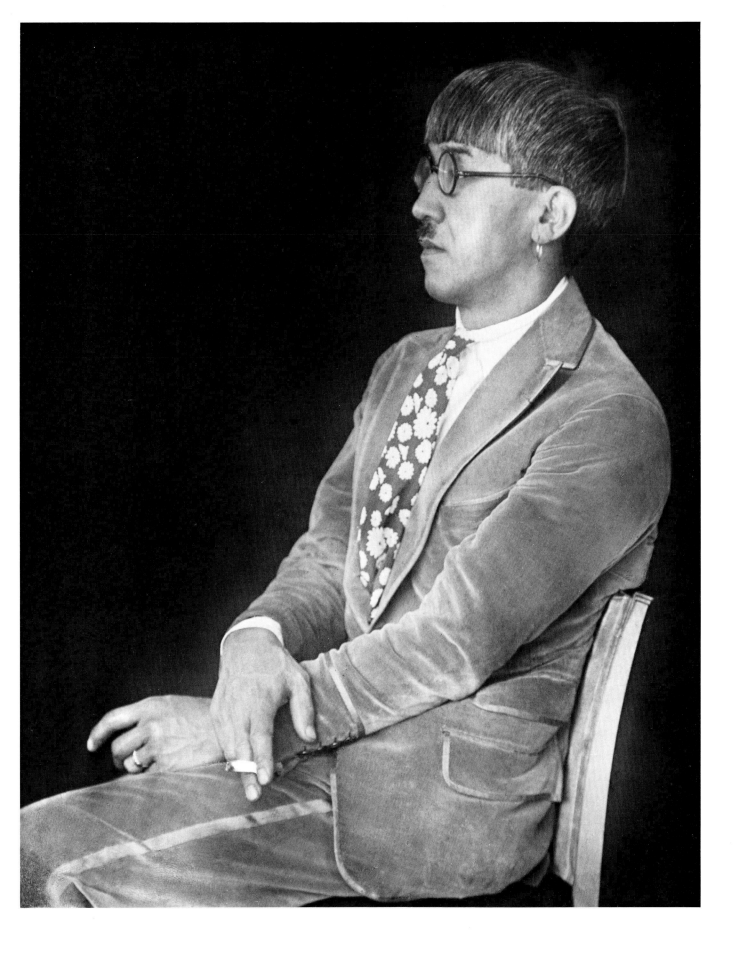

Foujita, painter

Max Ernst, artist (left)

Marcel Duchamp, artist (below)

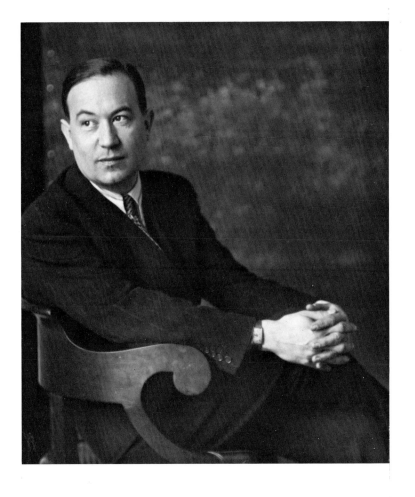

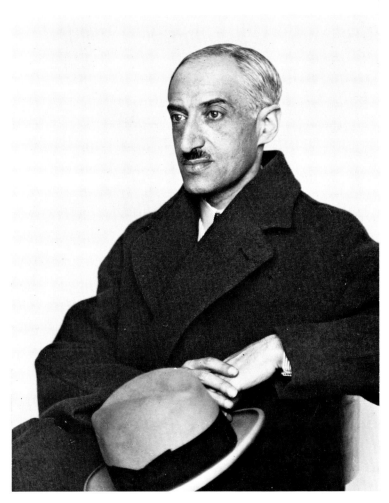

Paul Morand, writer (top left)
André Maurois, writer (bottom left)

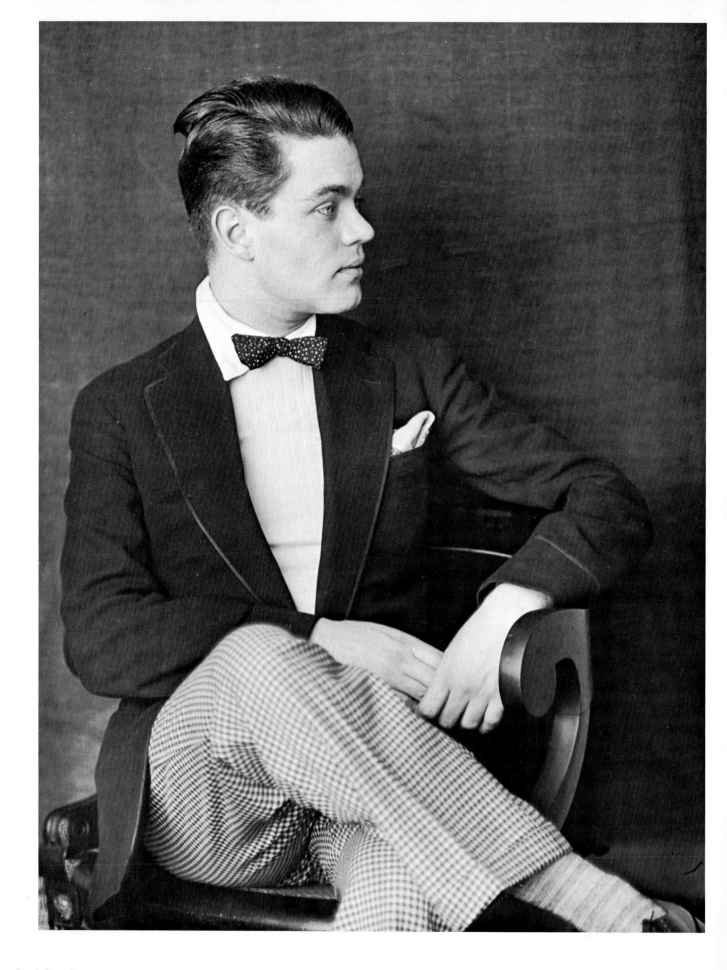

René Crevel, writer

42

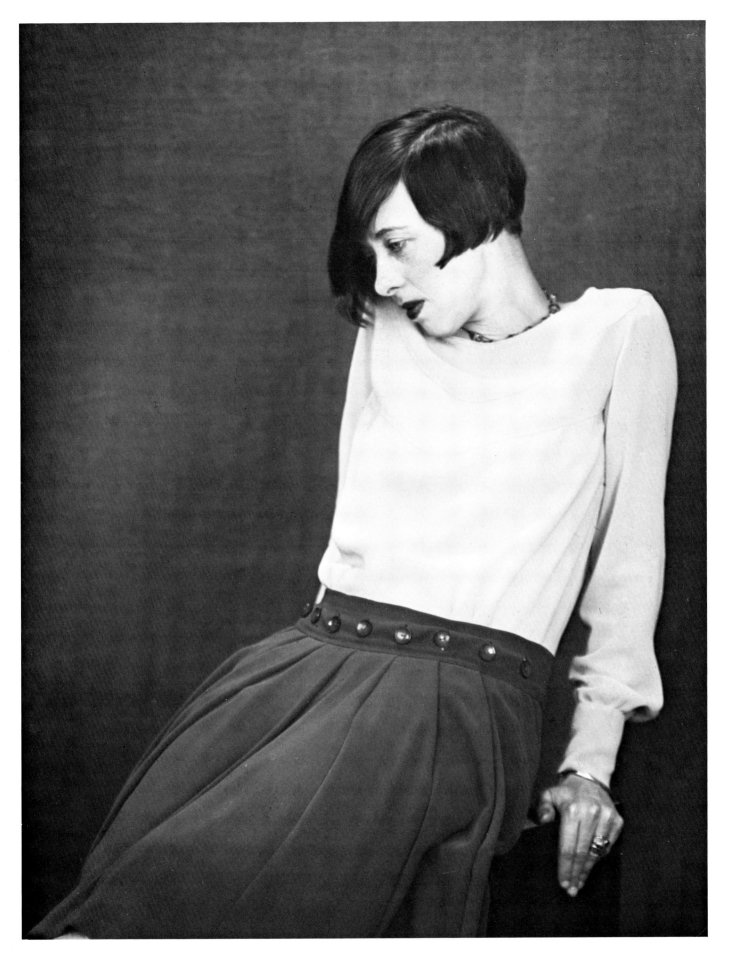

Solita Solano, drama critic, writer, and poet

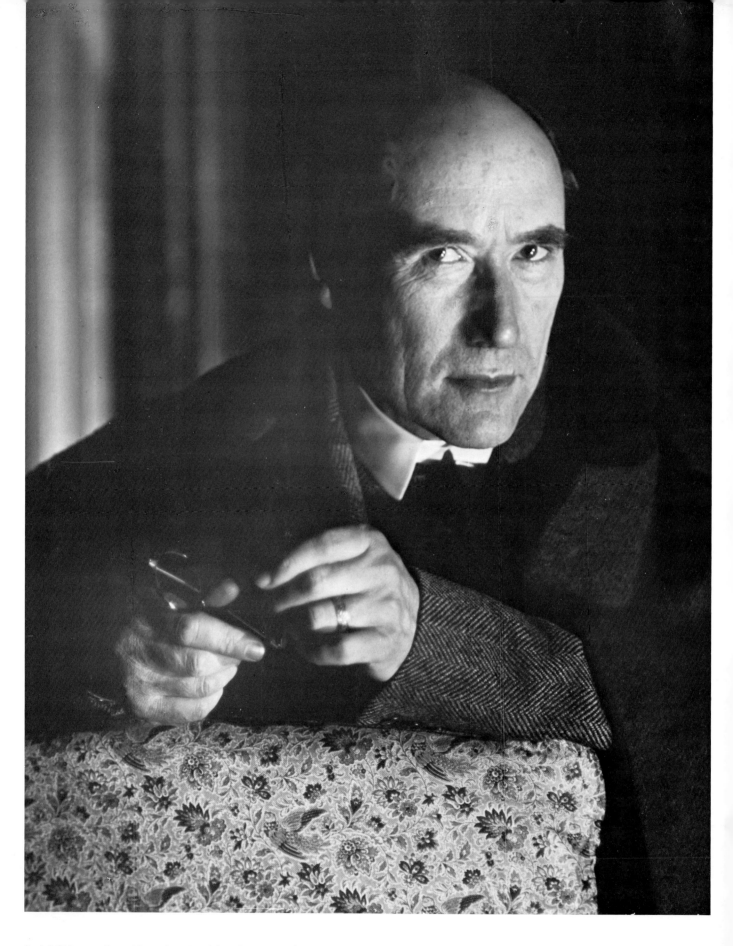

André Gide, novelist, critic, and essayist (above)

Princess Eugène Murat (right)

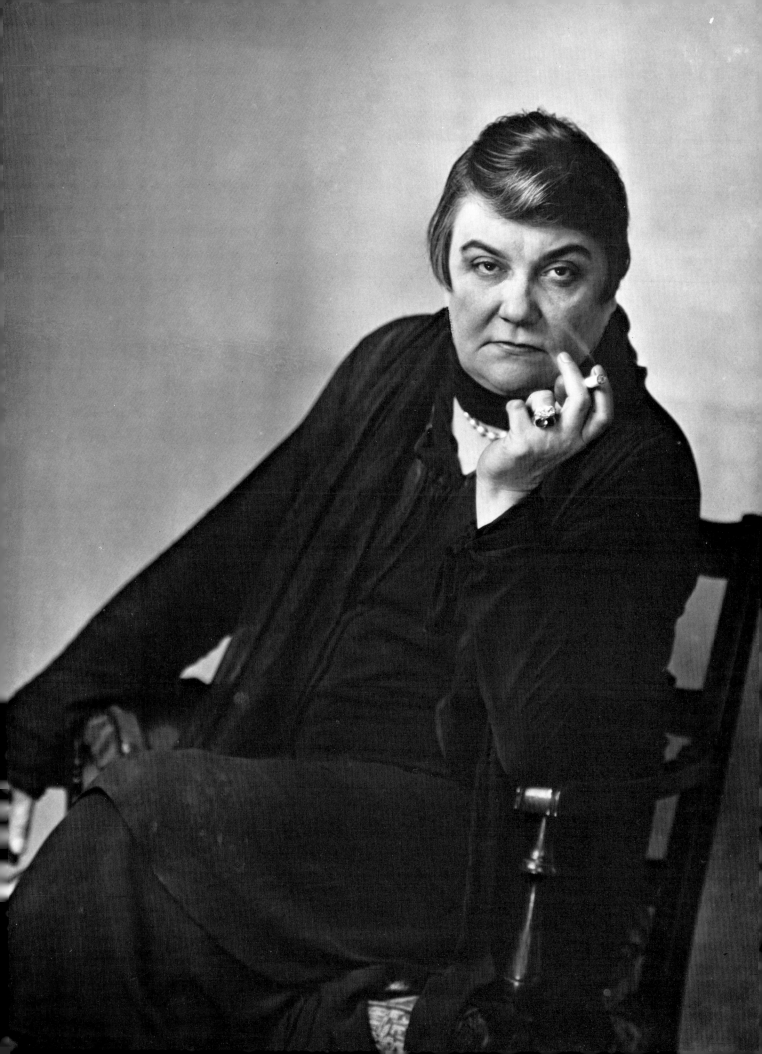

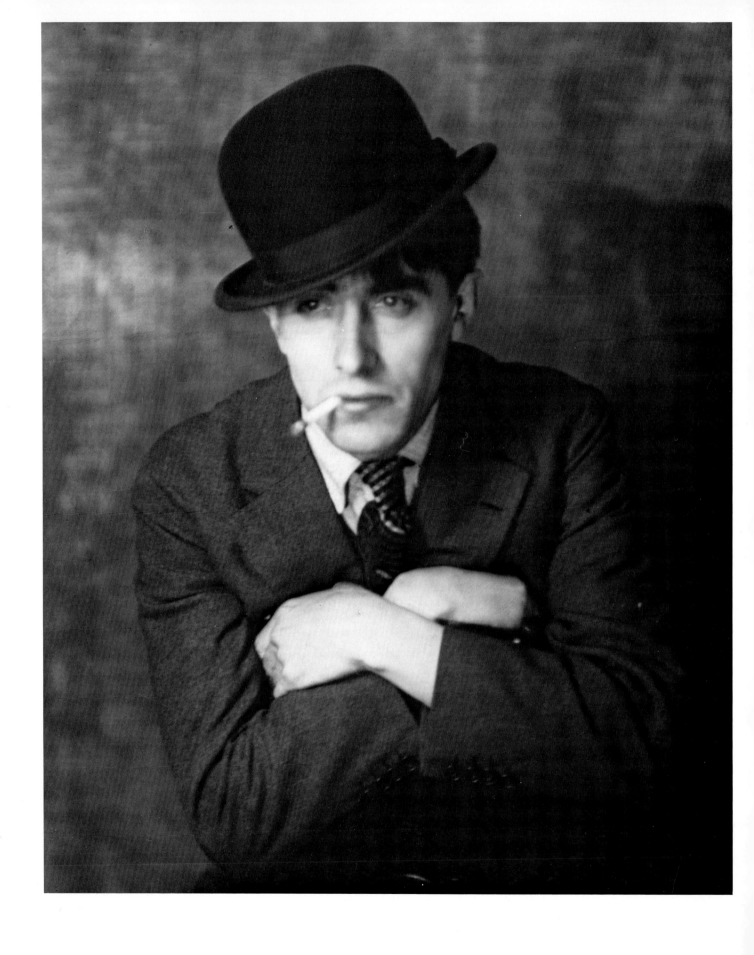

Pierre de Massot, writer

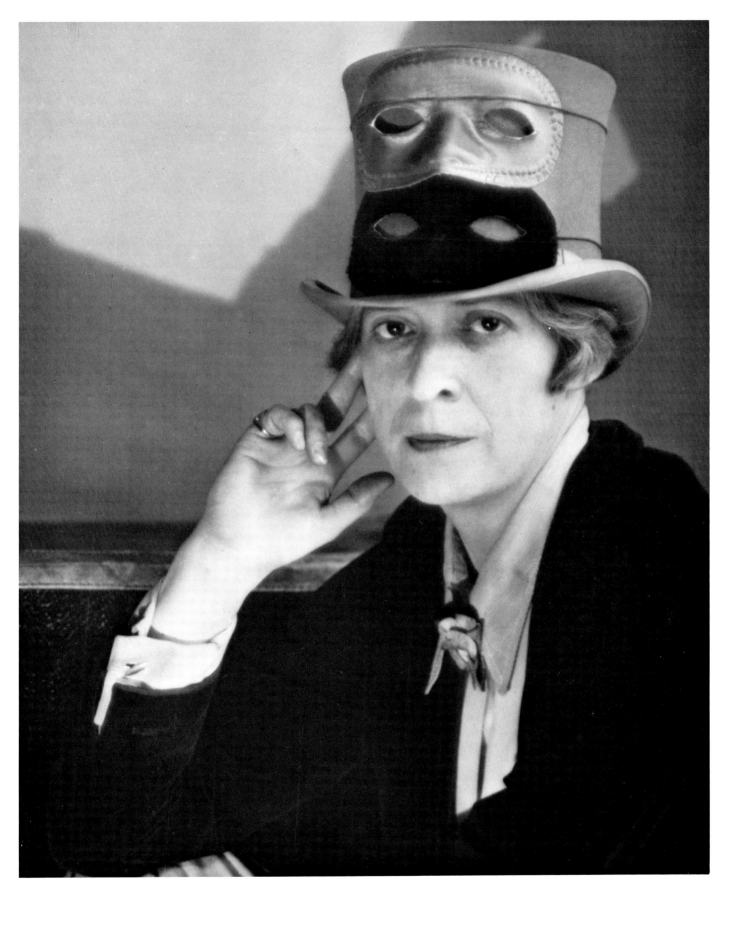

Janet Flanner, writer

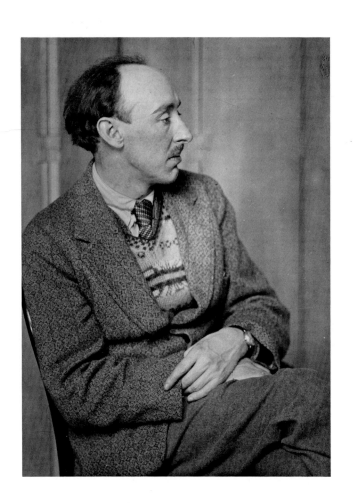 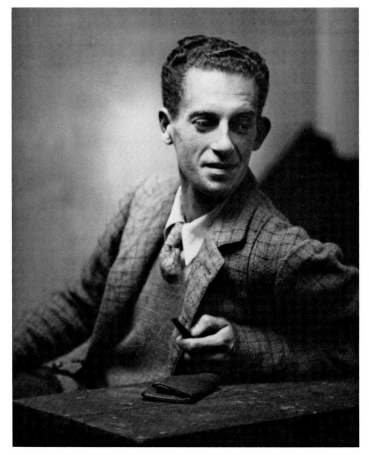

Frank Dobson, sculptor (above)

Cedric Morris, acquaintance of the artist (above right)

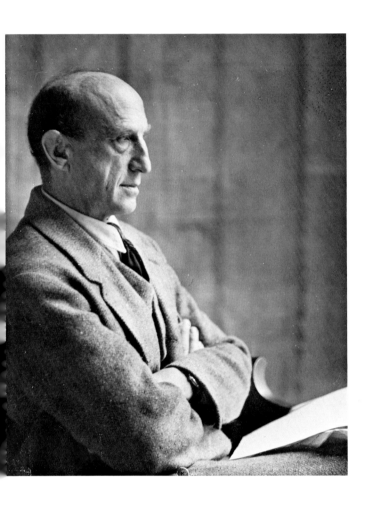

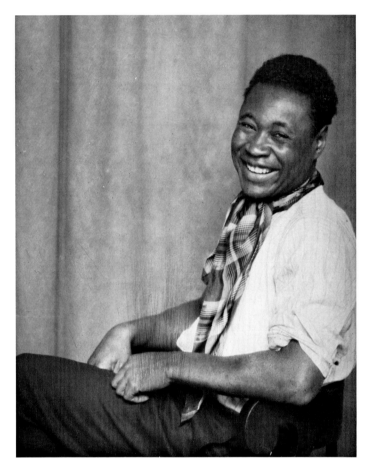

Claude McKay, writer and poet (above)

Leo Stein, writer and philosopher (above left)

49

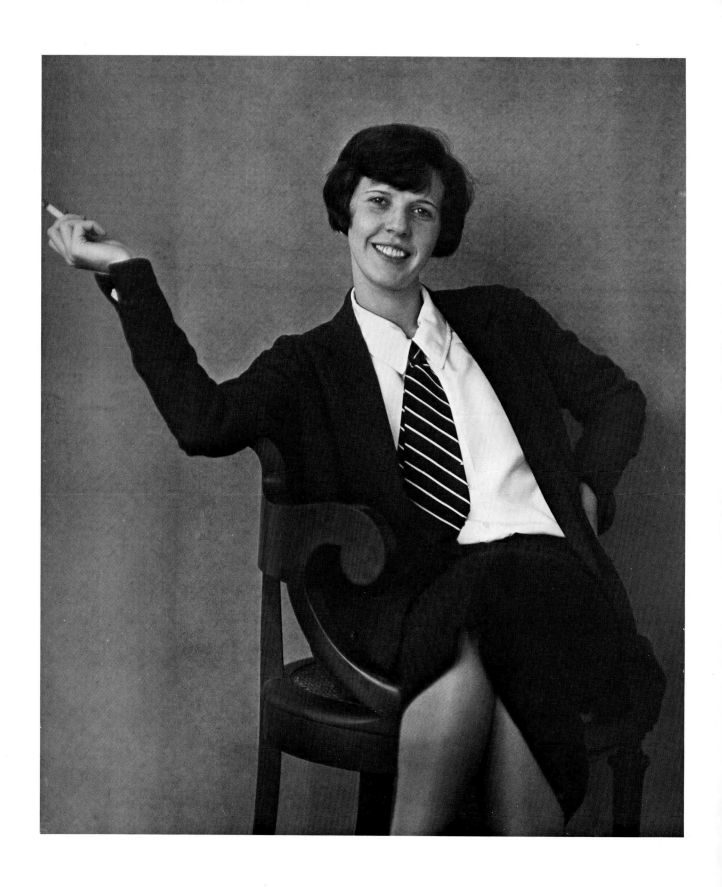

Mrs. Raymond Massey (above)

Buddy Gilmore, drummer (right)

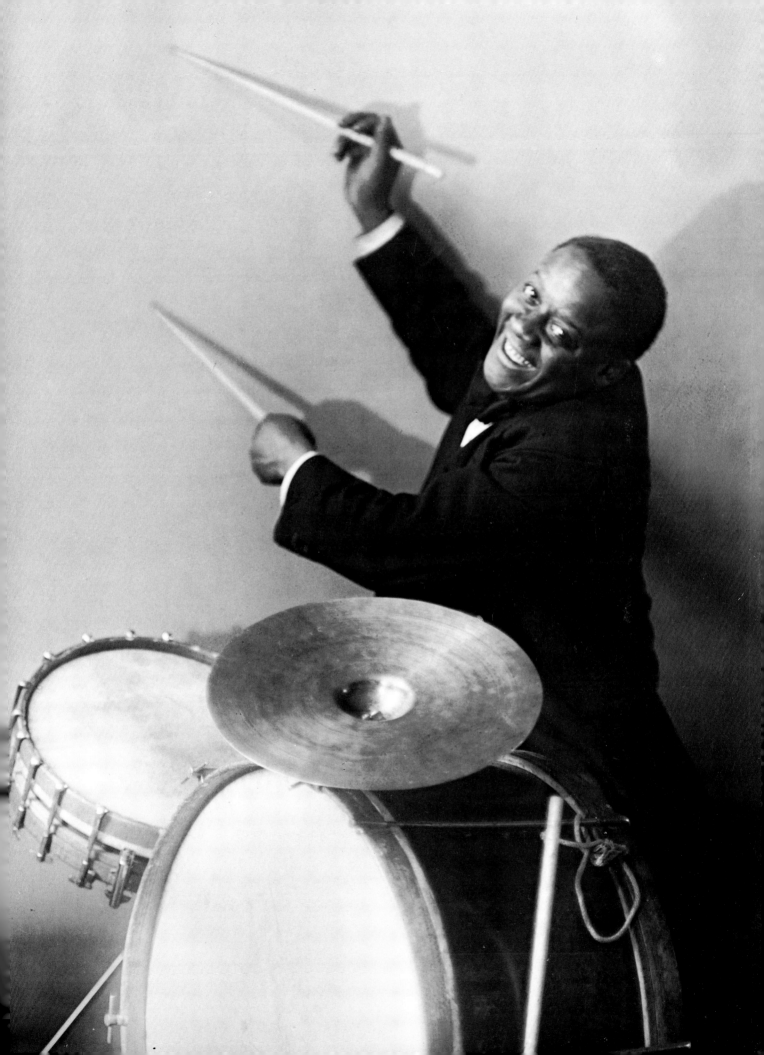

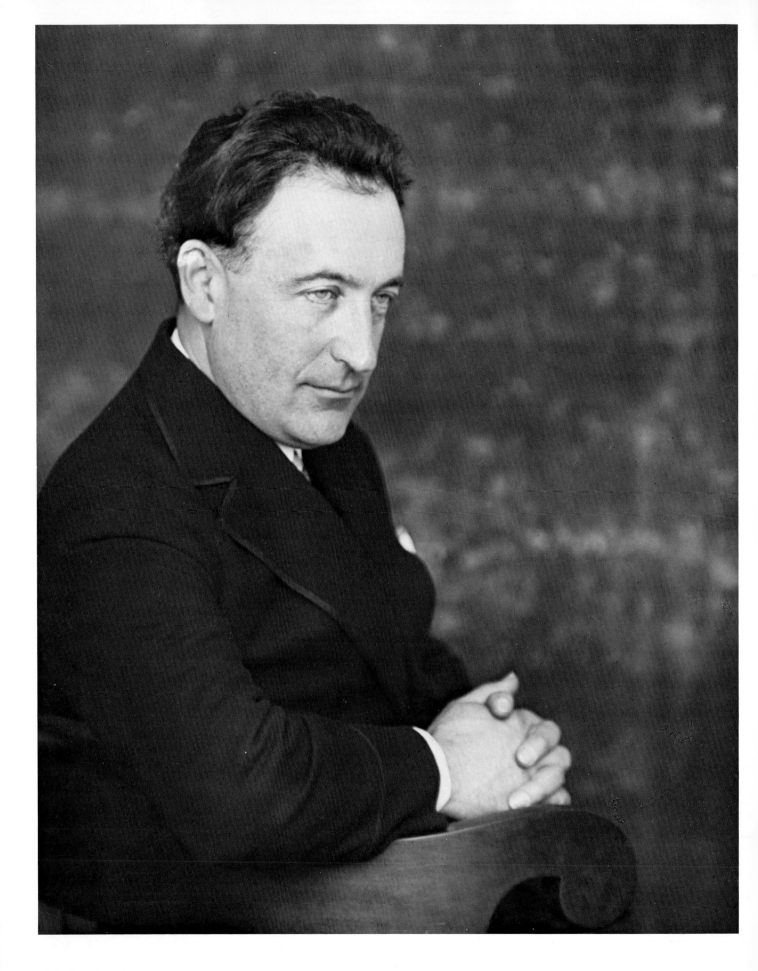

Jules Romain, writer

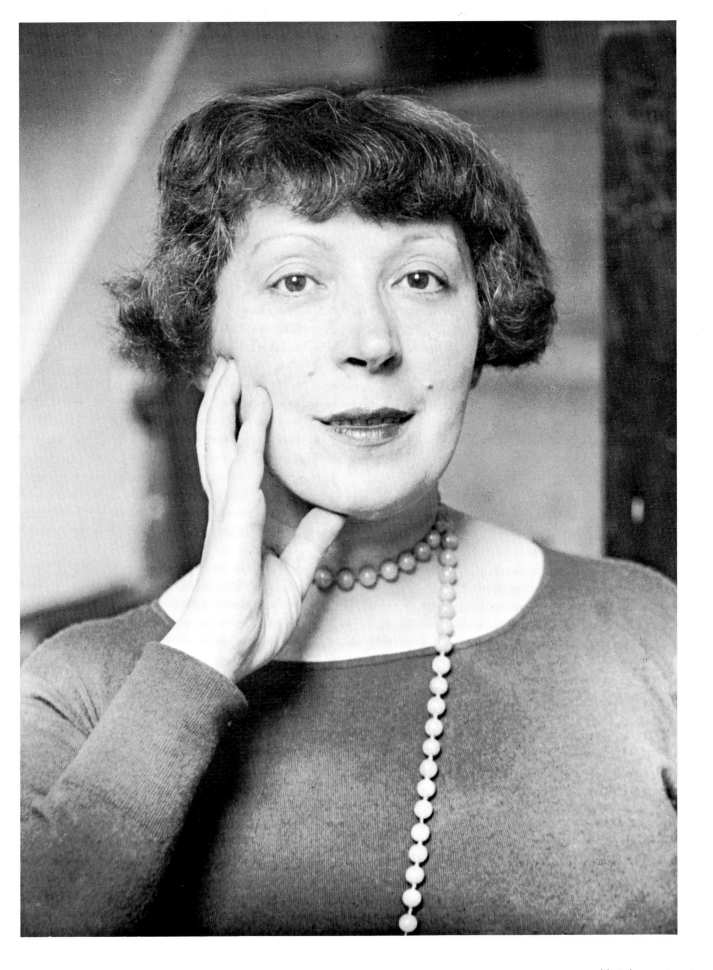

Marie Laurencin, painter

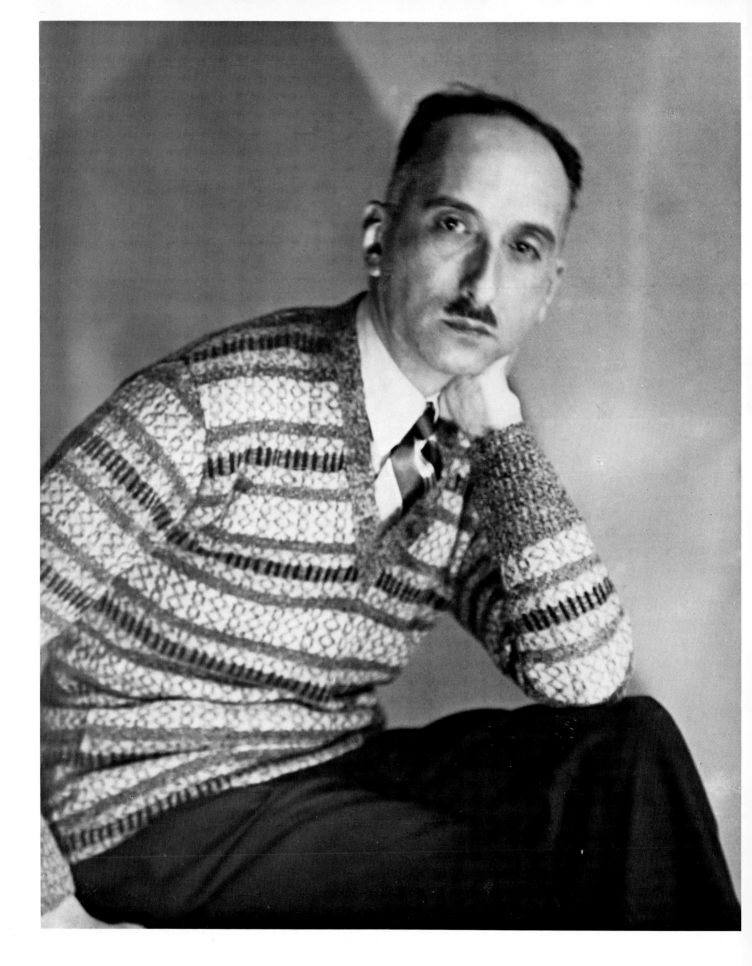

François Mauriac, writer

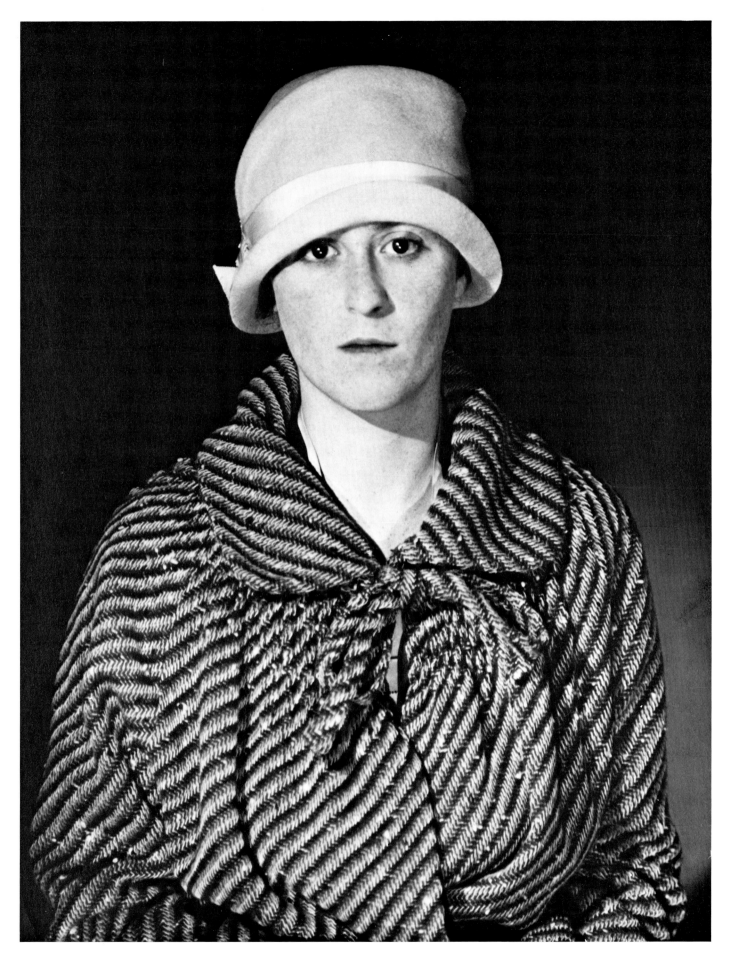

Sophie Victor, friend of the artist

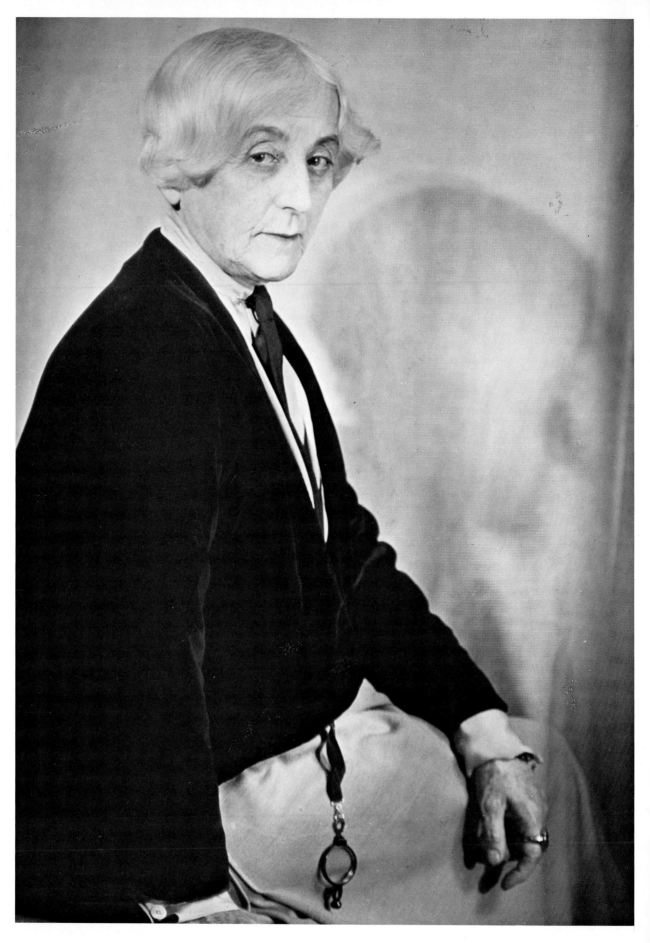

Madame Theodore van Rysselberghe, writer (above)

Djuna Barnes, writer (right)

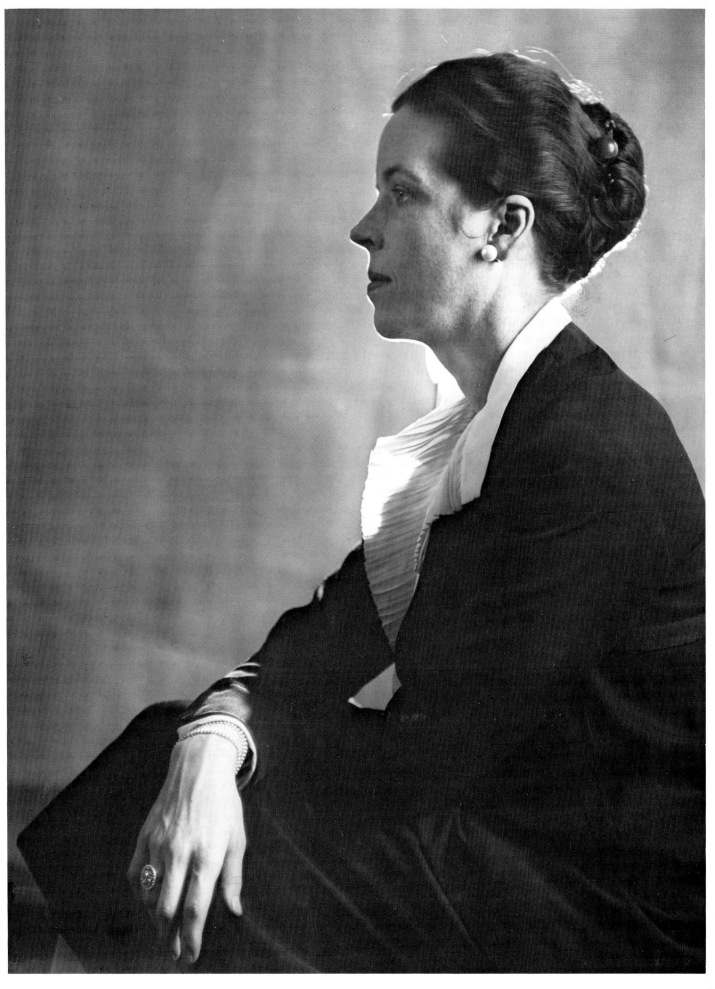

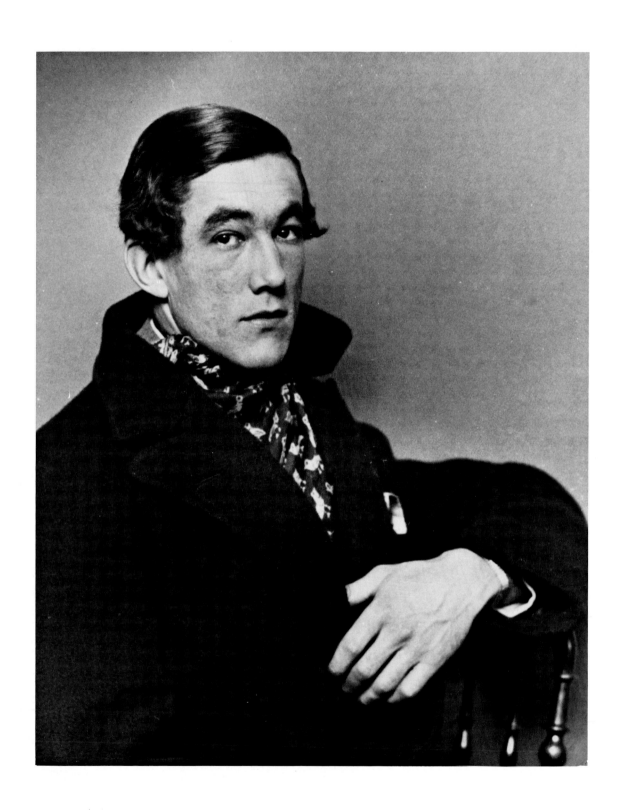

Paul Cross, poet (above)

Philippe Soupault, writer (top right)

André Sigfried, writer (bottom right)

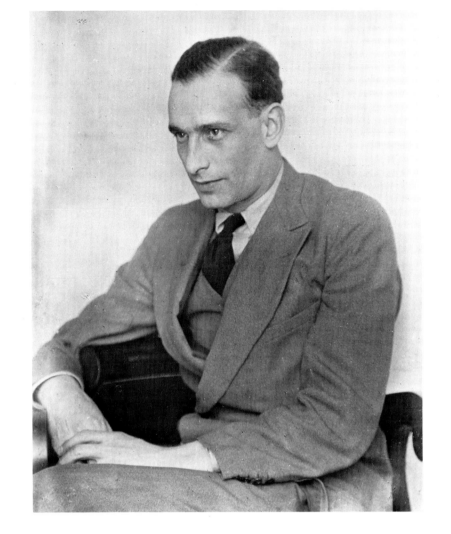

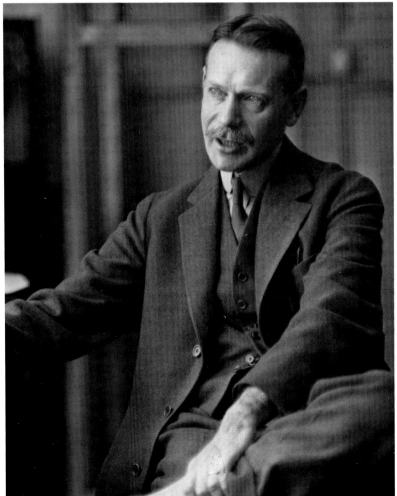

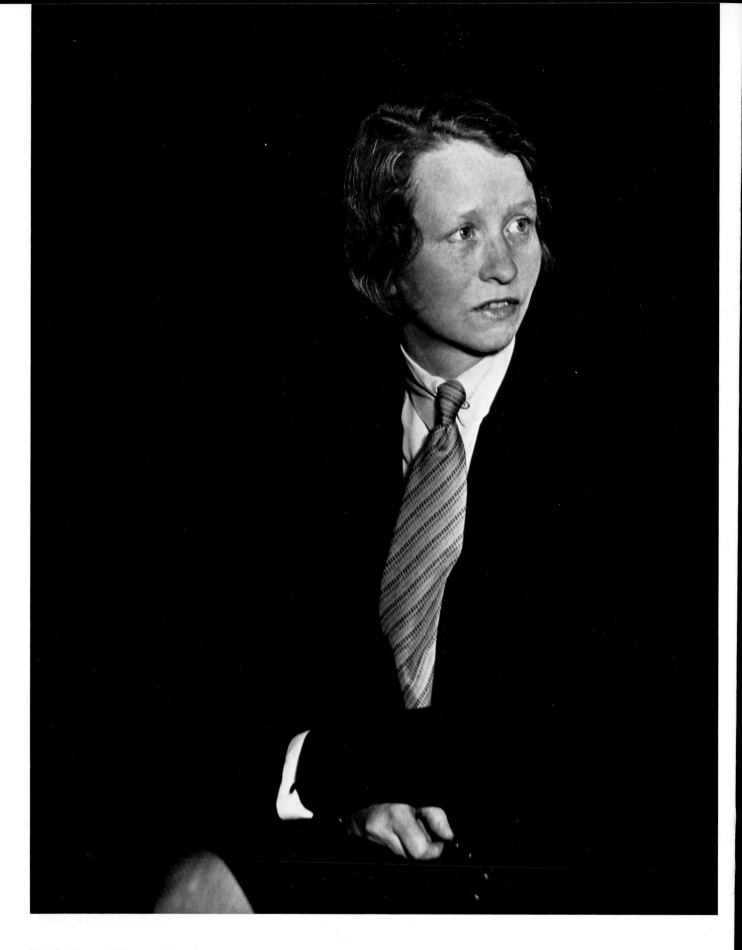

Edna St. Vincent Millay, poet (above)

Eugéne Atget, photographer (right)

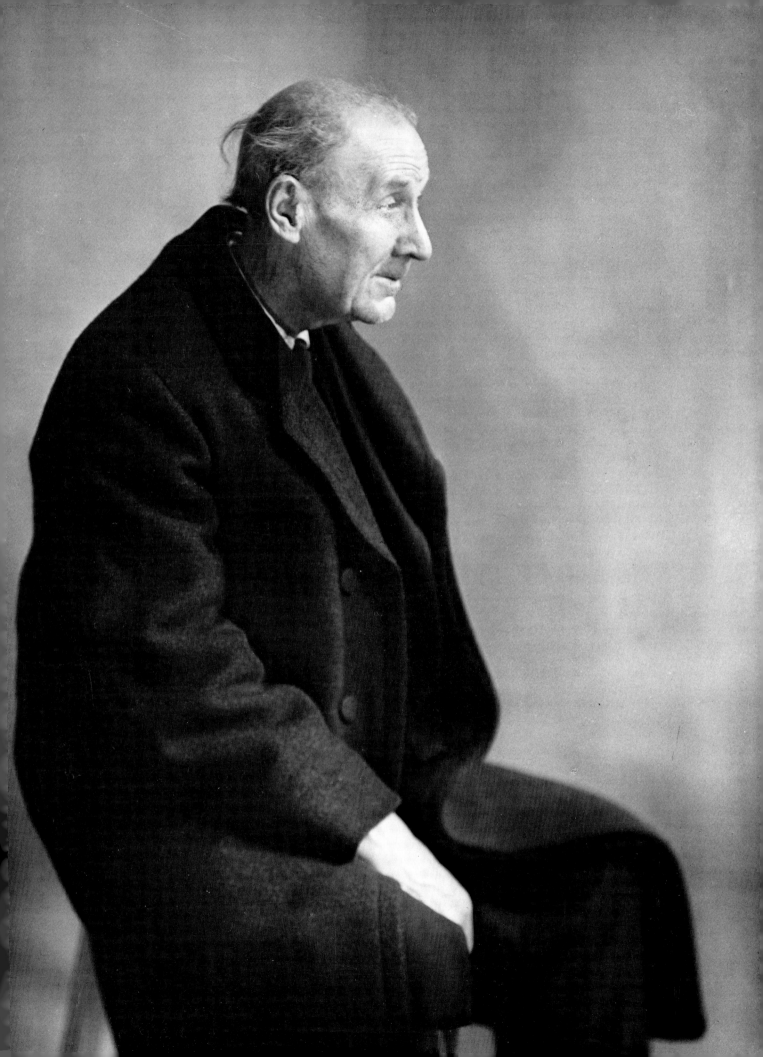

NEW YORK

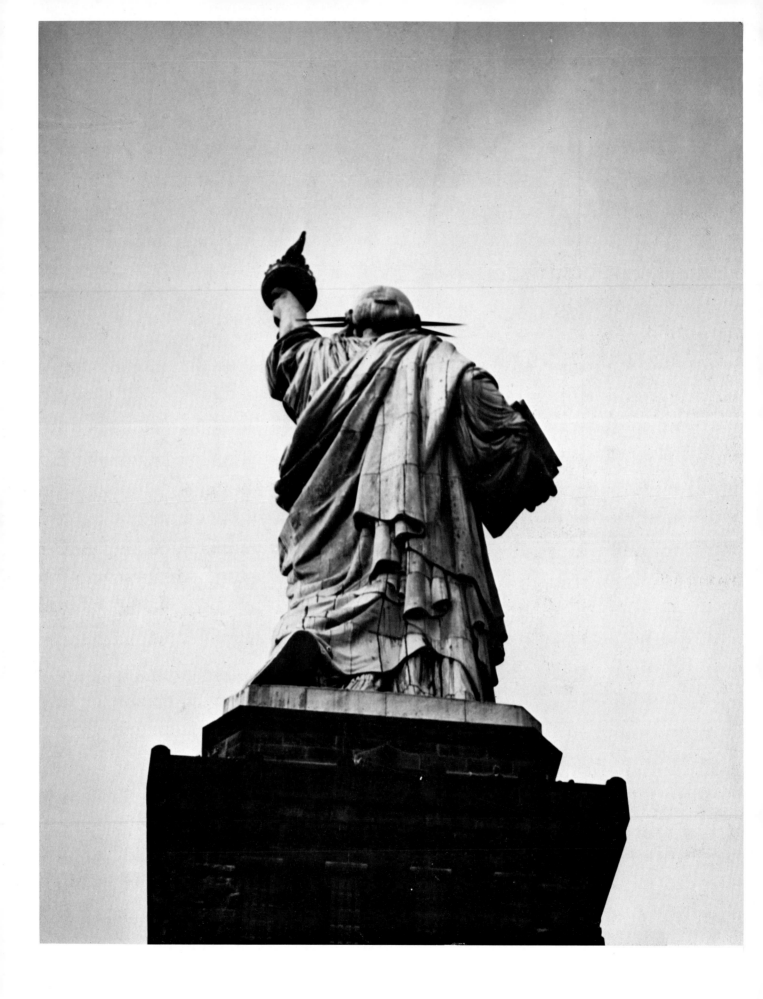

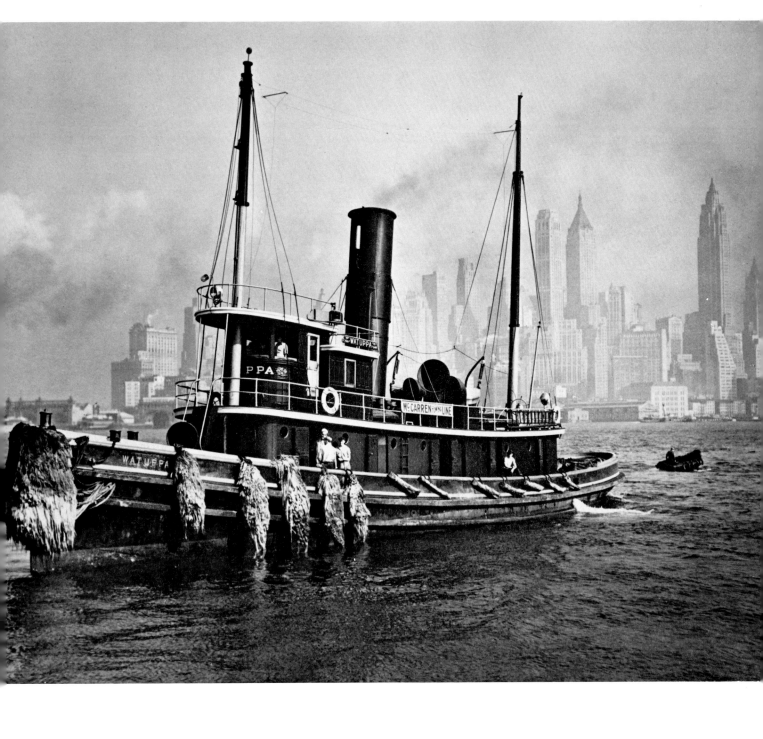

The *Watuppa* off Manhattan Island (above)

Statue of Liberty (left)

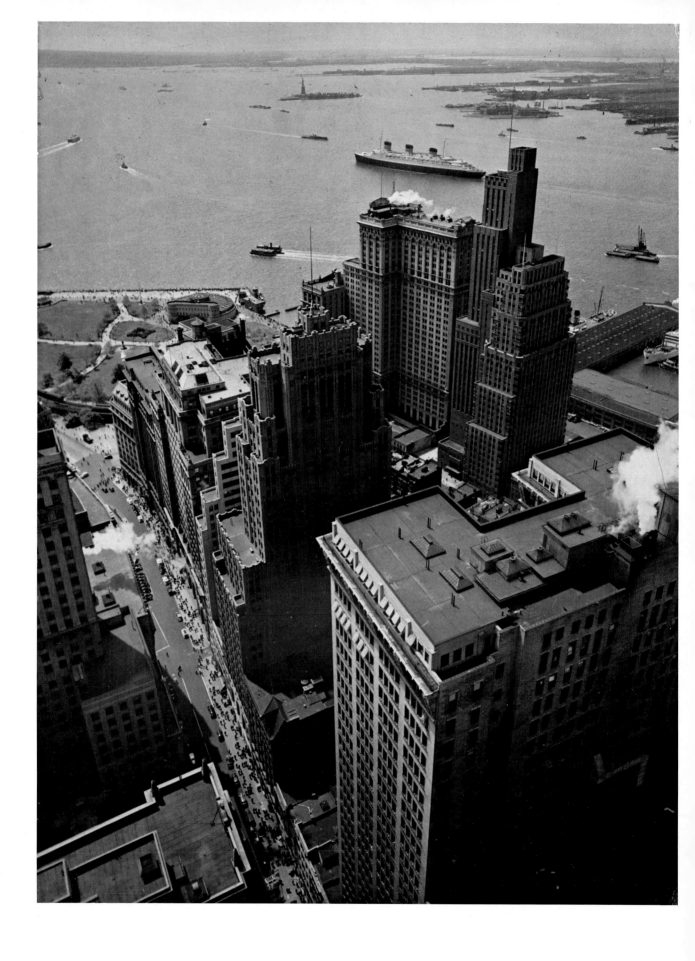

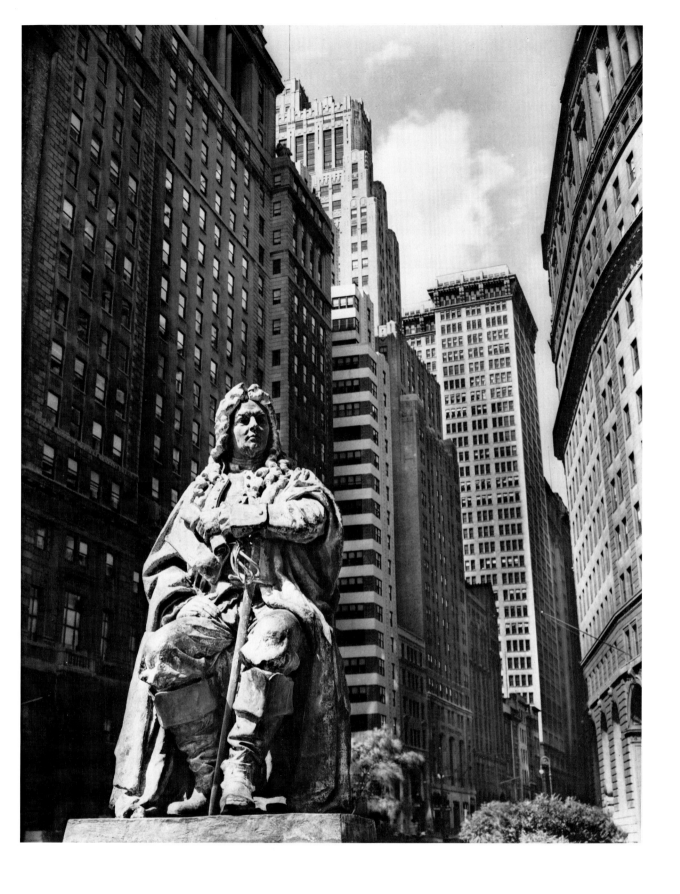

The Abraham De Peyster statue, Bowling Green (above)

Broadway to the Battery (left)

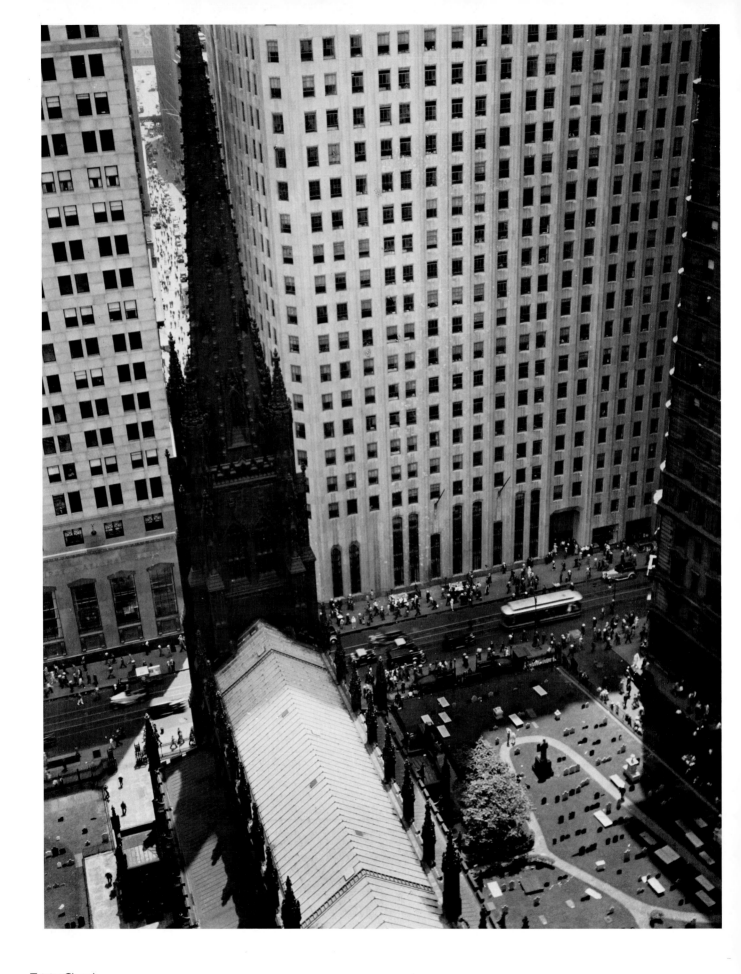

Trinity Church

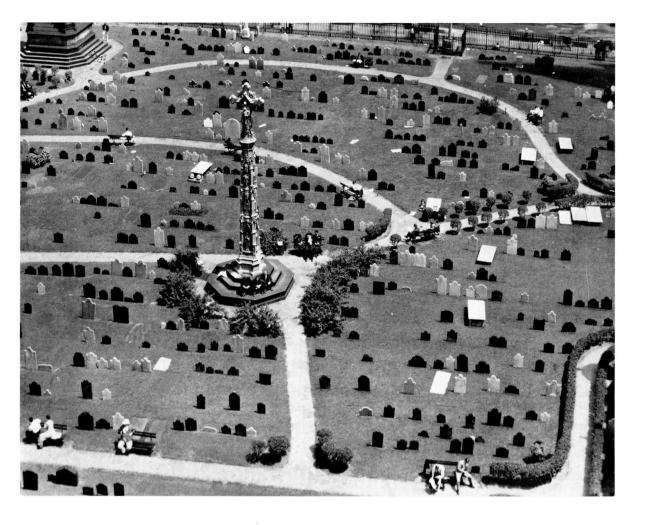

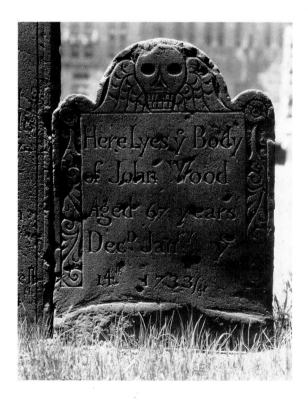

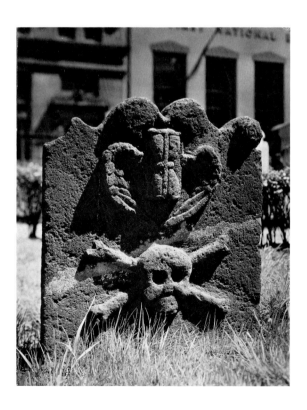

Three views of Trinity Churchyard

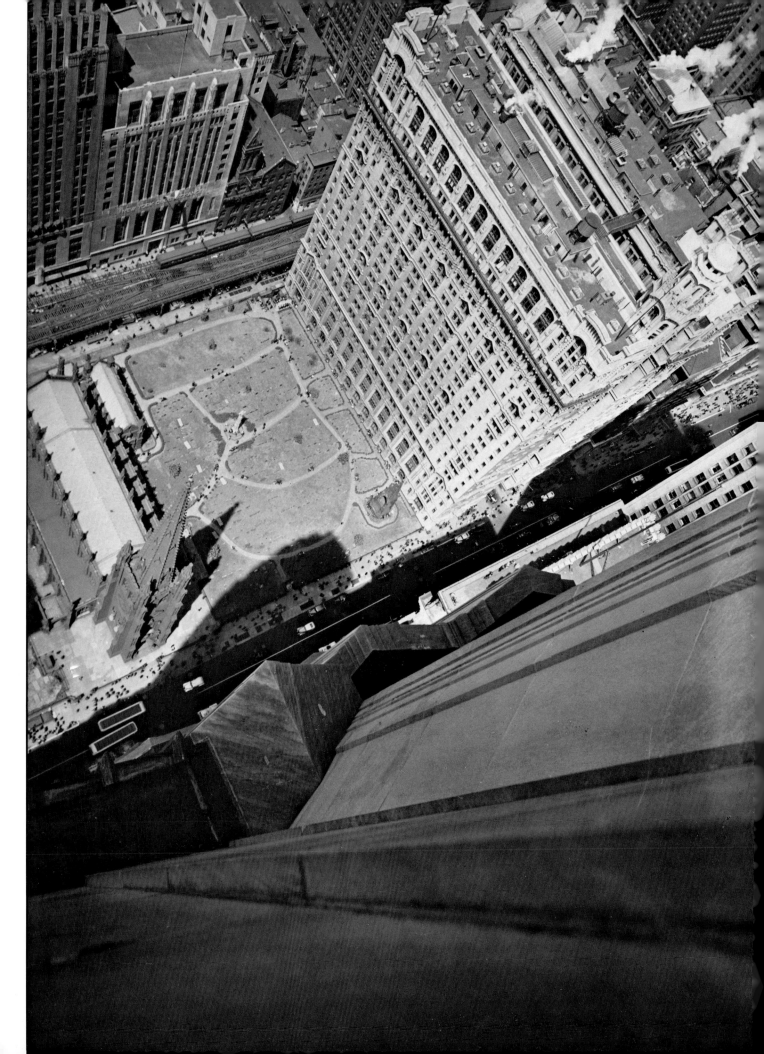

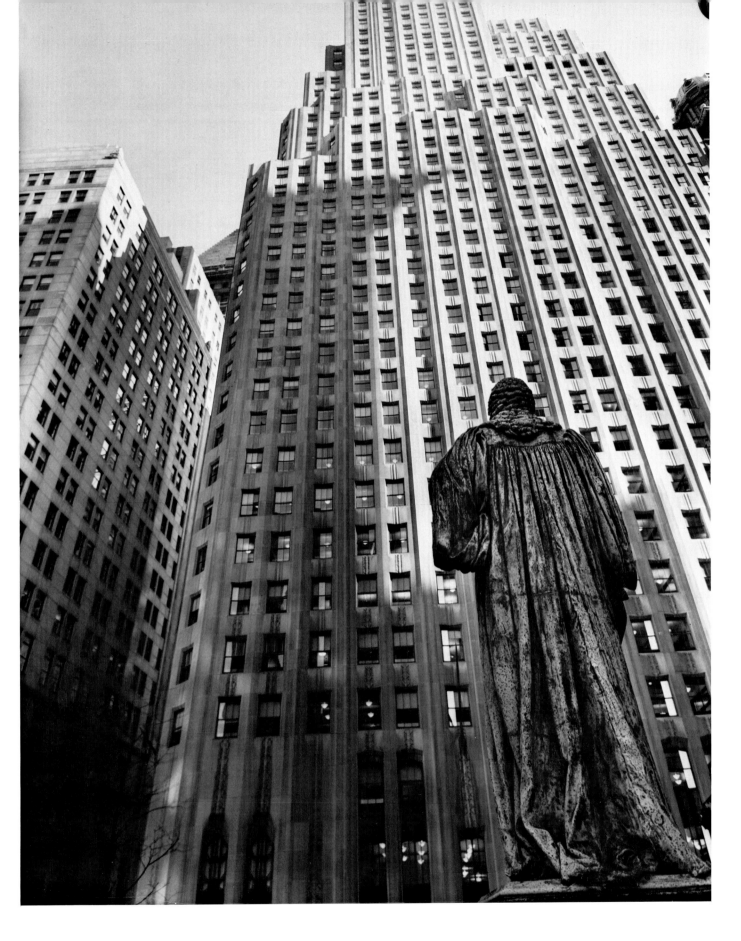

The John Watts statue in Trinity Churchyard (above)

Trinity Church (left)

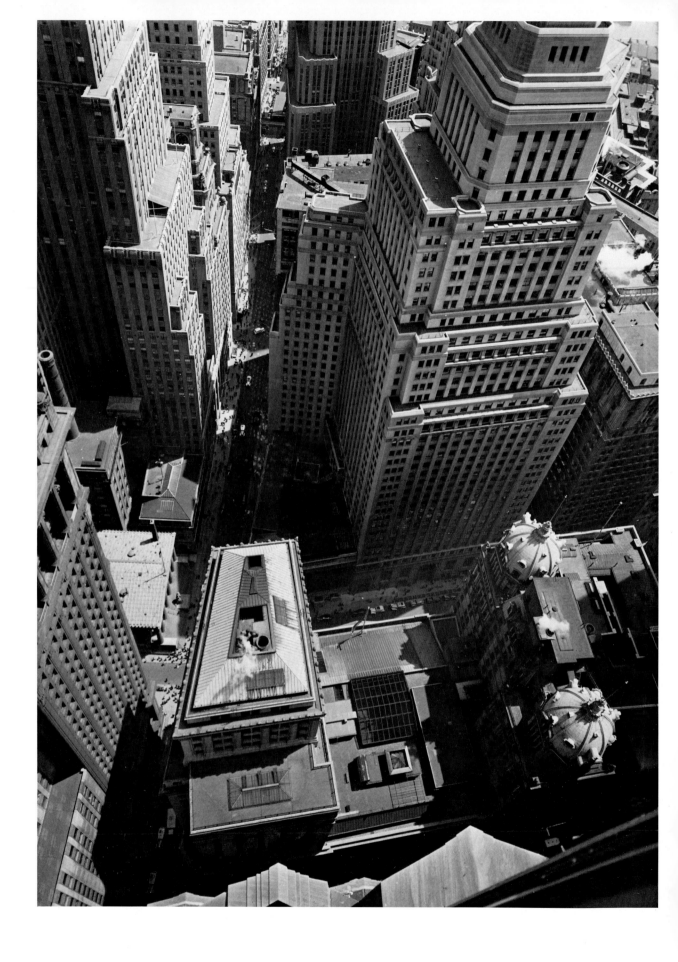

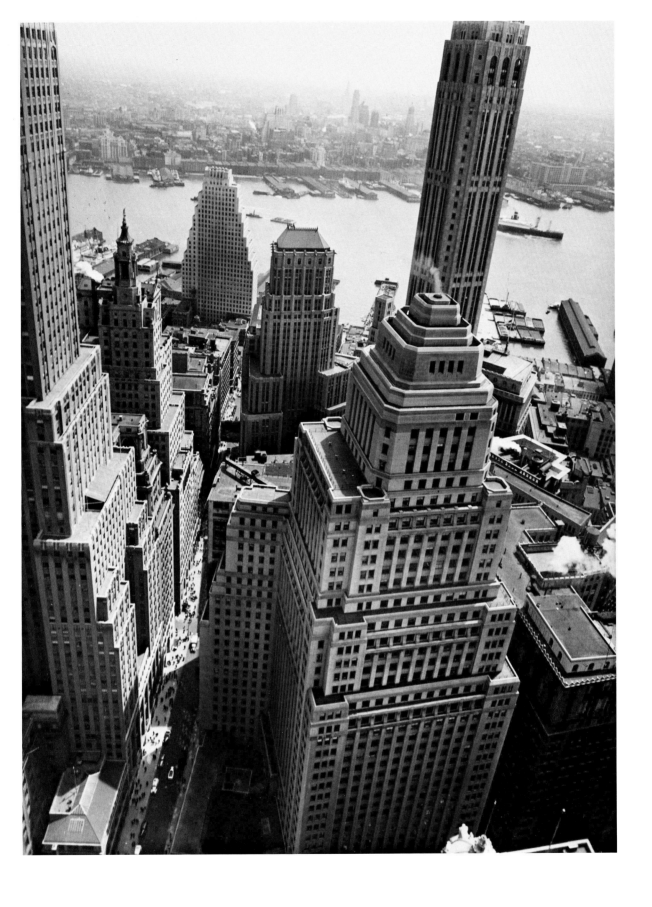

Lower Manhattan, view toward Brooklyn (above)
Birdseye view, Wall Street (left)
Financial District (overleaf)

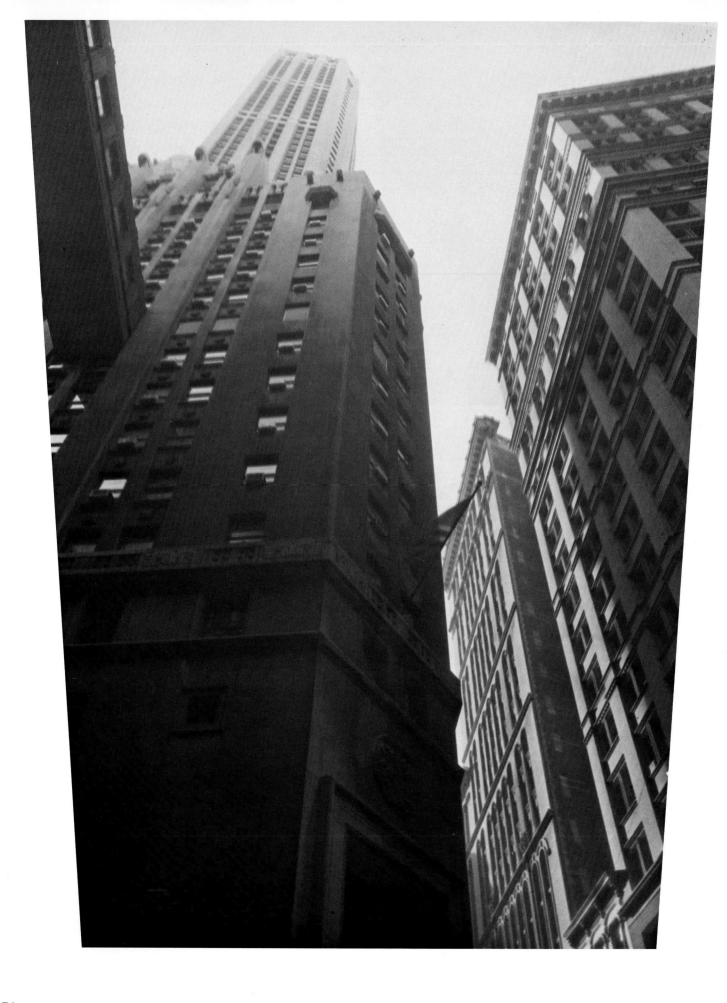

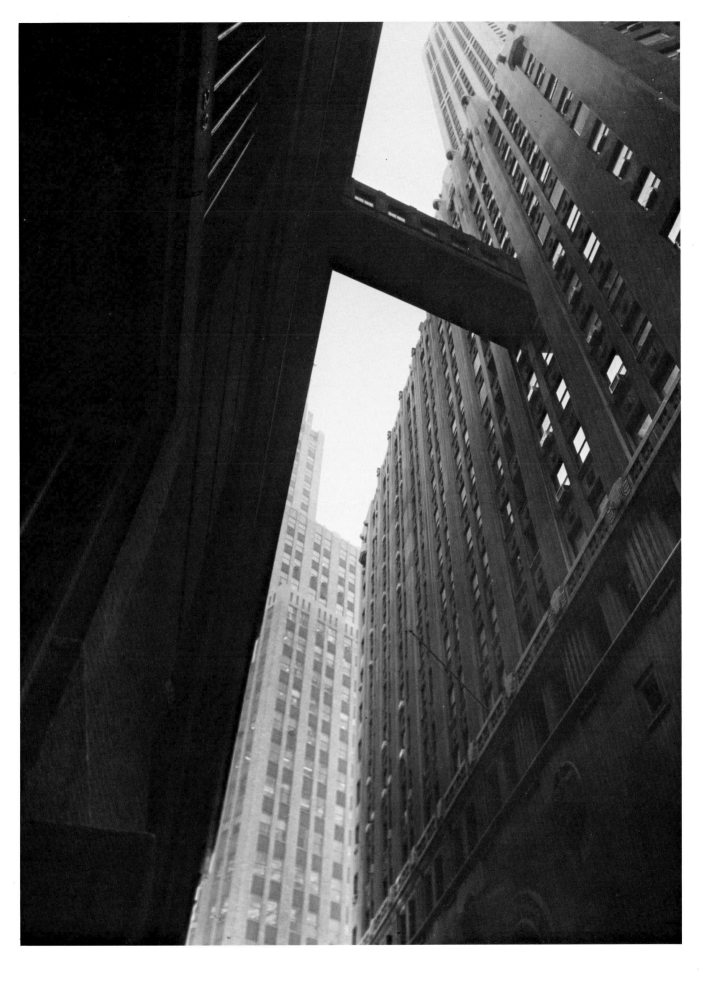

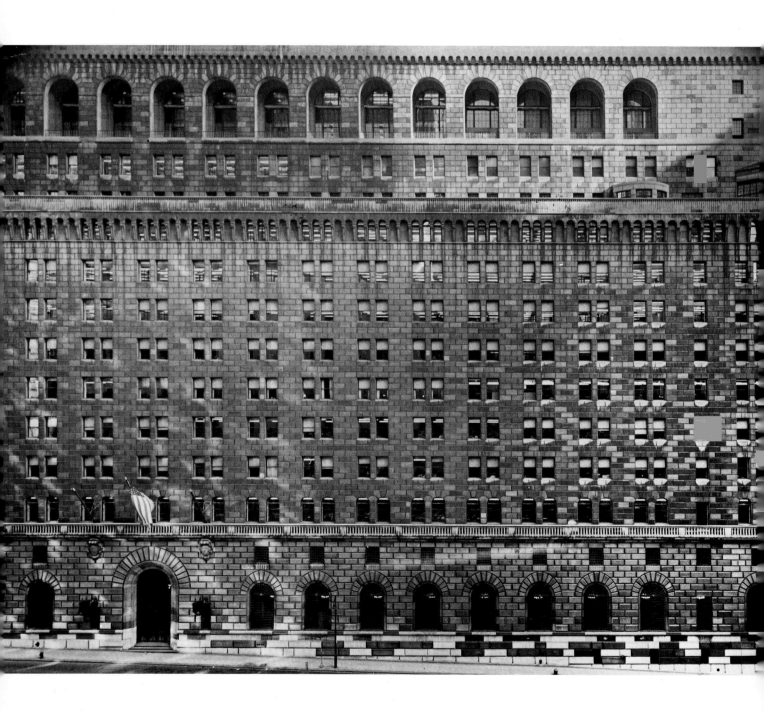

Federal Reserve Building (above)

At Beaver and William Streets (right)

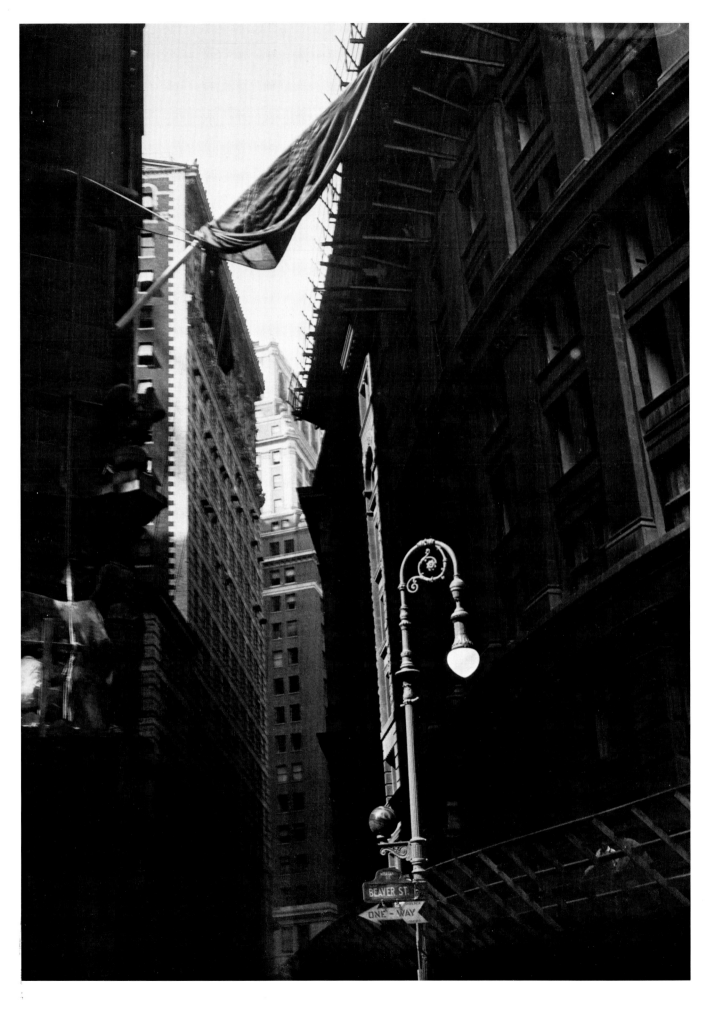

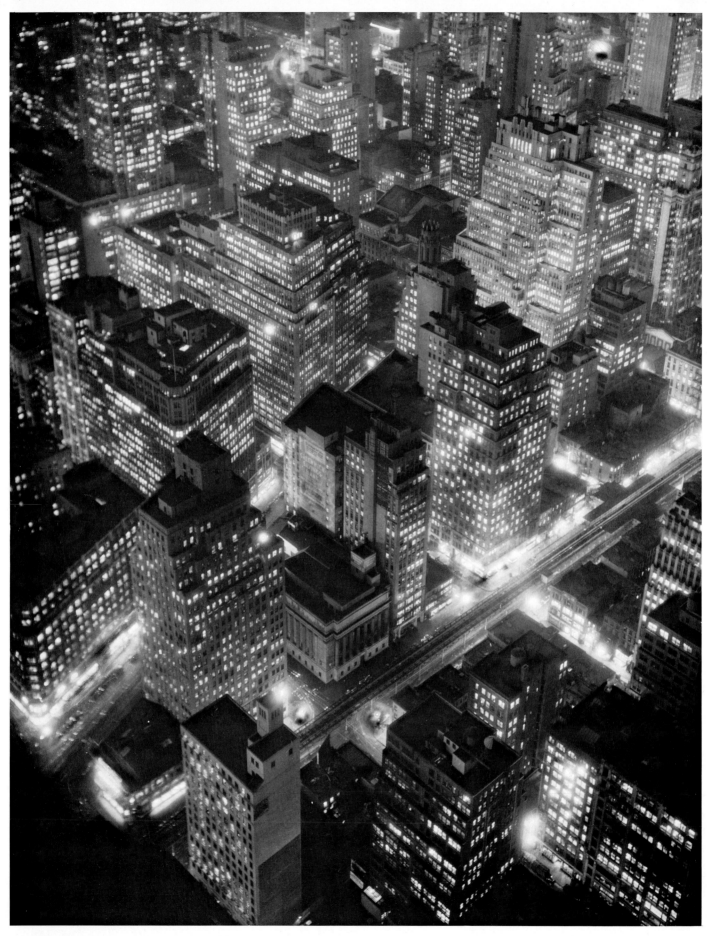

West Side looking north from upper 30s (above)

Exchange Place (right)

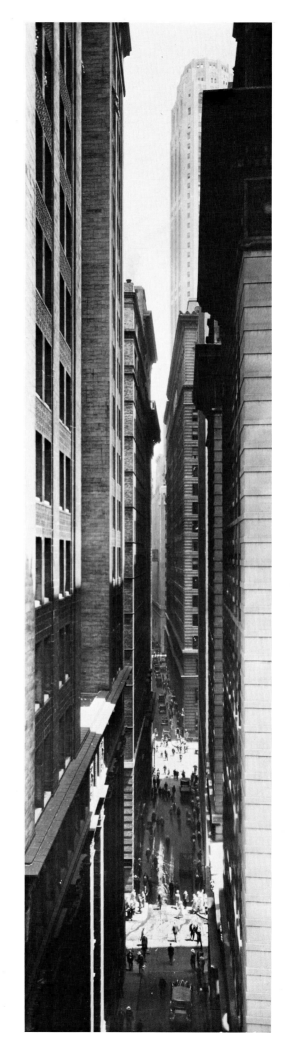

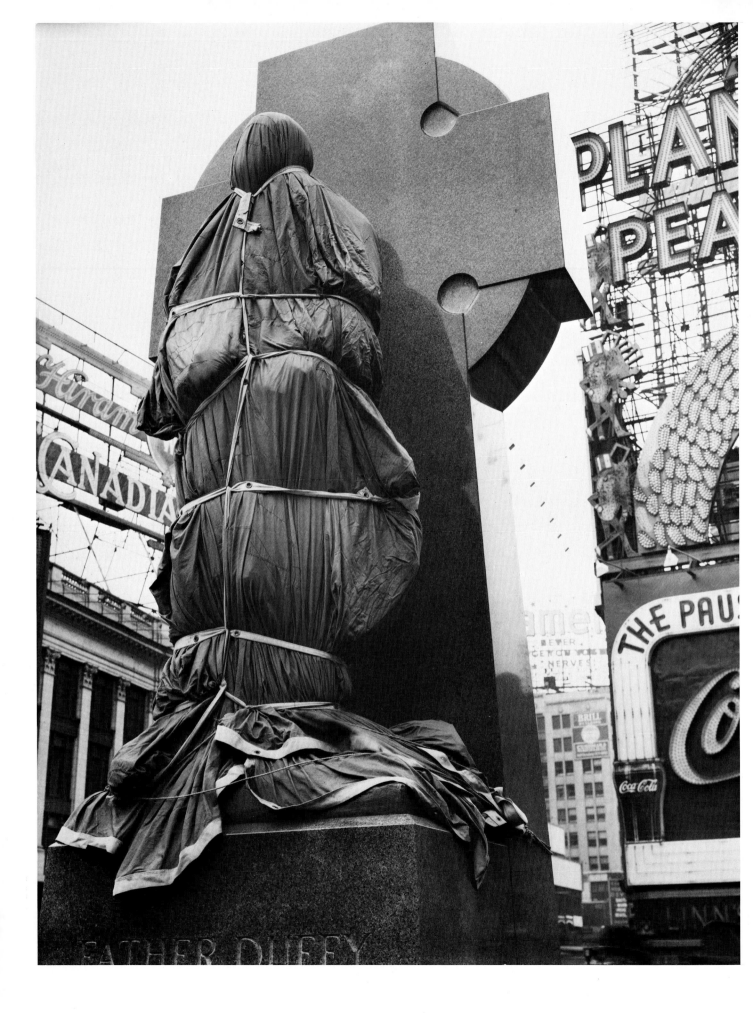

FATHER DUFFY

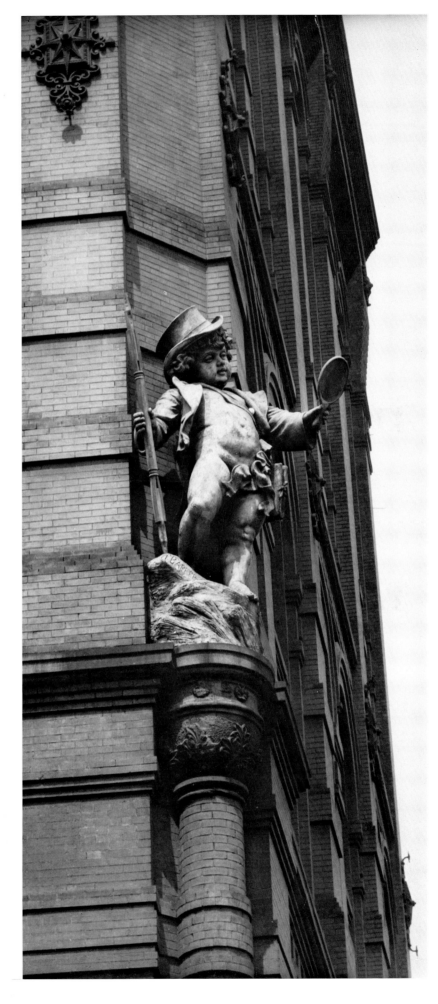

Puck Building (right)

Times Square (left)

Daily News Building and
Flatiron Building (overleaf)

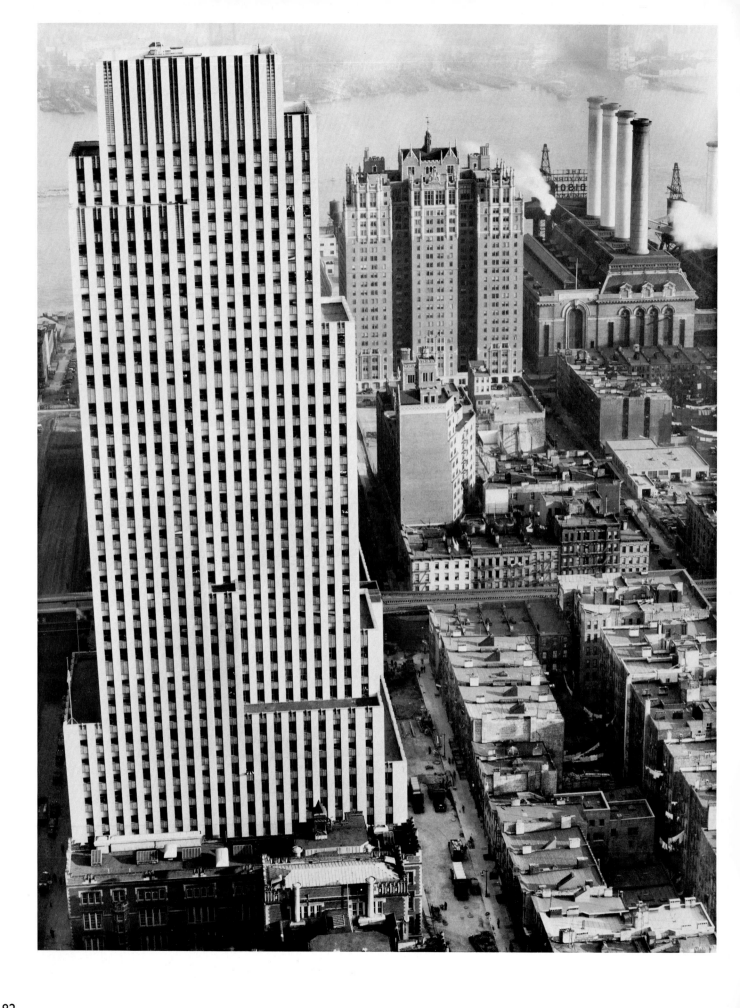

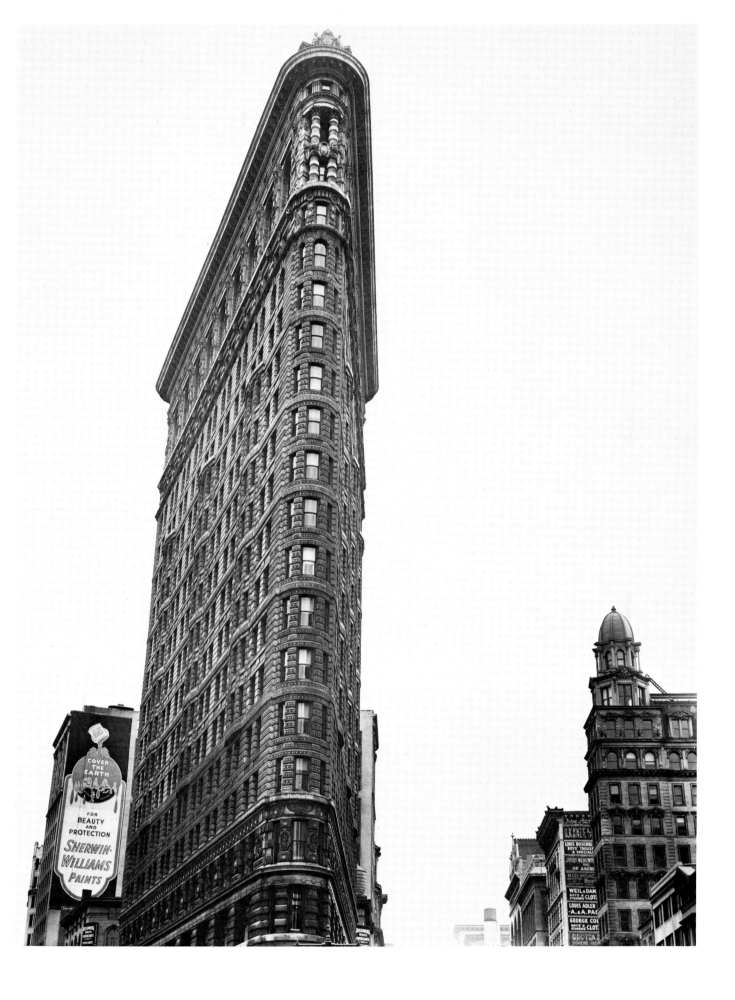

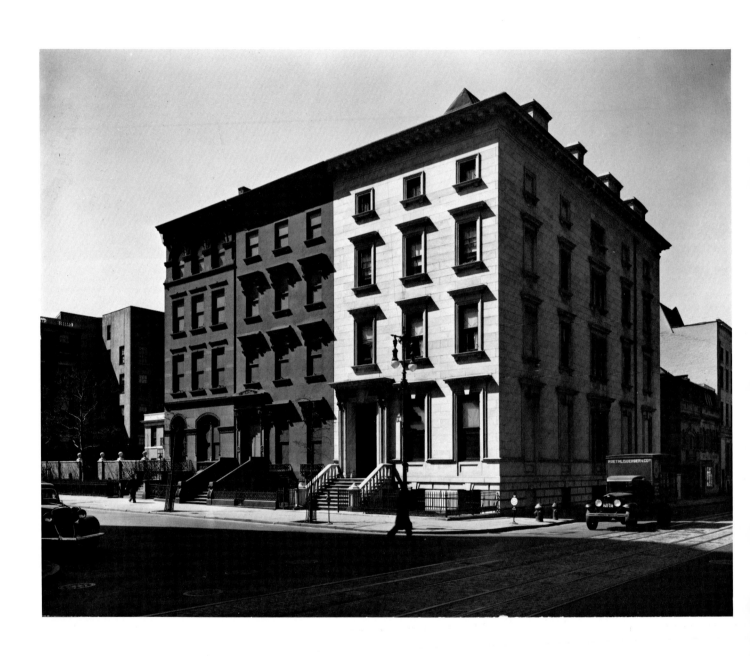

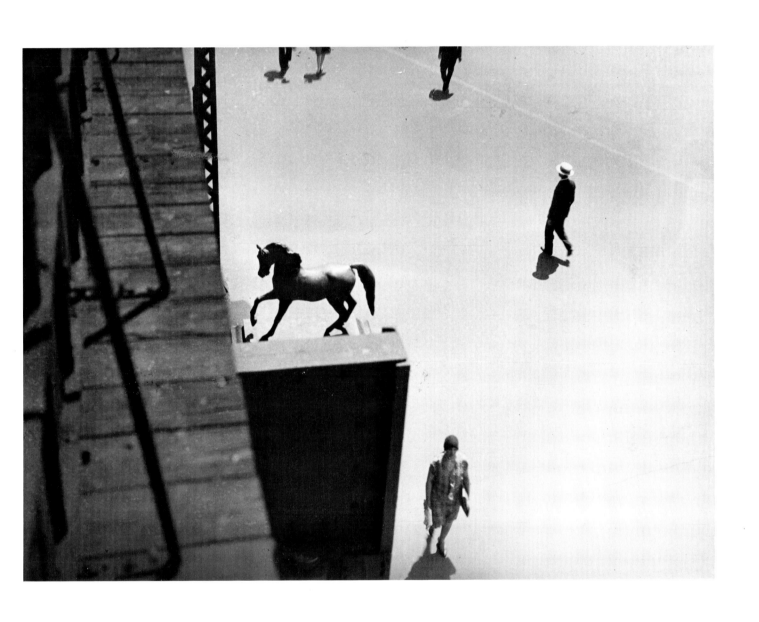

El at Columbus Avenue and Broadway (above)

Fifth Avenue at 8th Street (left)

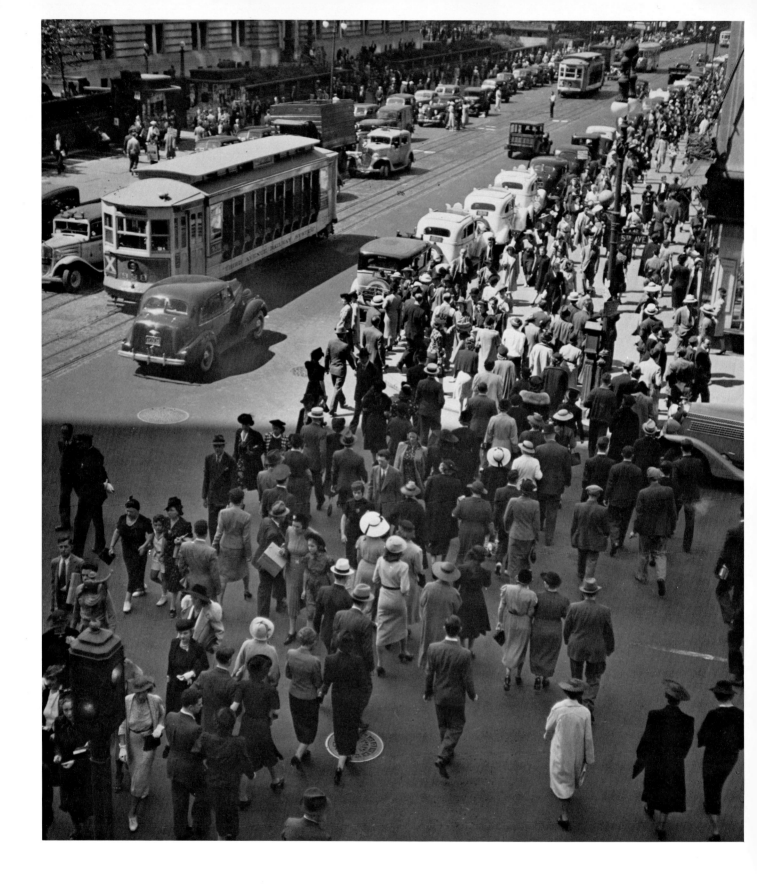

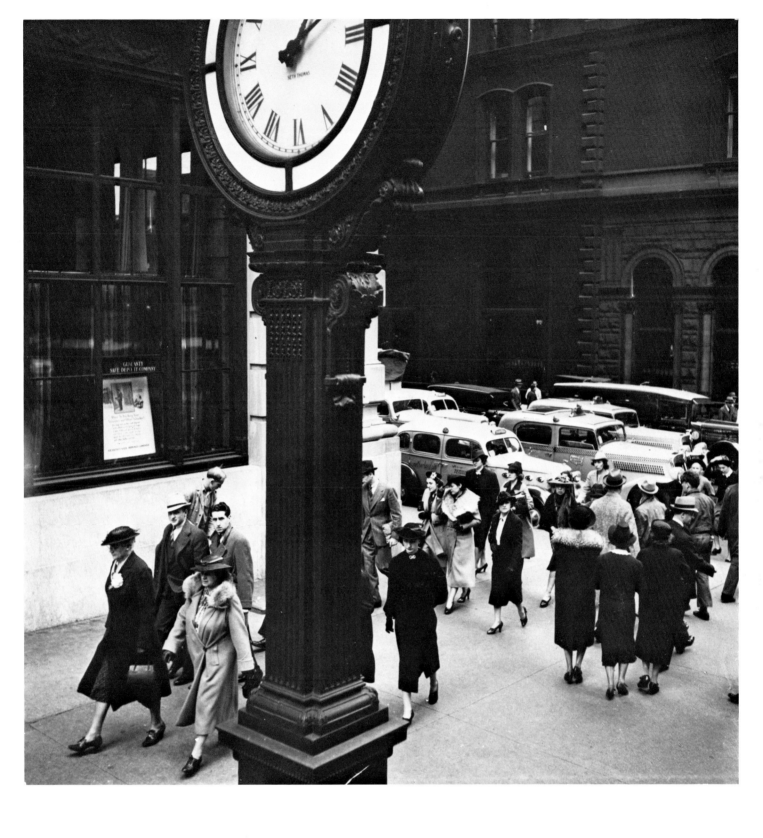

Fifth Avenue at 44th Street (above)

42nd Street at Fifth Avenue (left)

Newsstand (overleaf)

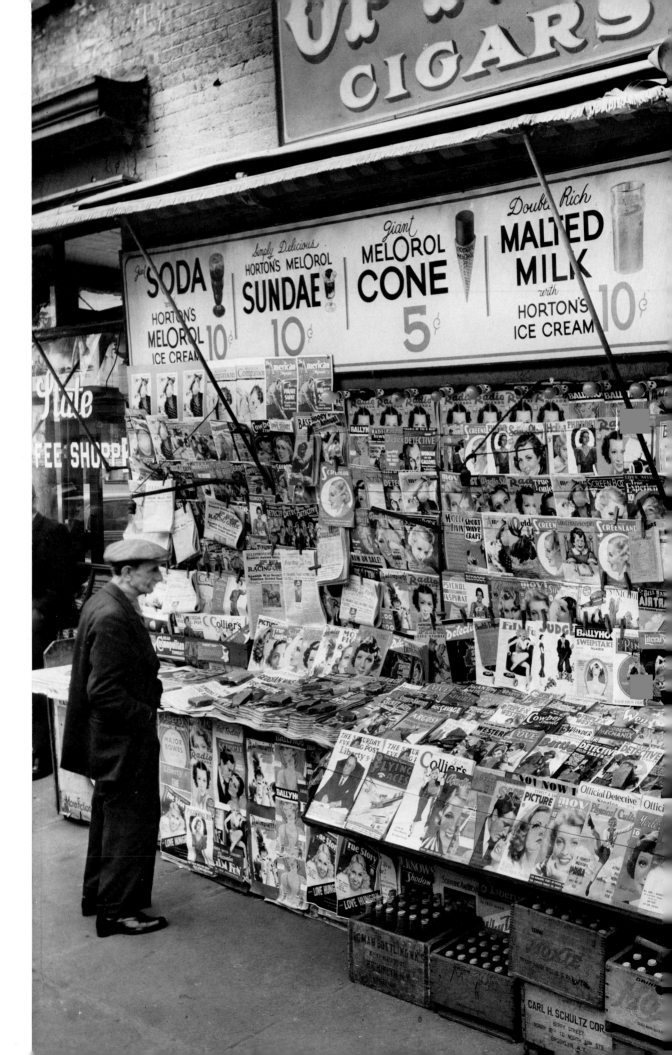

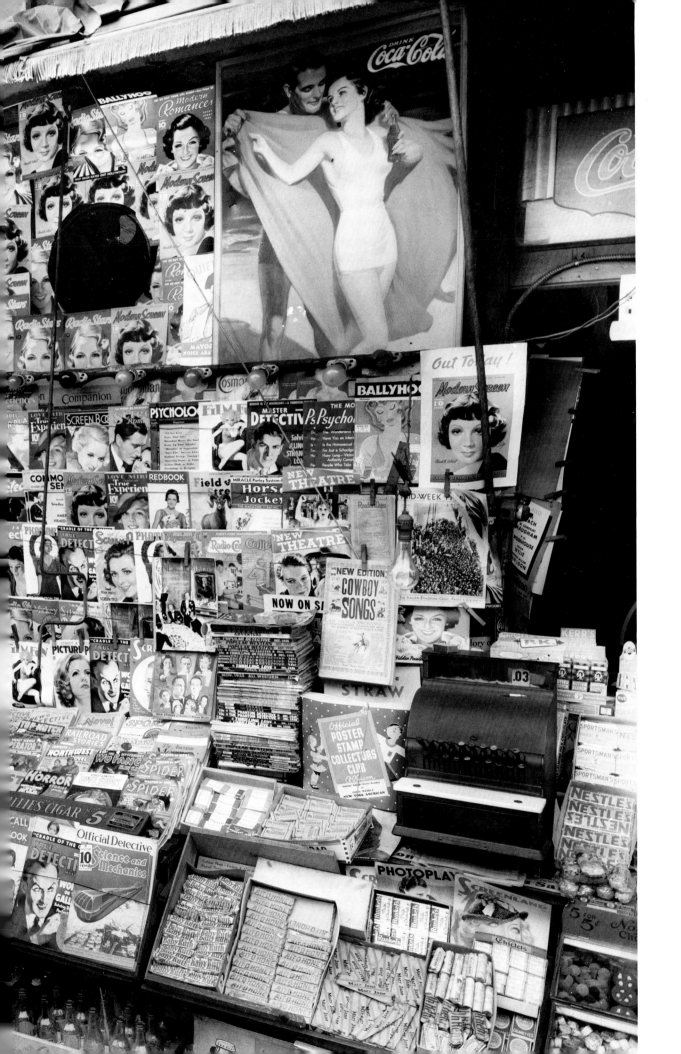

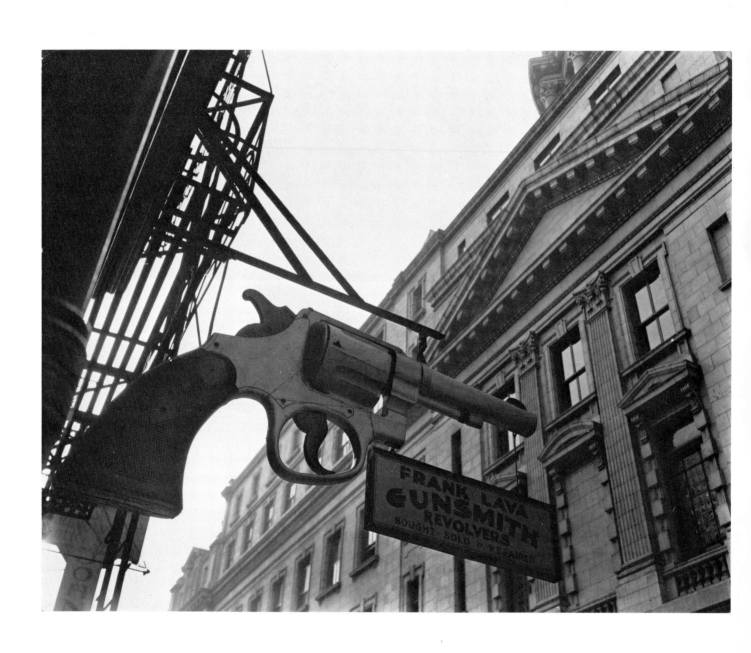

Centre Street (above)

View toward Brooklyn Bridge (right)

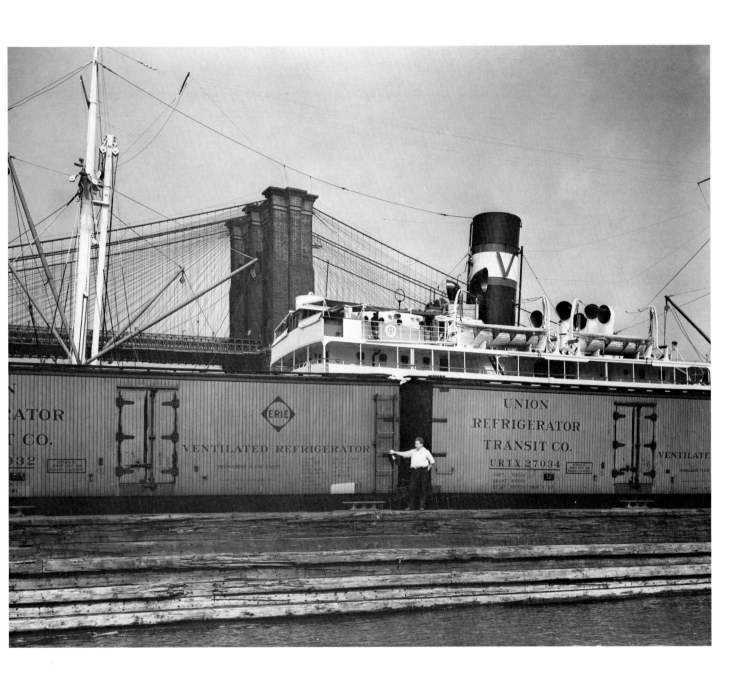

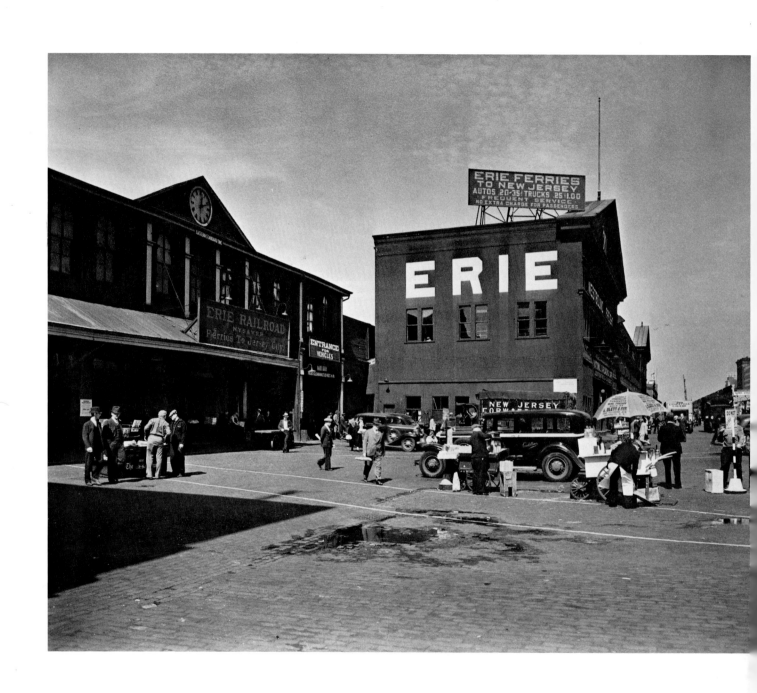

Erie Station (above)

Barclay Street Hoboken Ferry (right)

Warehouse, Water and Docks Streets, Brooklyn (overleaf)

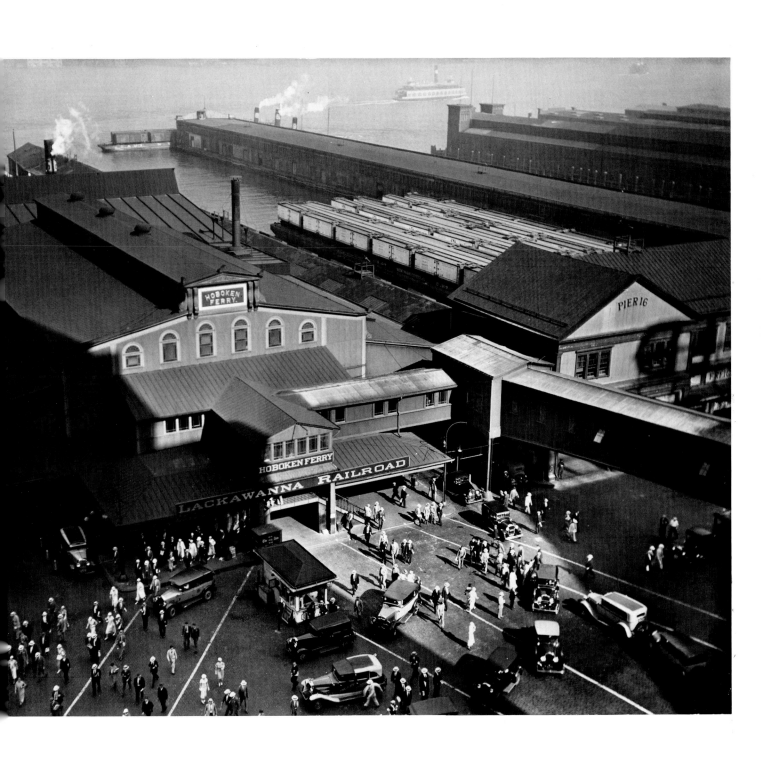

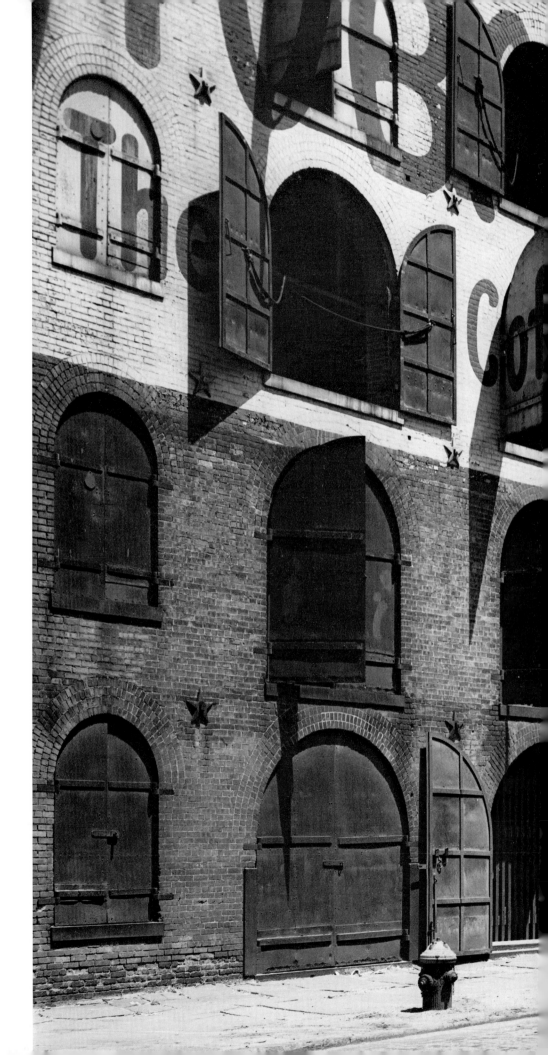

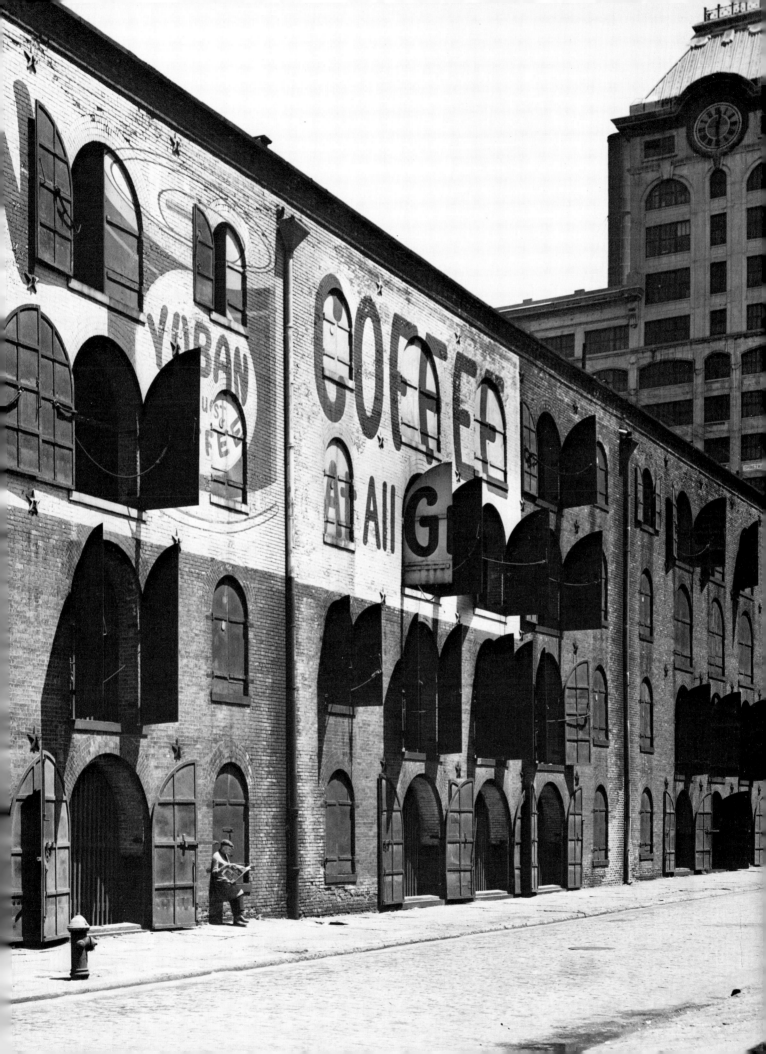

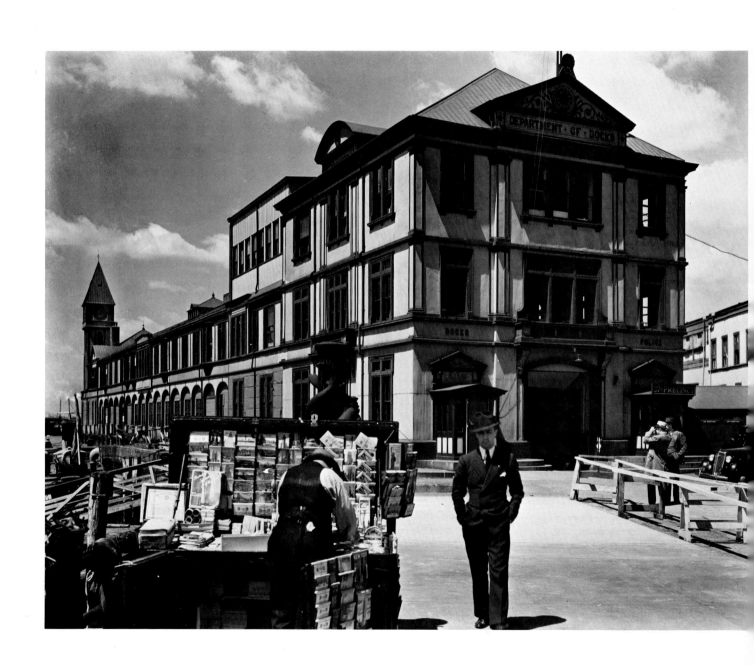

Department of Docks

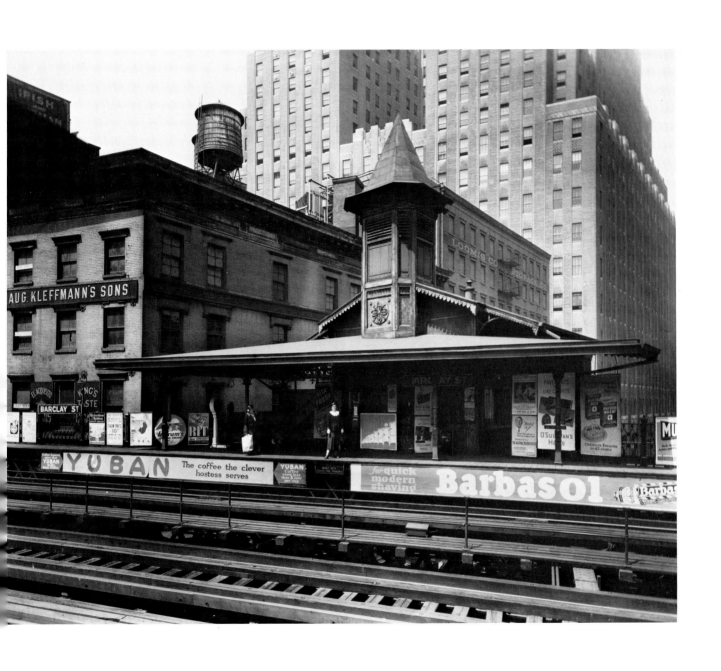

Barclay Street Station

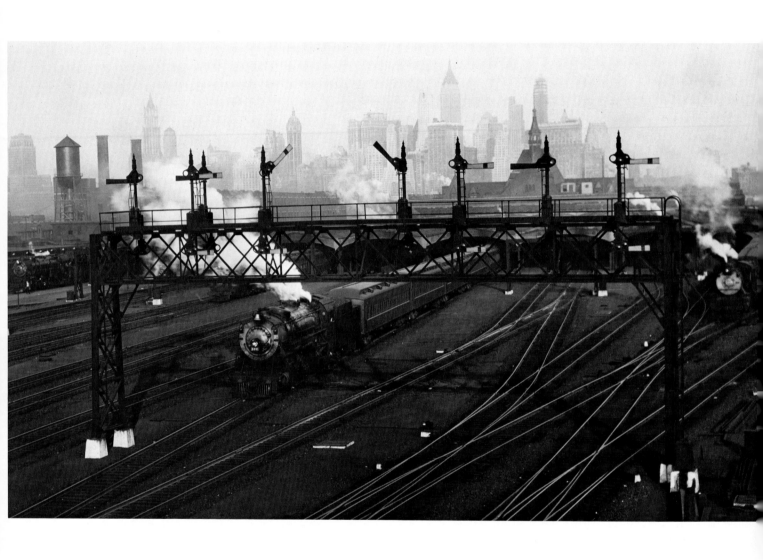

Railroad Yard (above)

At 125th Street (right)

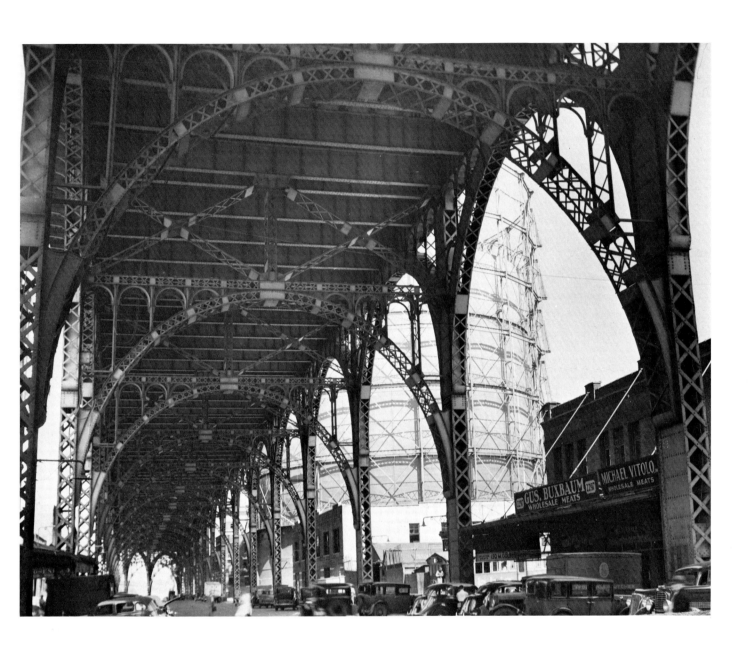

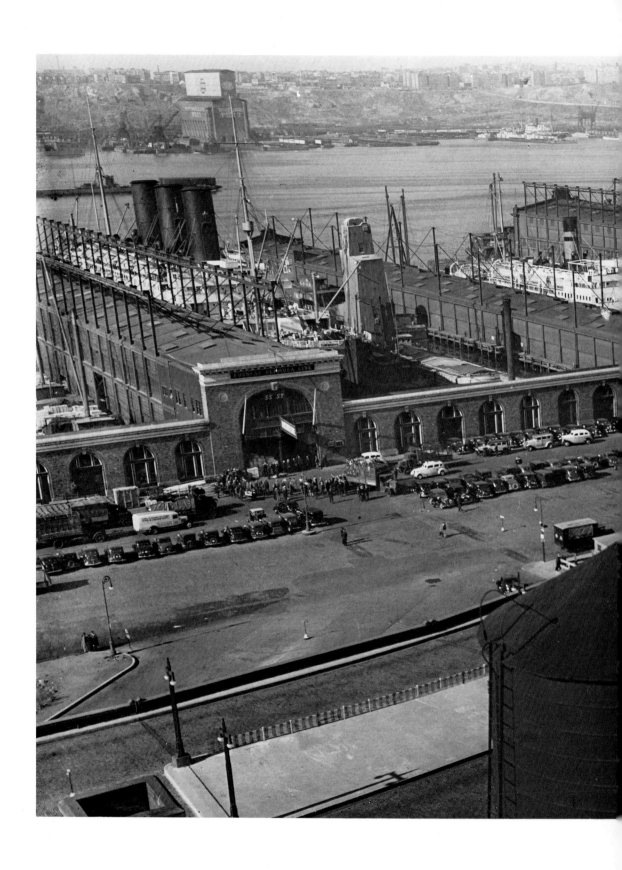

West Side, highway and piers

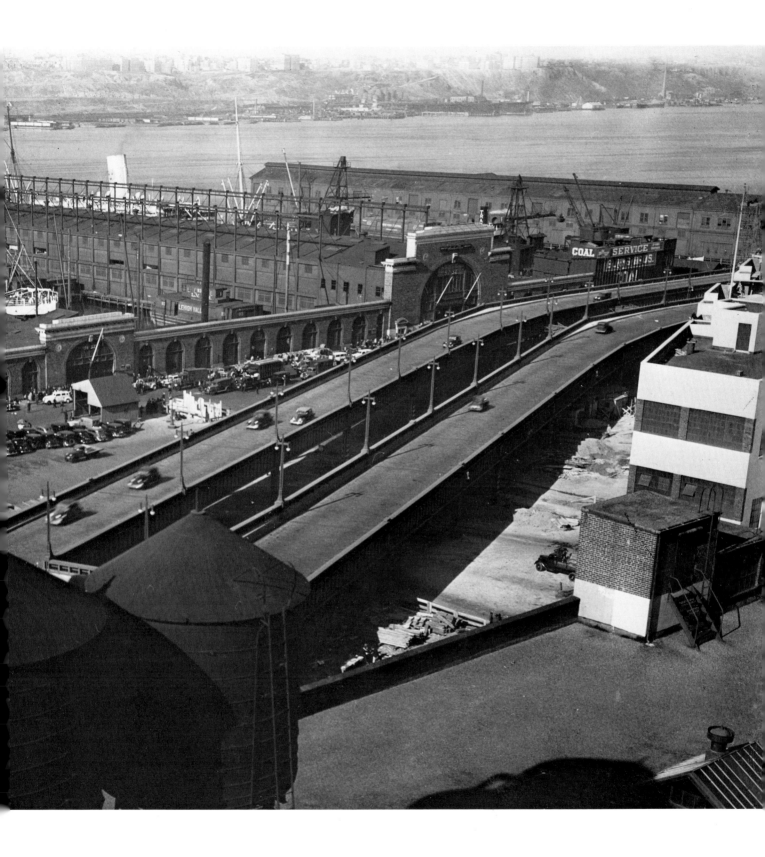

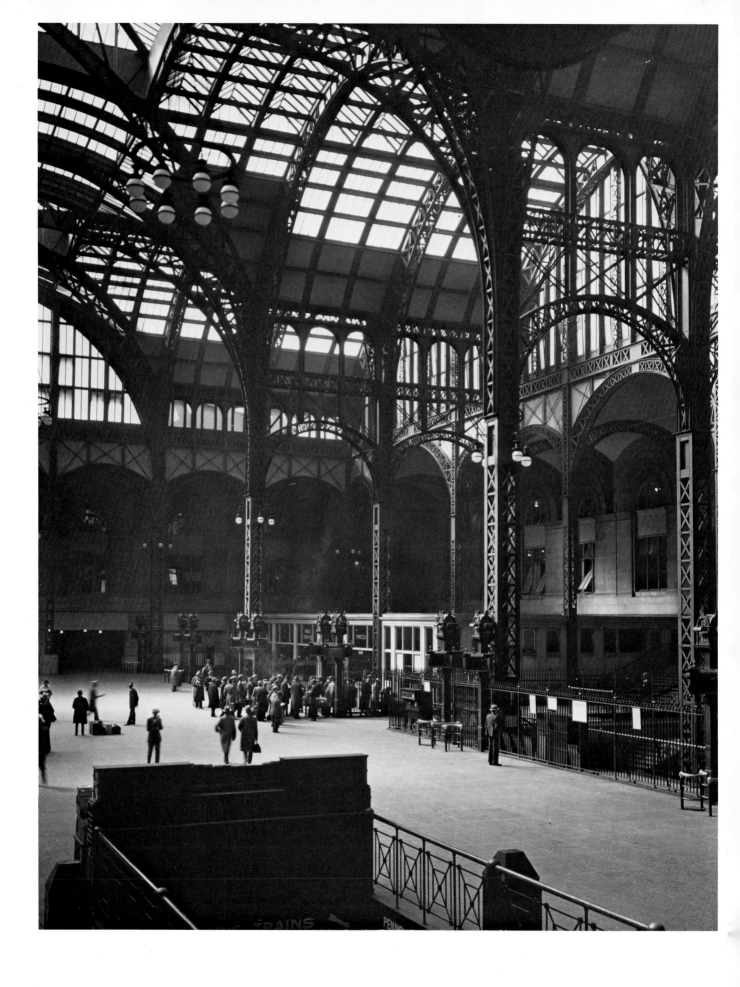

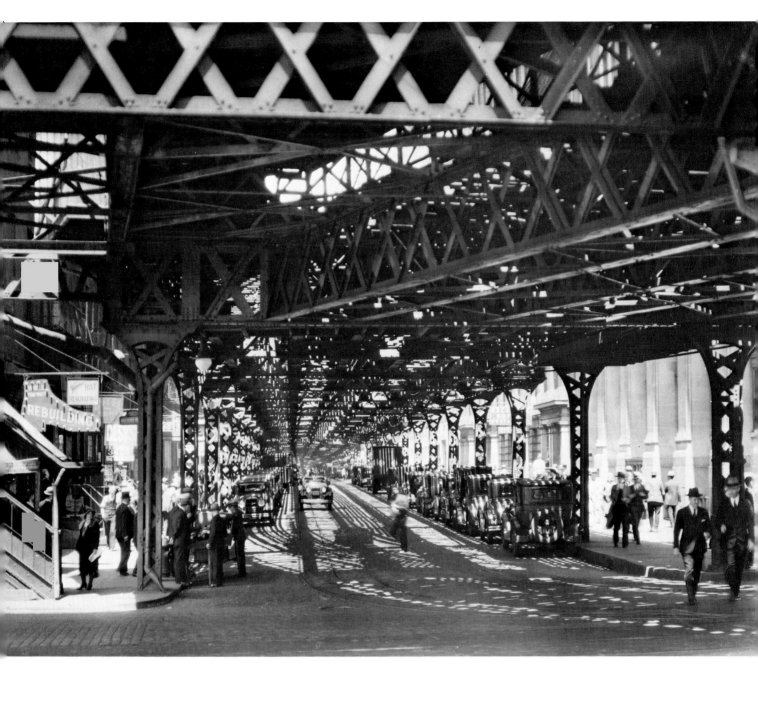

El at Battery (above)

Pennsylvania Station (left)

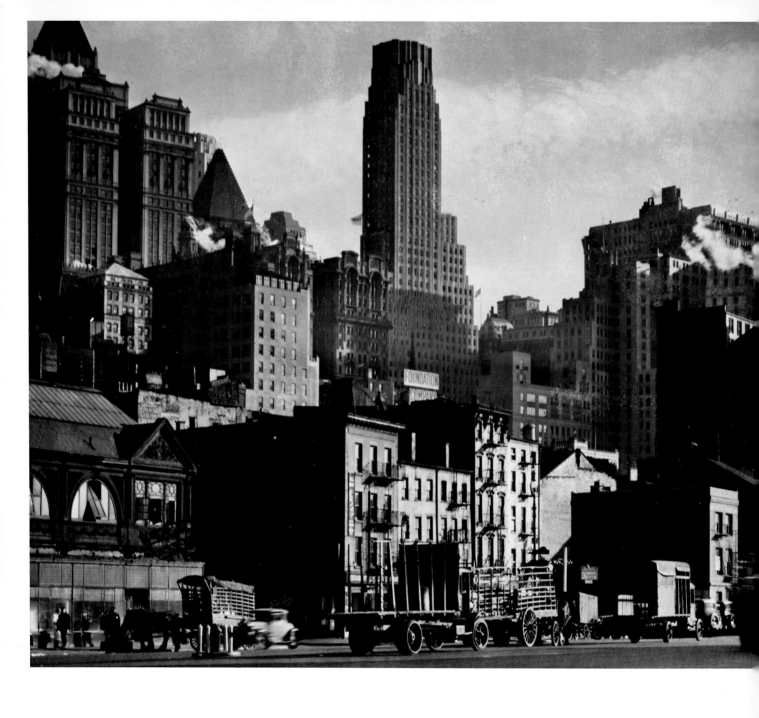

West Street (above)

Washington Street (right)

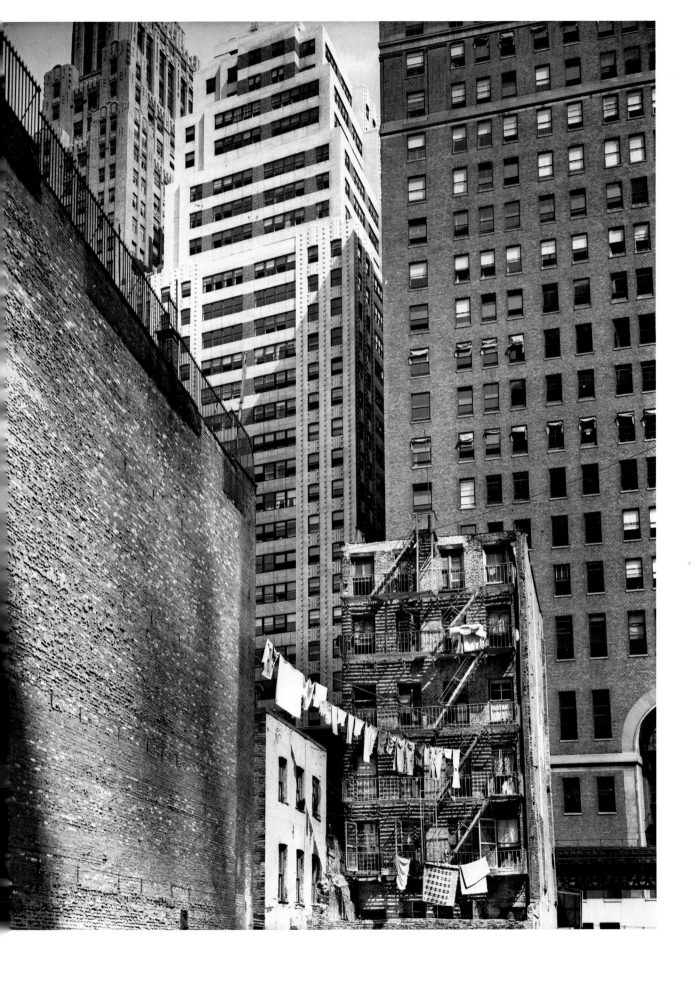

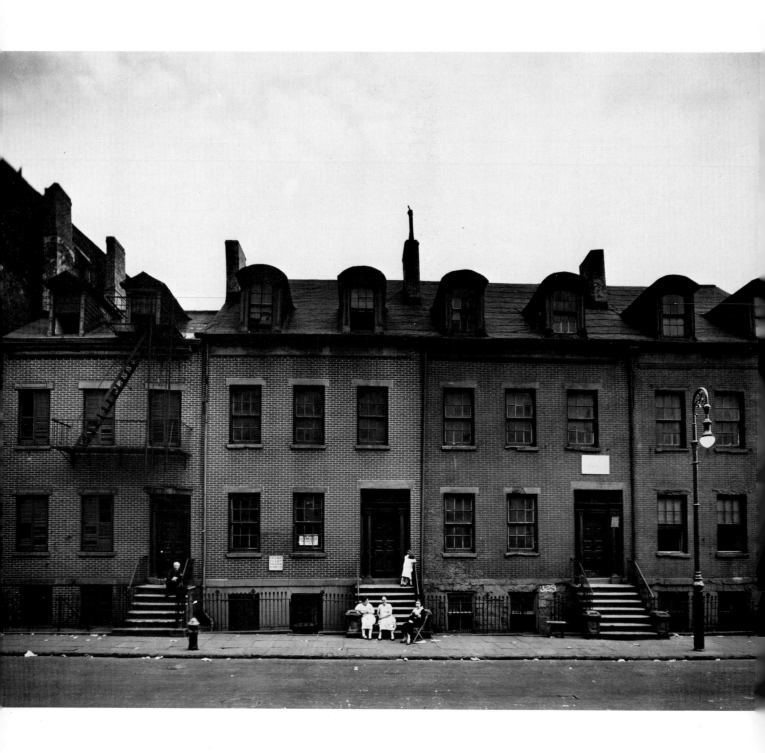

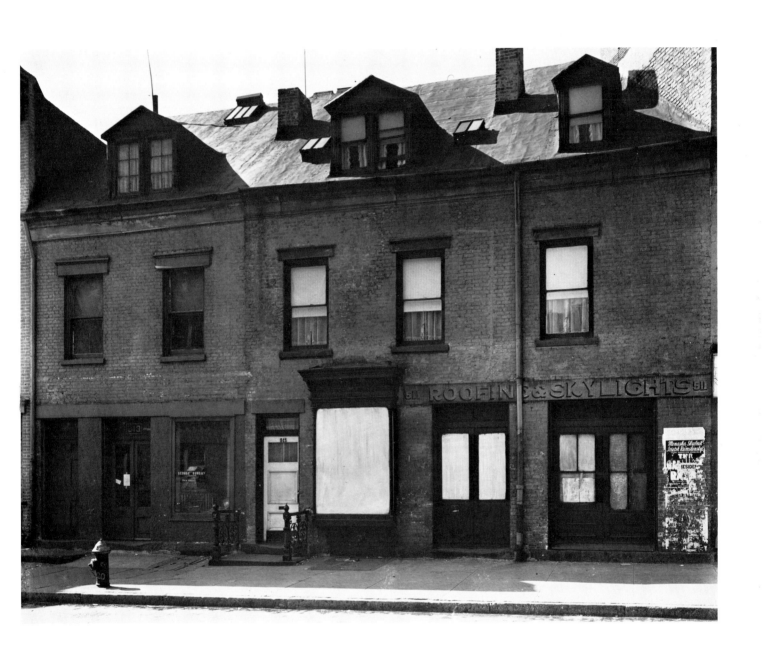

Grand Street (above)

Cherry Street (left)

Dancer, Macdougal Street, Greenwich Village and
Huddie (Leadbelly) Ledbetter (overleaf)

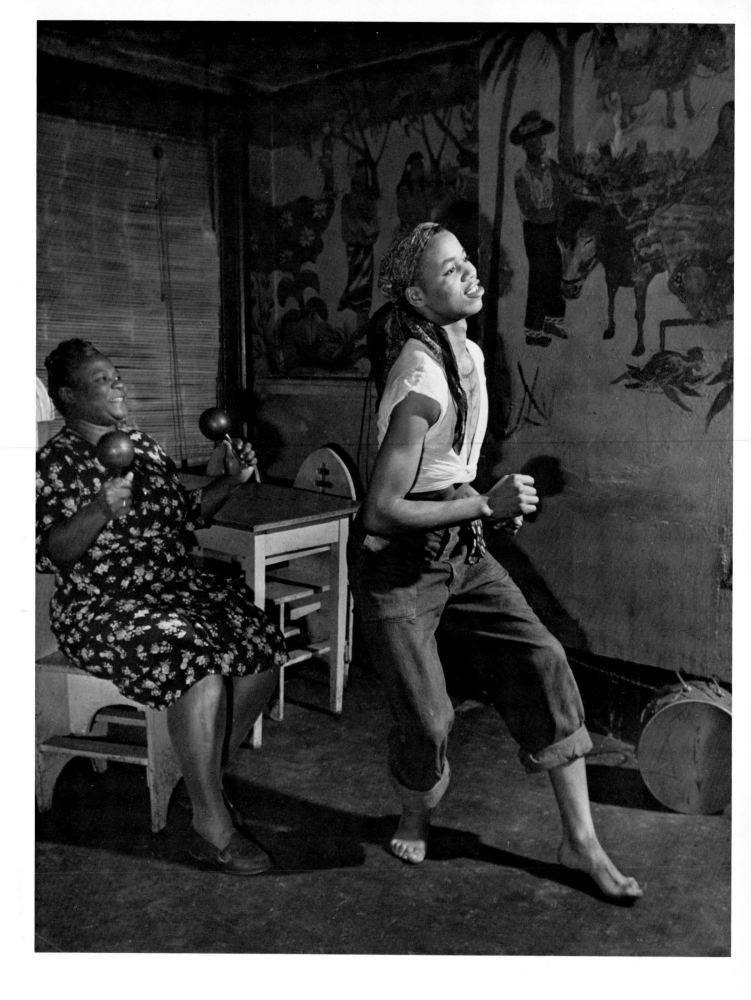

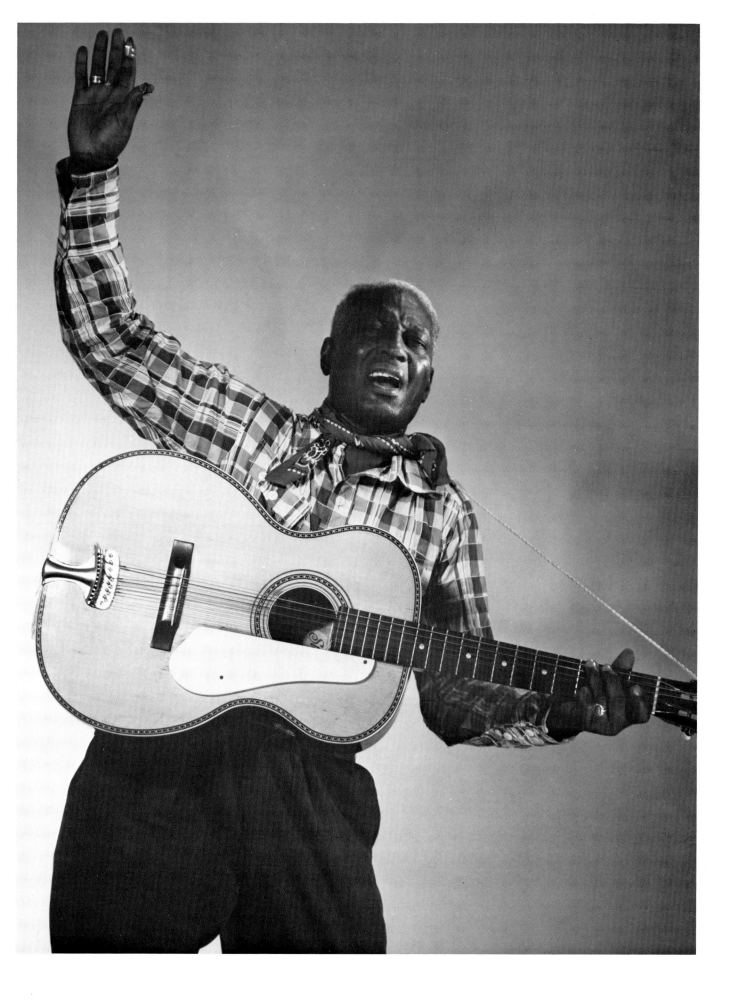

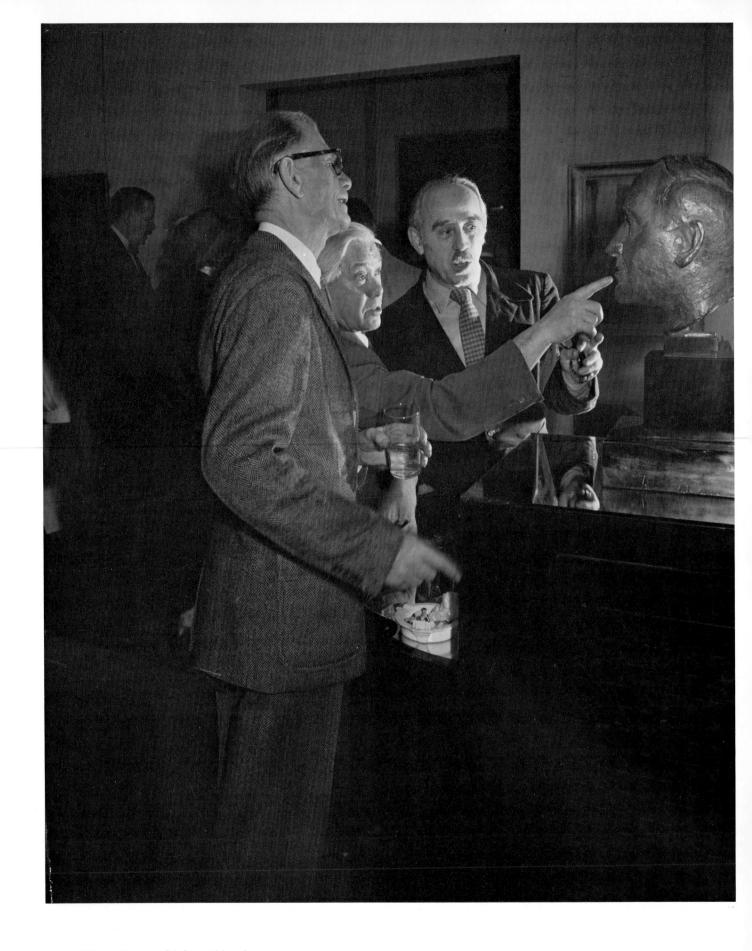

At the Whitney Museum, 8th Street (above)

John Sloan (right)

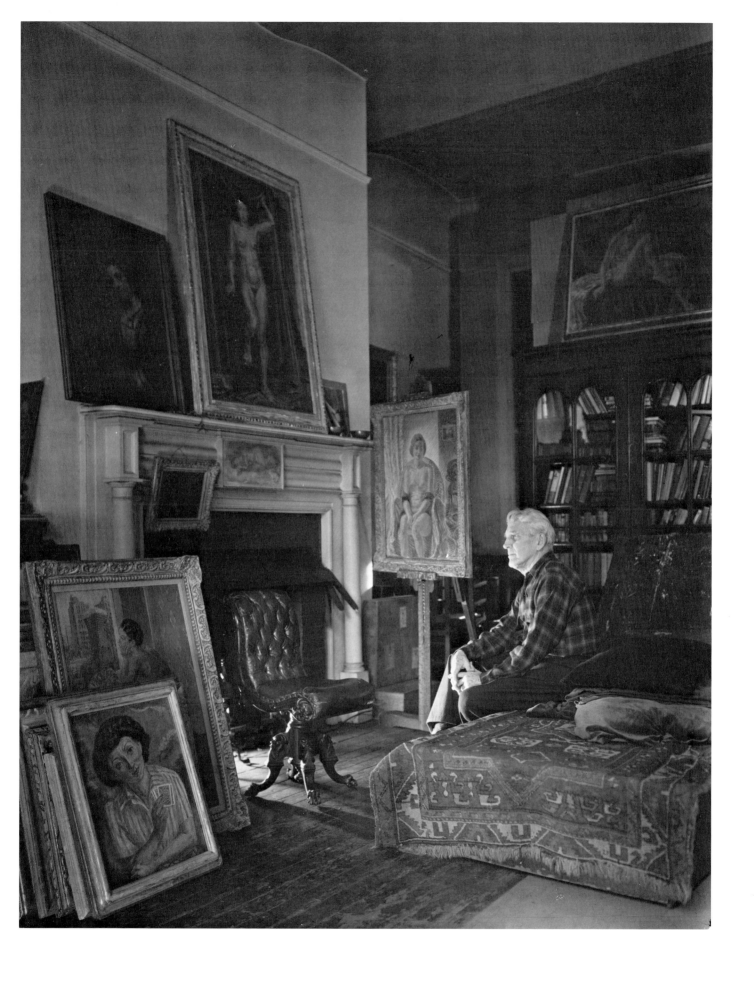

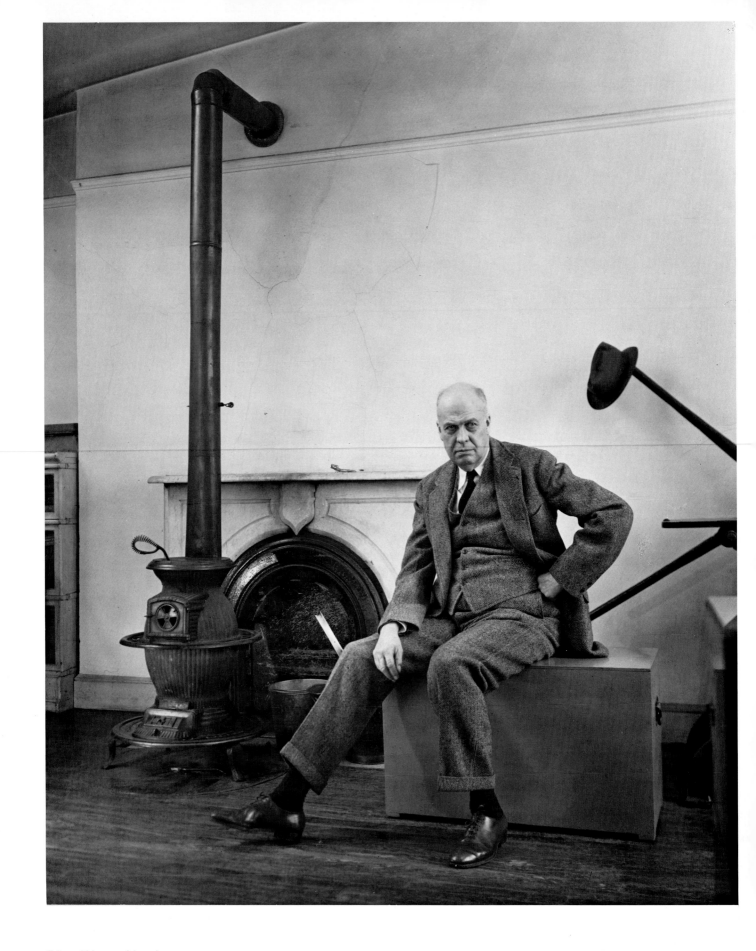

Edward Hopper (above)

East Side Portrait (right)

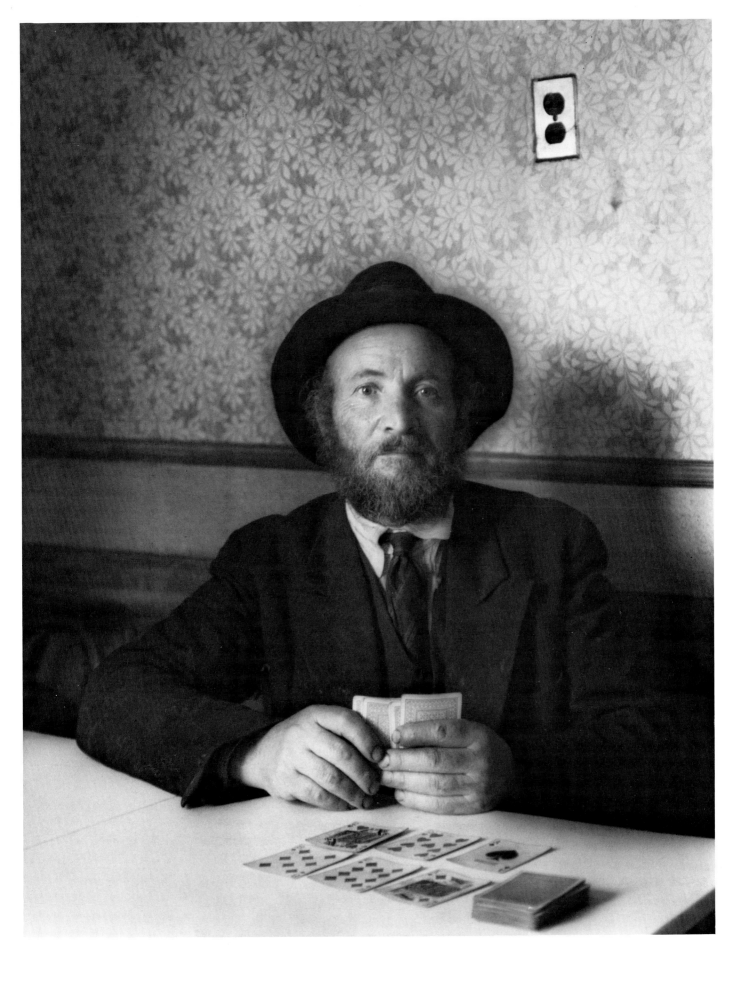

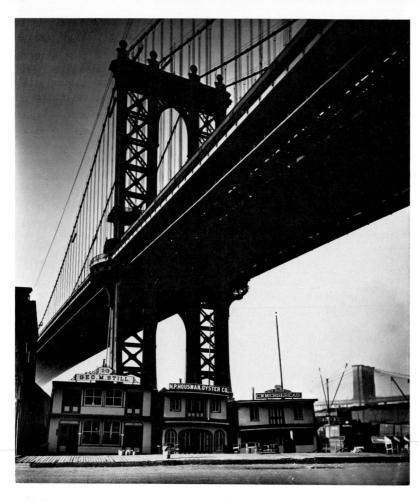

Floating Oyster Houses (left)

Peddler (below)

Hester Street (top right)

Under the El (bottom right)

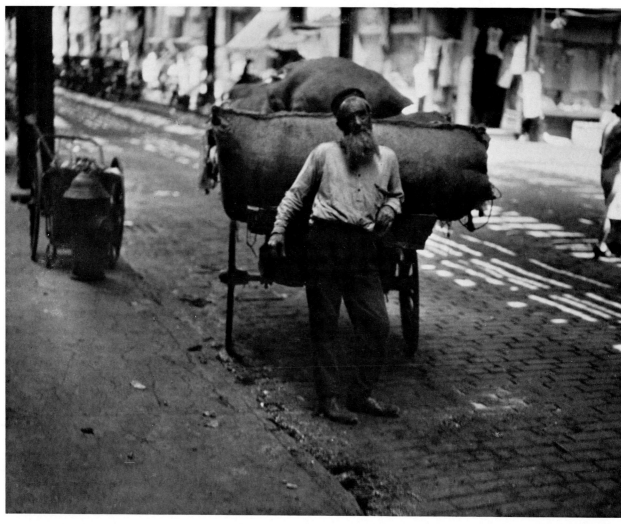

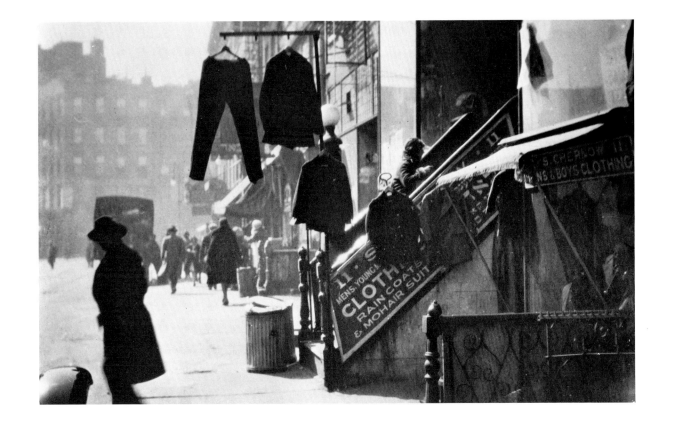

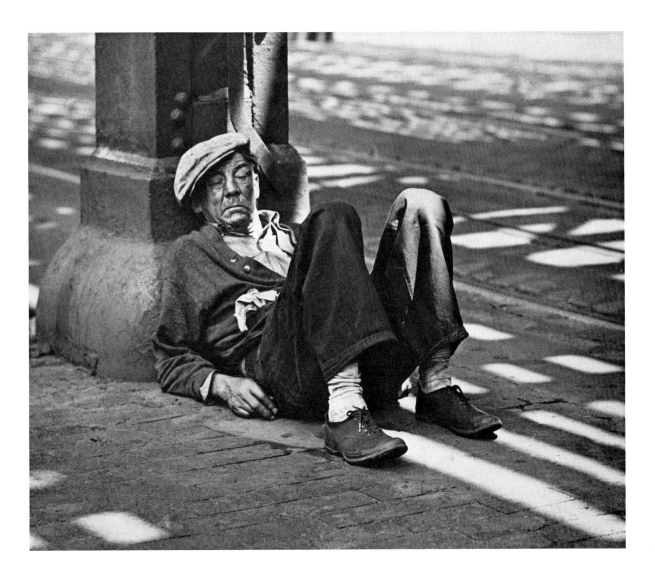

Courtyard of model early tenement, East 70s (right)
Blossom Restaurant, The Bowery (overleaf)

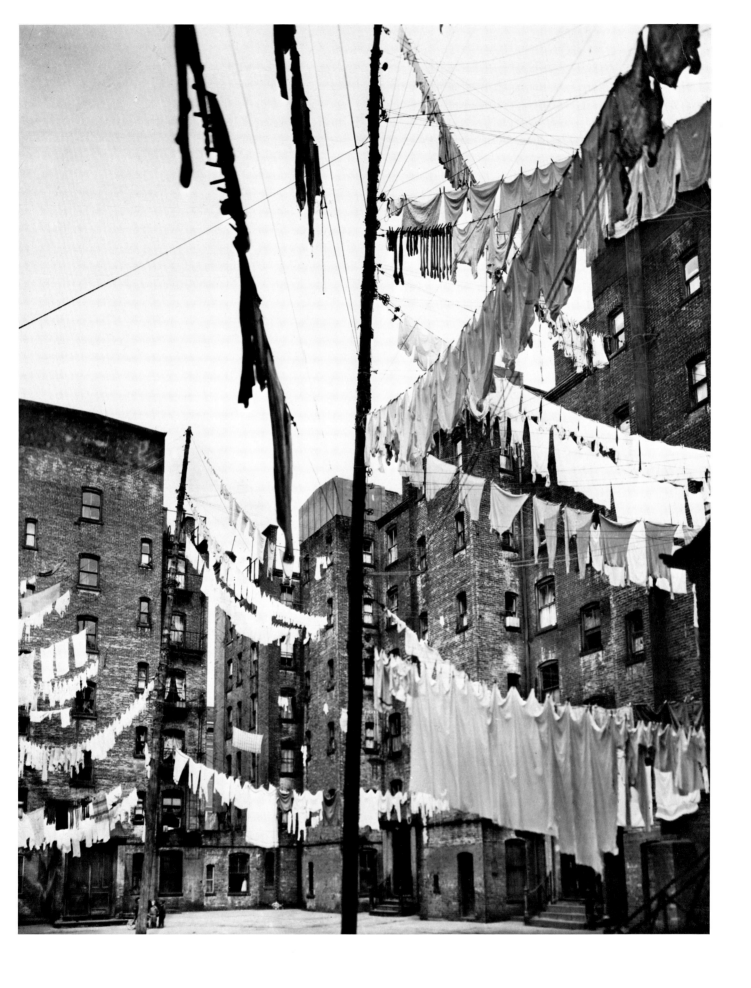

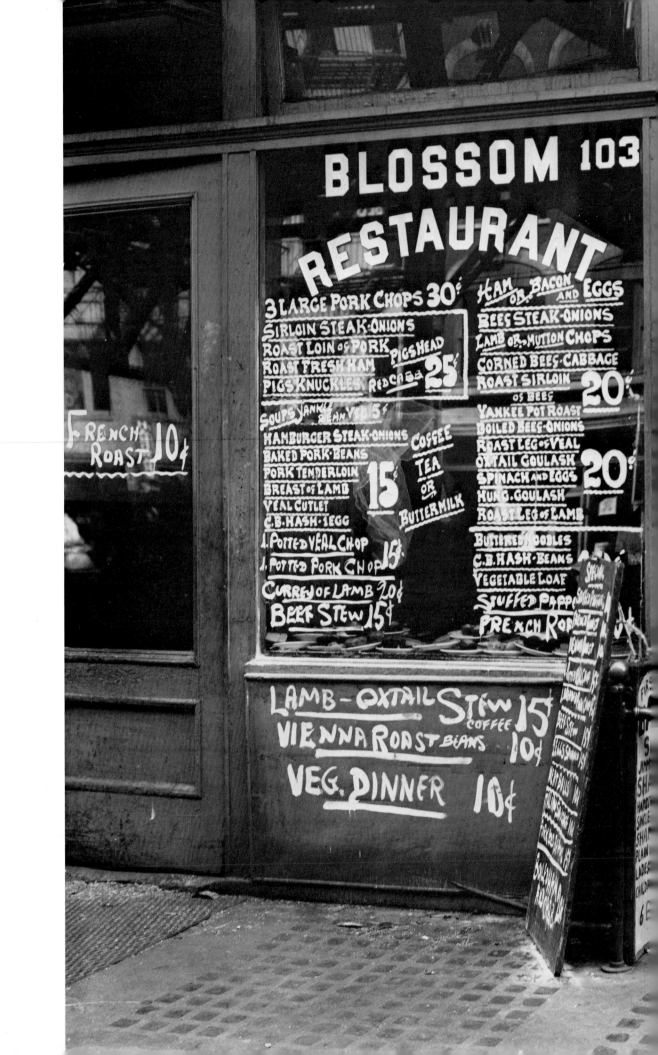

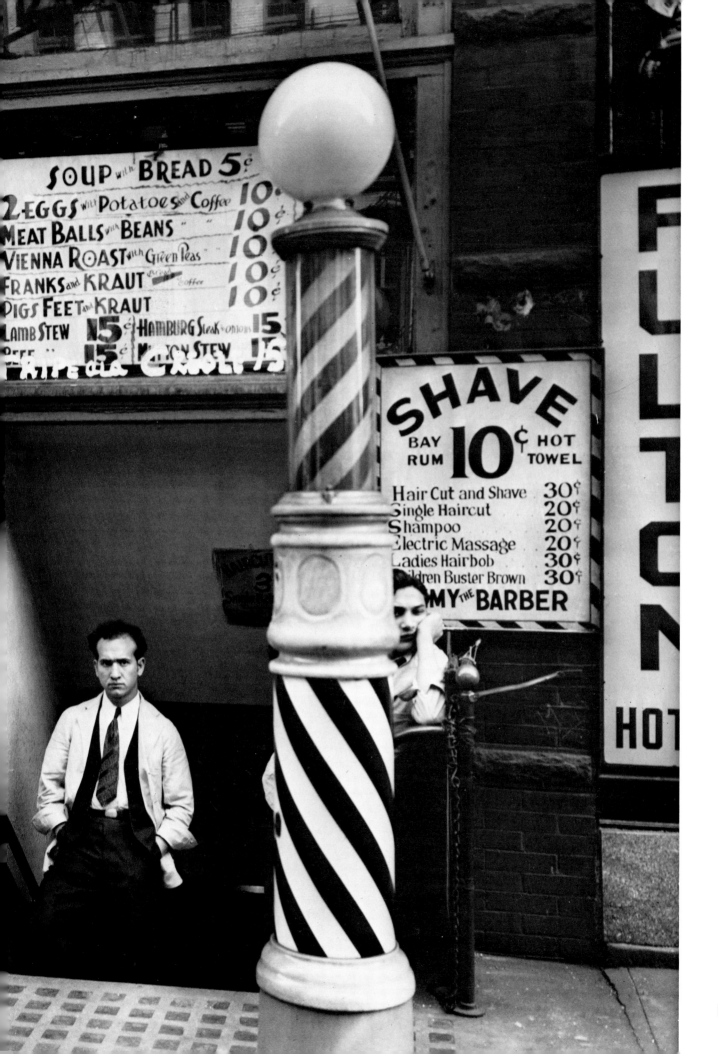

119

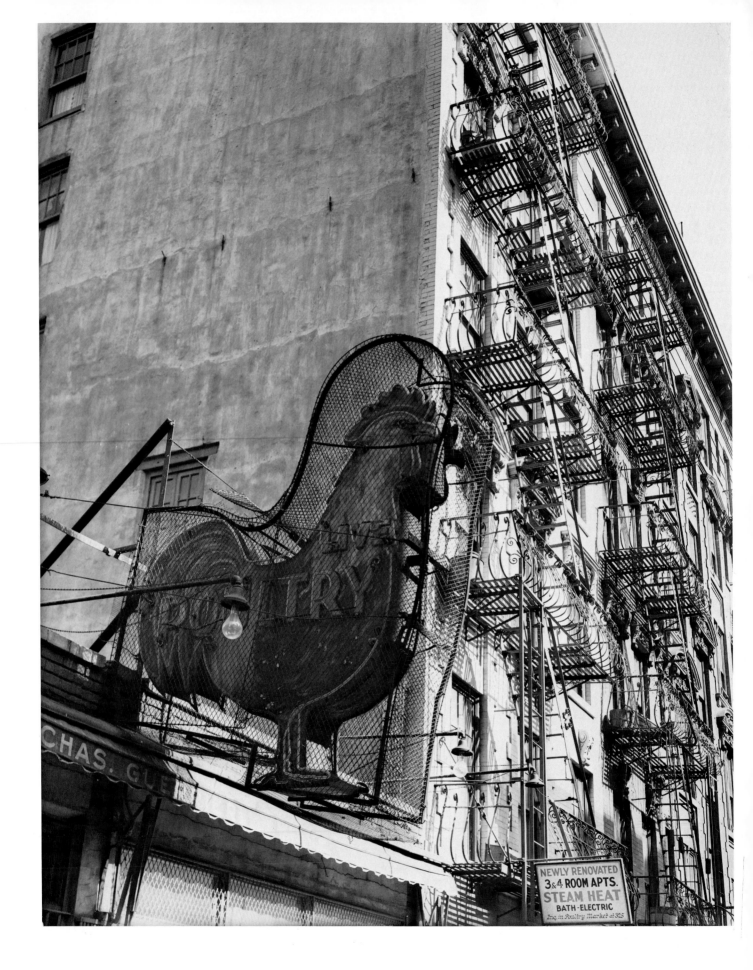

Lower East Side

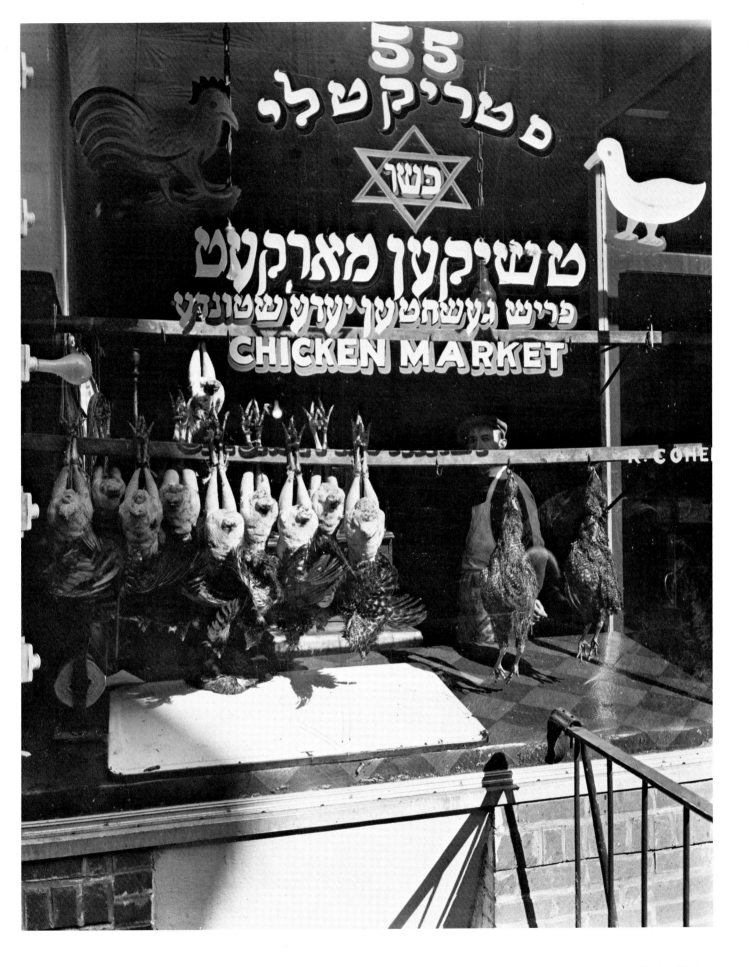

Chicken Market

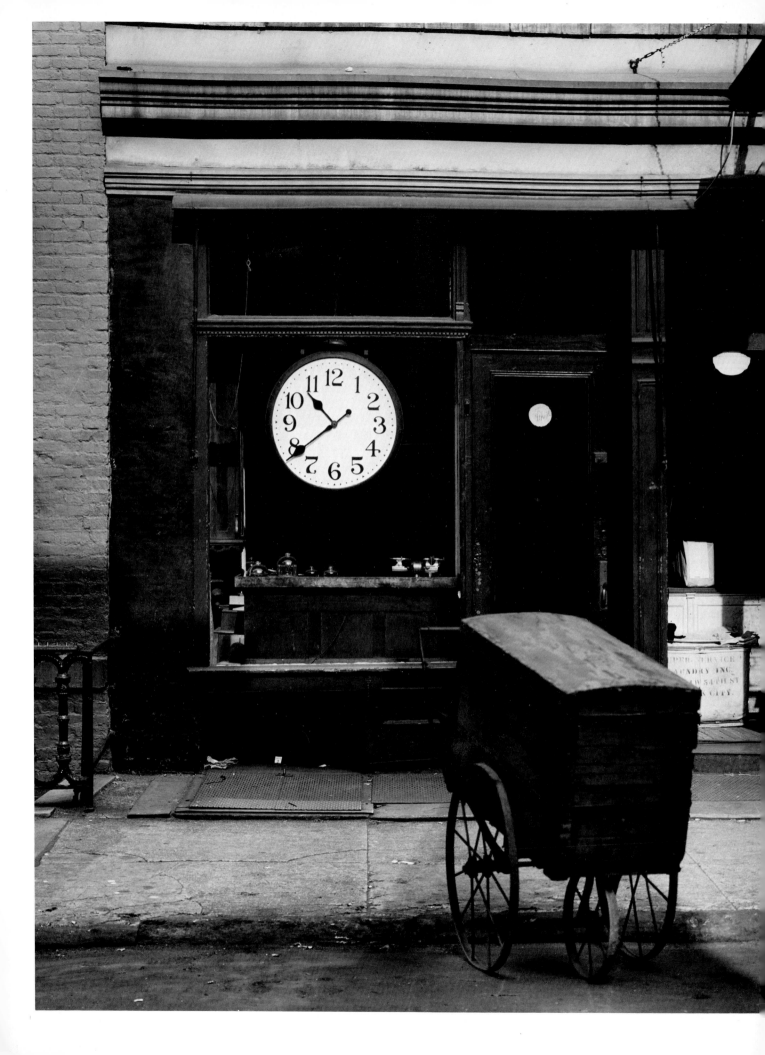

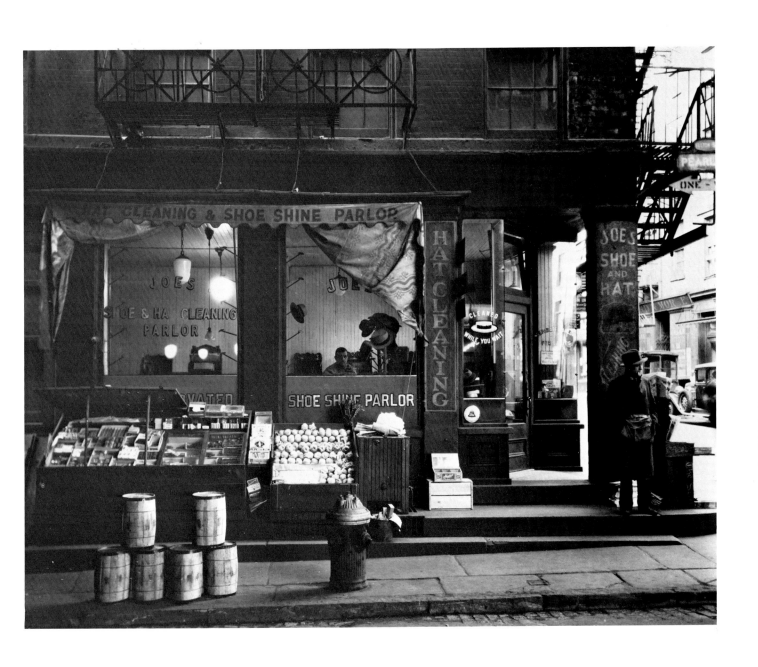

Shoeshine Parlor (above)

Christopher Street Shop (left)

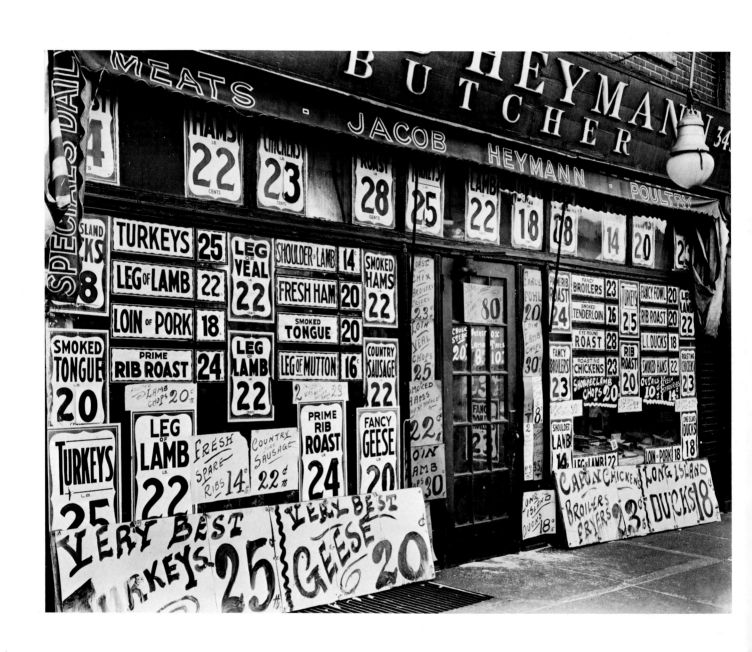

Butcher Shop (above)

A & P (right)

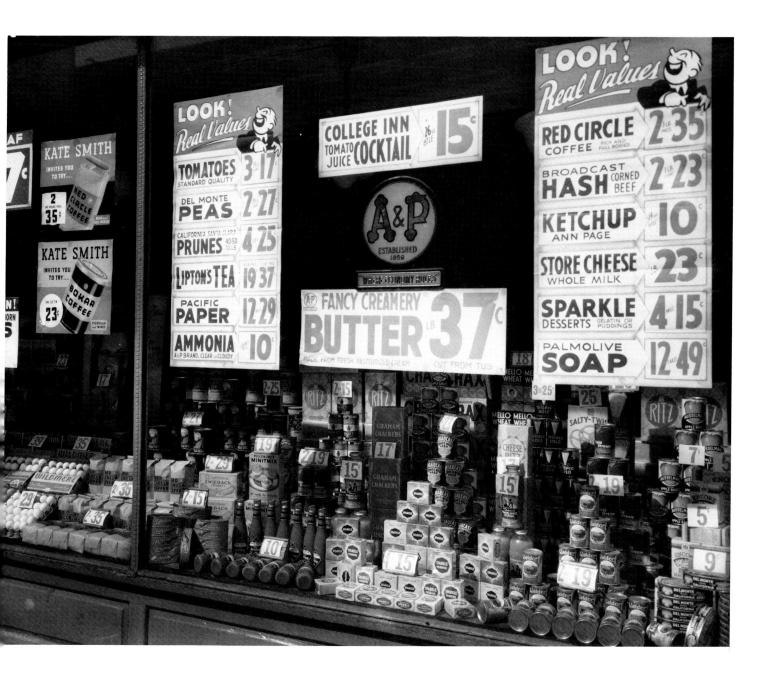

125

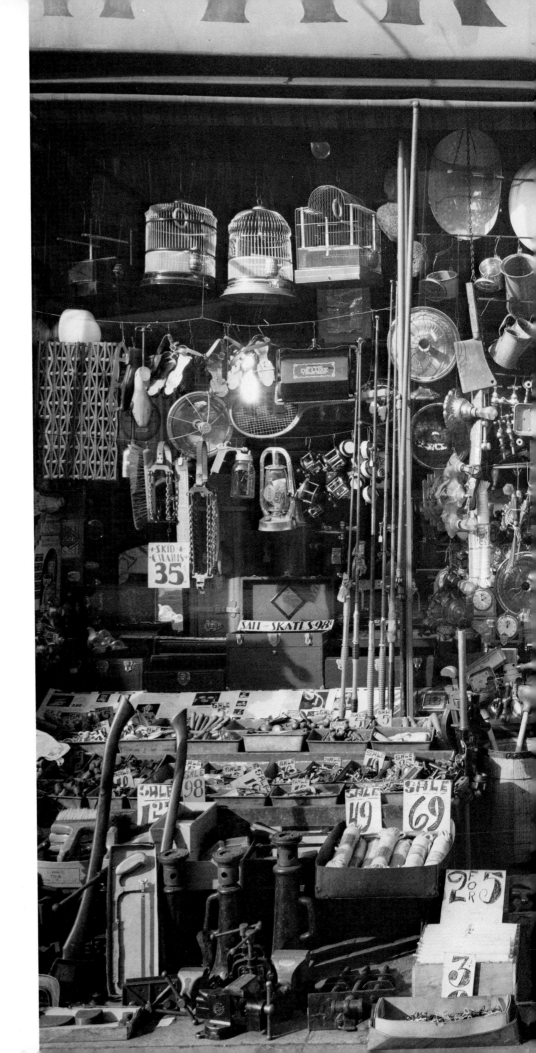

Hardware Store

Rockefeller Center (overleaf and pages 130–131)

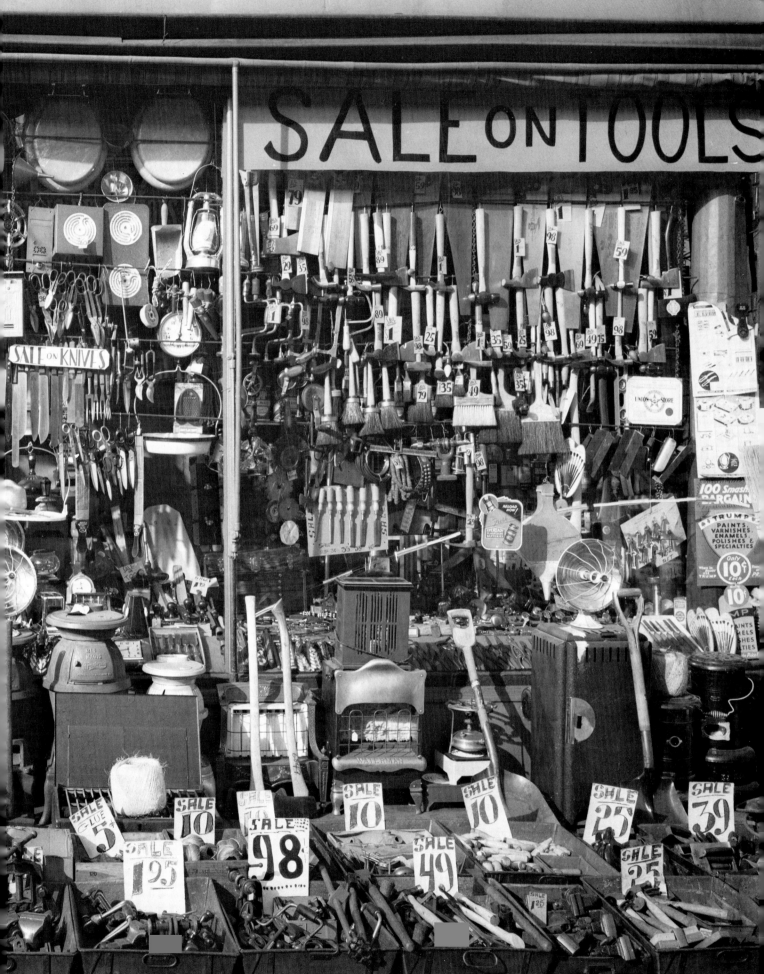

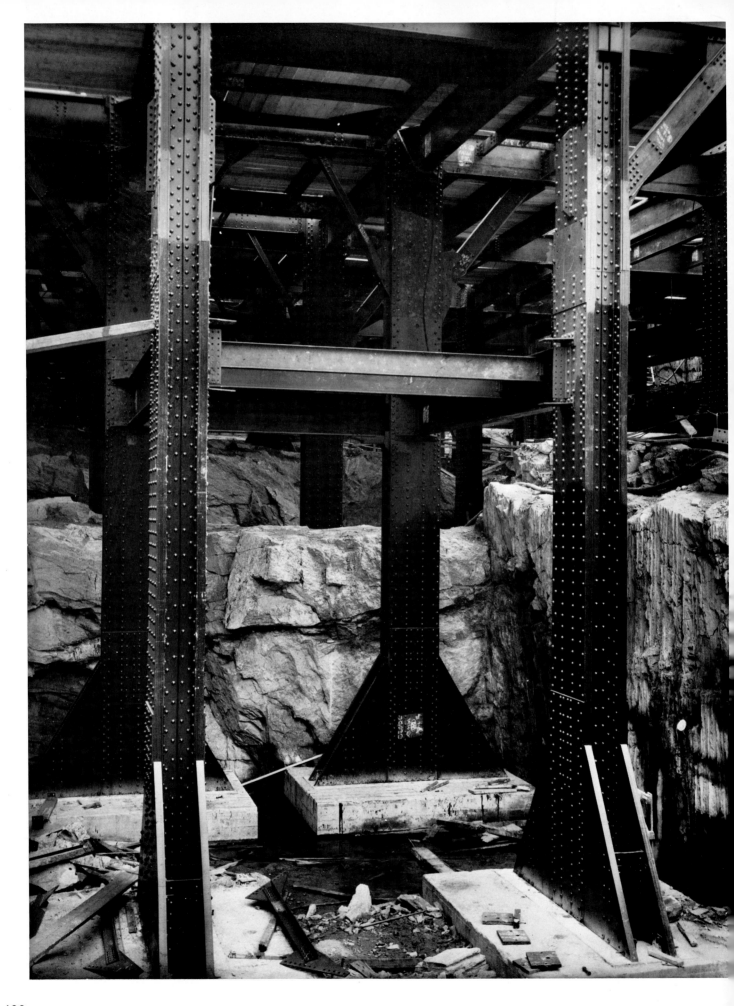

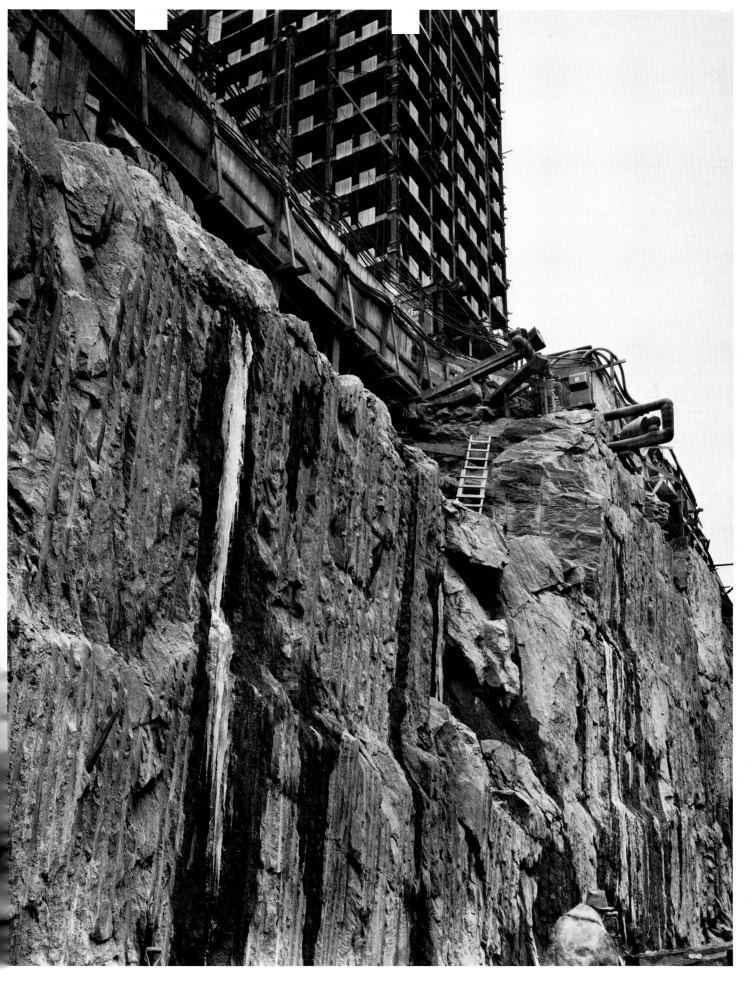

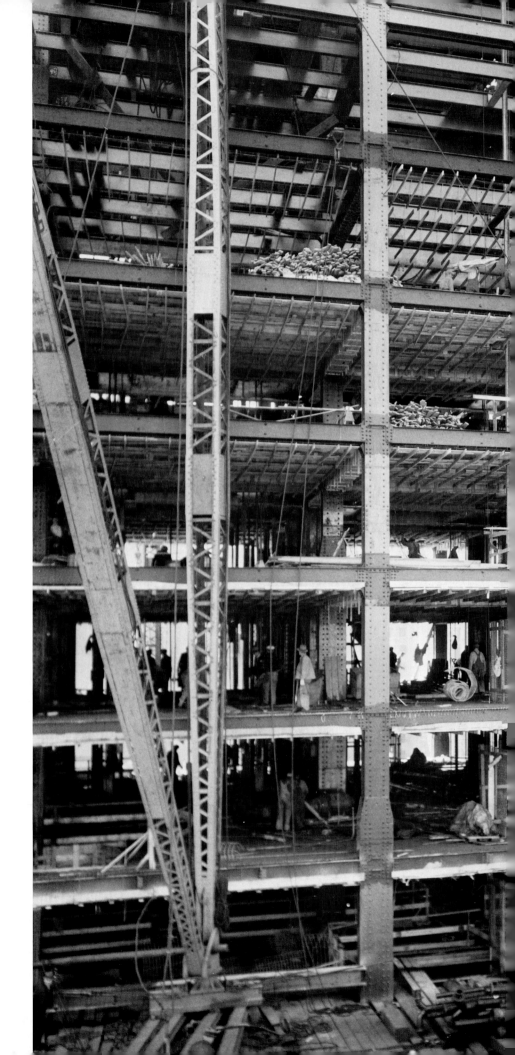

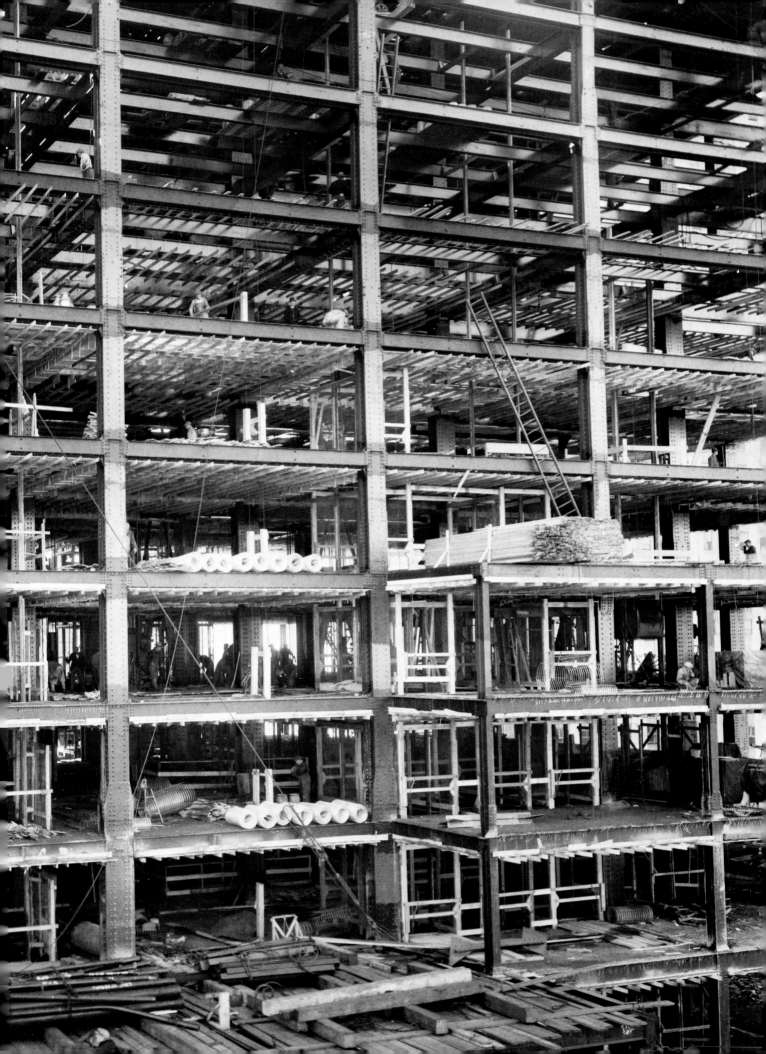

SCIENCE

A girl's eye was photographed and the enlarge-
ment was mounted on a stiff cardboard. This
in turn was placed in such a position as to reflect
in each small mirror mounted on a concave
surface. Because the position of the camera was
dictated by the reflections of the images, it ex-
cluded the base, which I wanted to include
because I believe such homely devices, often used
in science experiments, to be important and even
"beautiful." In order to include the base, I used, as
I had never used before nor since, an elaborate
raised back swing, possibly only because of my
flexible "old fashioned" swinging Century Univer-
sal view camera. Most scientists still thought you
could do these things with a Brownie.

Parabolic mirror, made of many small flat
sections, reflecting one eye (right)

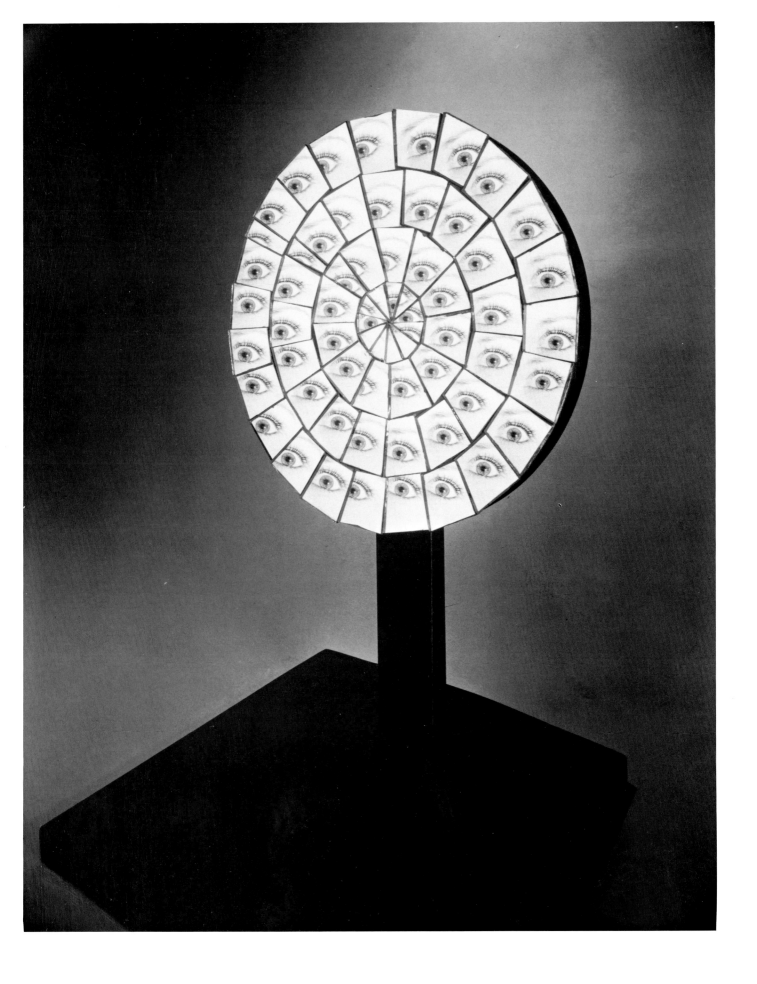

The magnetic induction photograph with the key (page 139) was made with iron filings around a magnet.

The two other field photographs (pages 137–138) had a current-bearing wire instead of a magnet. This time steel filings were used; they gave very clean lines. This caused an unexpected new problem: how to sprinkle the fine steel filings, which were heavier and tended to clump, more or less evenly on the board. Various systems of sifting and sprinkling were tried, but it was found that by gently but firmly blowing through a soda straw the filings were less likely to clump and could be more or less evenly distributed on the board.

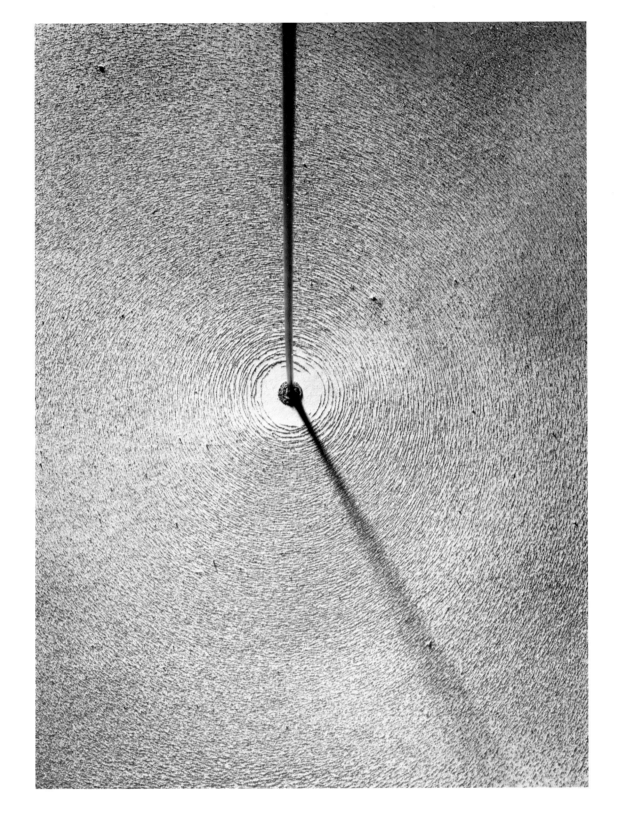

Magnetic field pattern due to current in a long straight wire

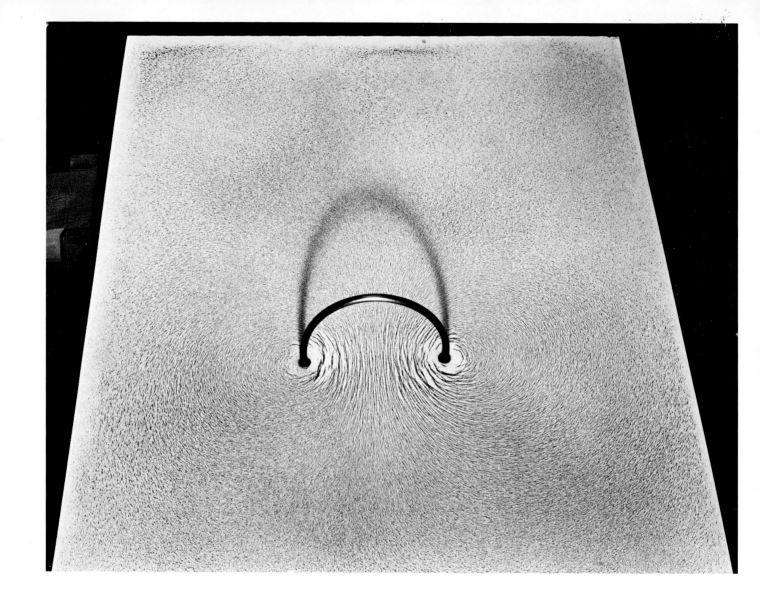

Steel filings show the magnetic field around
a loop carrying an electronic current (above)

A metal key changes the magnetic pattern
of iron filings around a bar magnet (right)

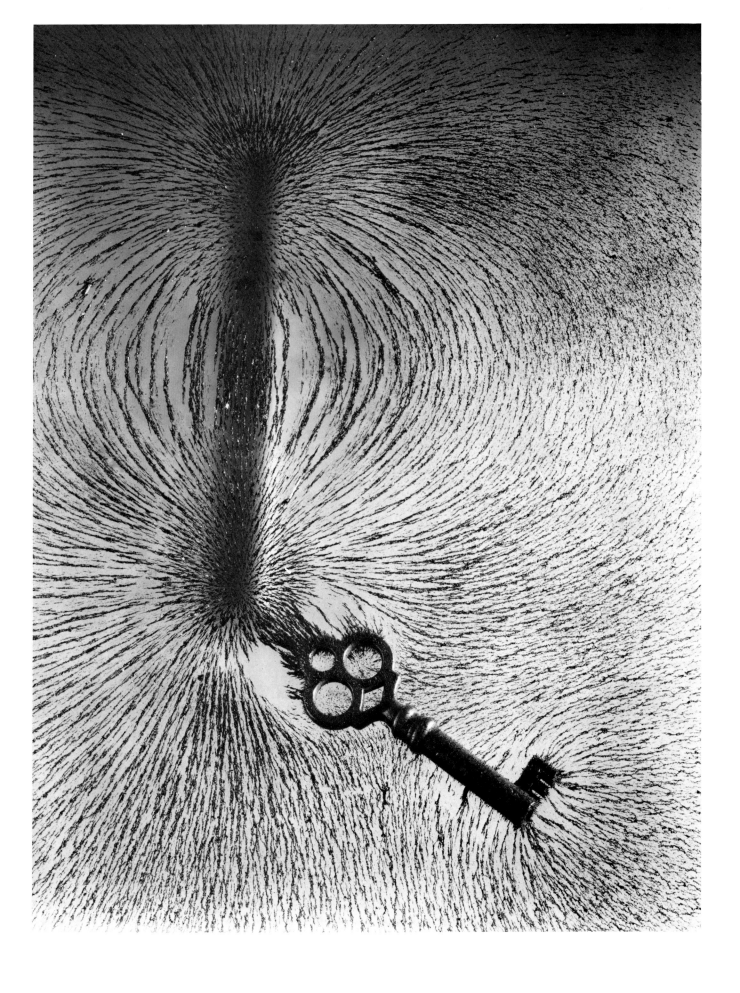

All wave pictures were made in the same manner. No camera. No lens. To my knowledge, the method had not been used before. It evolved from experiments I had made previously with point source light and photograms in motion. I intended to place a sheet of sensitive paper on the bottom of the ripple tank with flash-light above the waves to make their own picture. I had previously made such a photogram to see if action could be stopped. By rocking the developer tray to make a wave over light-sensitive paper and firing a small flash-light of 1/200 second held at arm's length, the result was a "contact" print of the wave.

Waves in a ripple tank are propagated by one or two motorized probes and were too fast for my system. I found also that the result was disappointing because the waves were too small. Then I found that, if the paper was *below* the tank, at a specific distance, an "enlargement" resulted, the waves acting as lenses. I had also experimented with an enlarger without a lens, using a point source light. Such early lights were very weak and full of striae and could not stop action.

An appropriate light was devised by using a small speed light and by making a point source by covering the light with a black cardboard with a pinhole. The light was too strong for film, so photographic paper was used instead.

Circular waves produced in water by a falling drop of water (top right)

A drop of water falls on a water surface at the focus of a parabolic reflector. The portion of the wave reflected from the parabola has a straight wave front (bottom right).

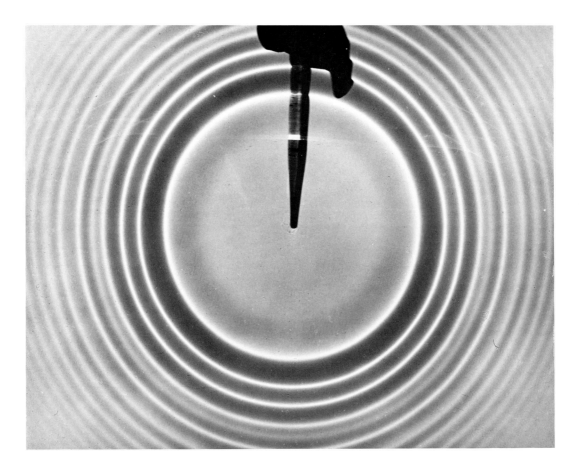

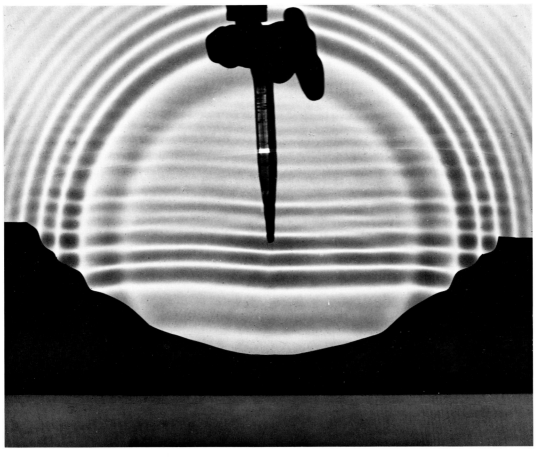

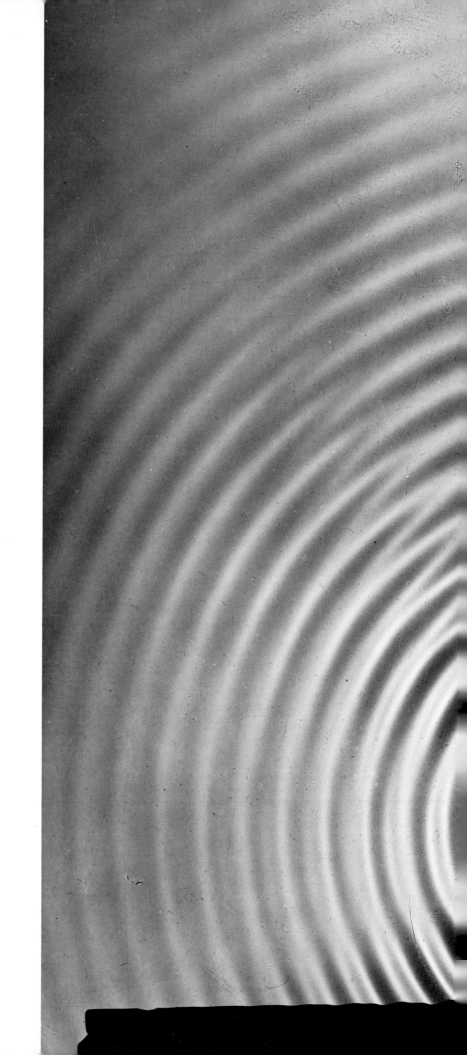

Interference pattern produced by two
interacting sets of circular waves

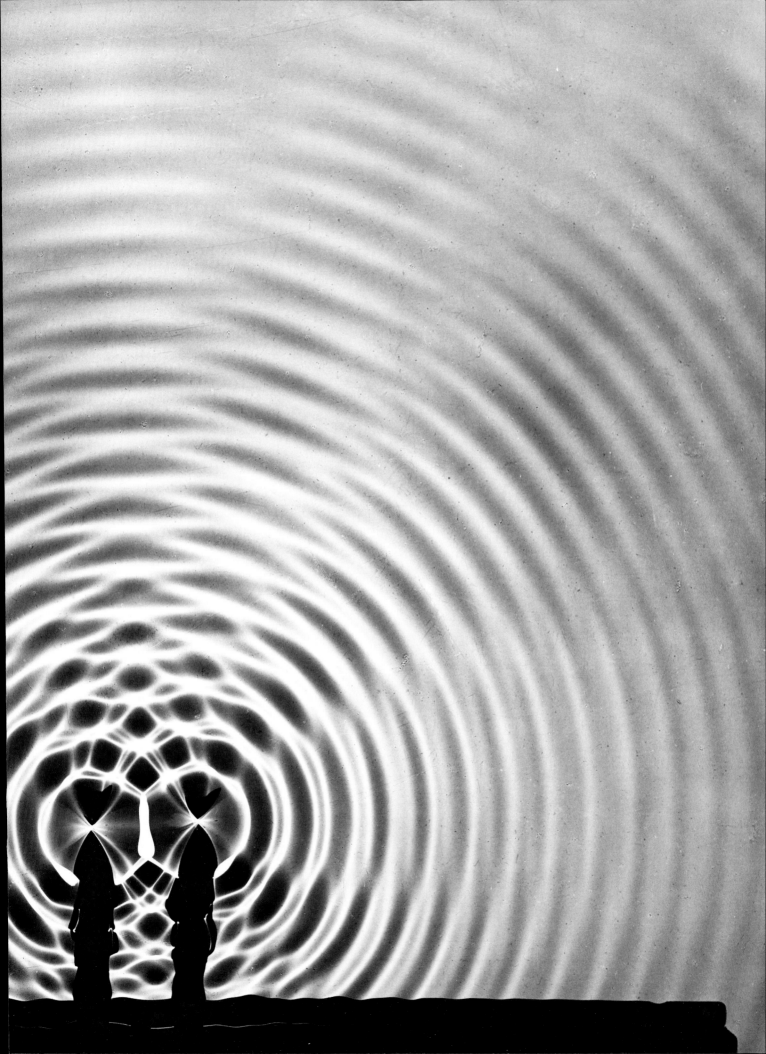

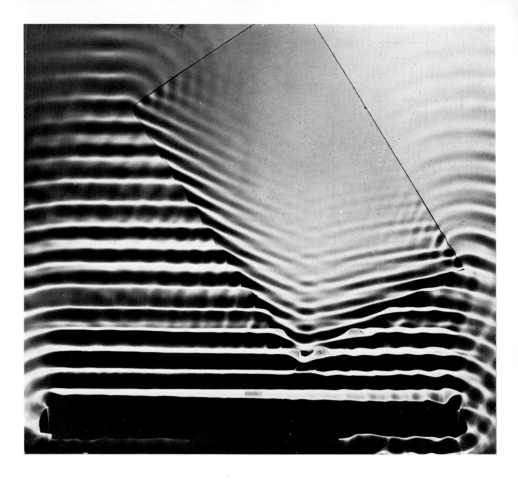

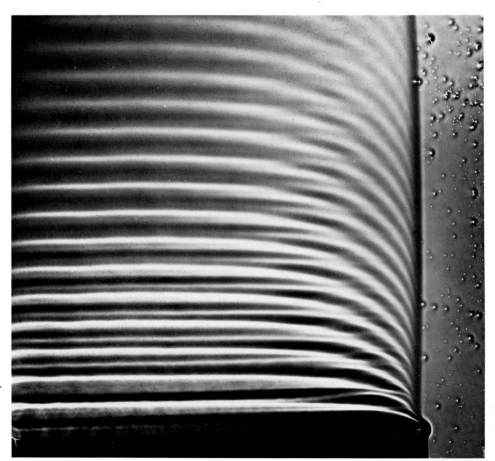

A glass plate changes the water depth. Water waves change direction when the depth of water changes (top left)

Water waves in a tipped water tank. Shallow water creates a drag at the wave edge (bottom left)

Soap bubbles (right)

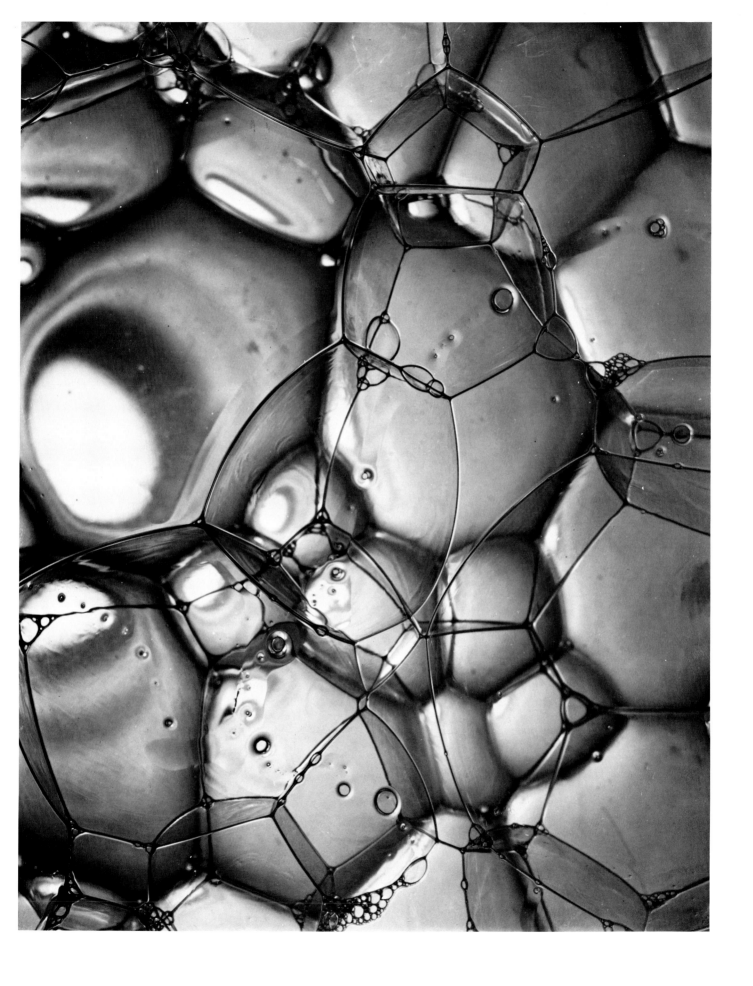

Six slits cut in a box with a light project six beams. The prism was a plastic box filled to the last drop with water. Wildly distracting rays and reflections developed around the thick transparent edges of the box. To avoid these, the base of the prism was buried in a cutout opening in the table so the refraction of the beams could be more clearly seen with fewer distractions.

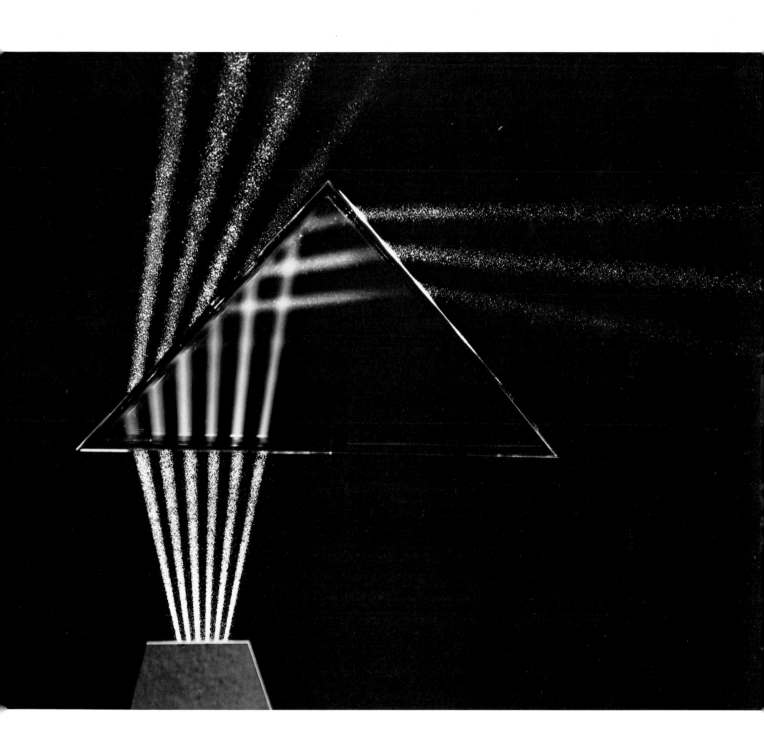

Multiple beams of light from a source change
direction when they go into a glass plate and when
they emerge. Some waves are reflected inside the
glass and then escape

The penicillin mold was less than the size of a fifty cent piece. It was therefore a macro-photograph with approximately 10X magnification to intensify the drama of this remarkable mold.

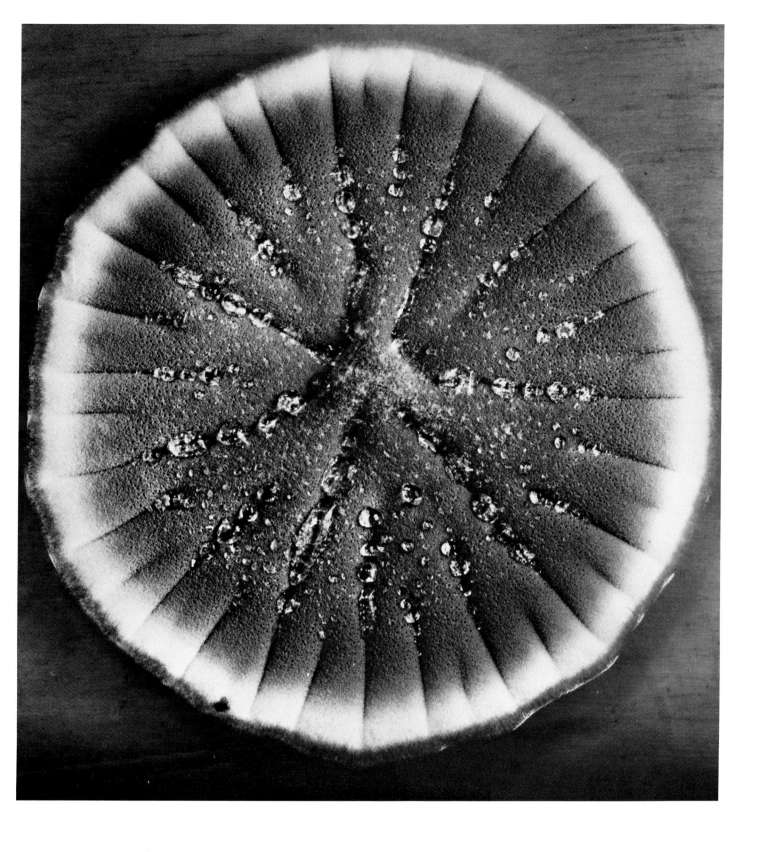

Penicillin mold in a petri dish

In the stroboscopic photographs on the following pages the disk was in front of the lens, but in this time-exposure photograph the shutter was simply held open on bulb during the flight of the ball. But even here the black dot on the white ball is seen to spin in the orderly rhythmic beauty in which matter moves.

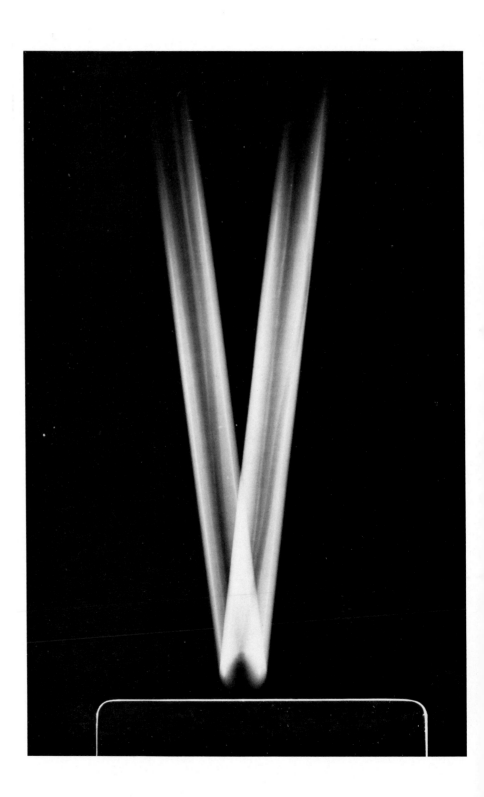

Time exposure of a bouncing steel ball (left)

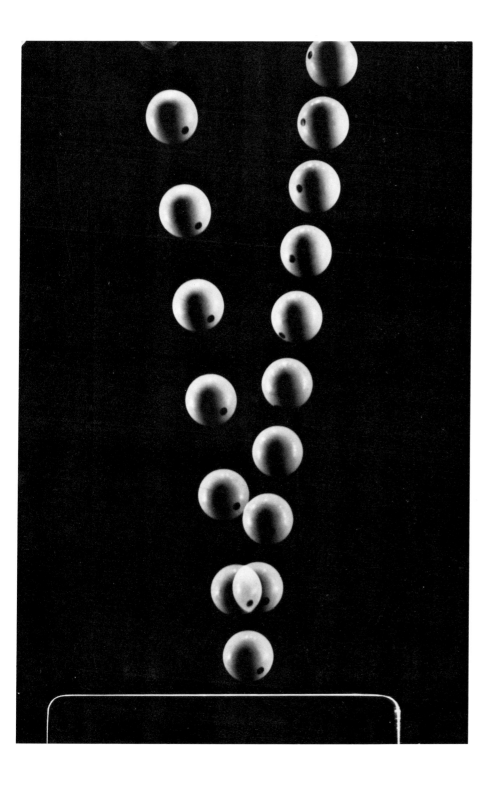

Strobe photograph of a bouncing steel ball

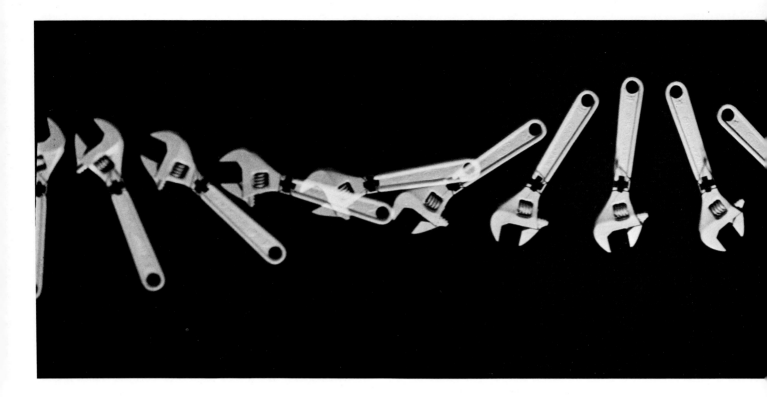

A wrench painted white was suspended at its center of gravity from a long piano wire, which does not give or stretch.

In this and subsequent "strobe" pictures with white balls, simple reflector photofloods or spots were used as the electric current was sorely limited. A device called a stroboscope was placed as near the lens as possible without touching it. This is simply an opaque black disk with a slit cut from its center to edge and made to revolve by a small motor. The disk shields the lens until the slit passes the lens and an exposure is made.

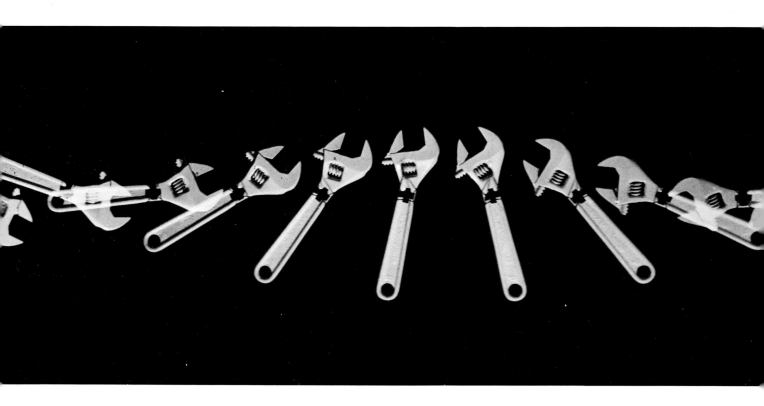

In all such stroboscopic pictures the background must be jet black and as far away as space permits so that light does not reach it, while the object must be white and well lighted. Otherwise multiple exposures would over-expose such areas and the object could be invisible, a white wrench against a white background.

In this case the wrench was near the floor, because the wire must be long, with the camera high on a ladder looking down. To keep light off the background, an R2 reflector flood was hand held and, with practice, followed the wrench in its flight, thus keeping the light off the background.

Spinning wrench suspended on a long string.
The center of mass moves in a straight line

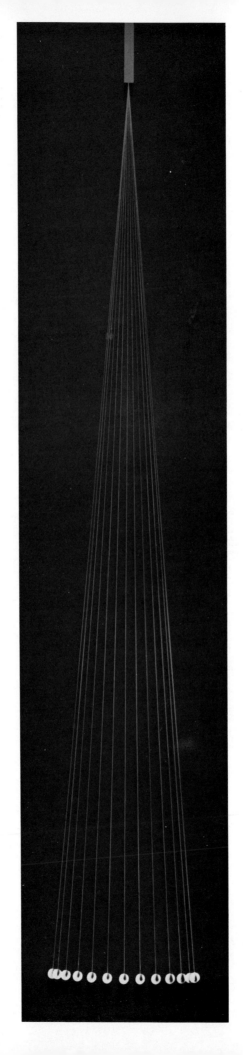

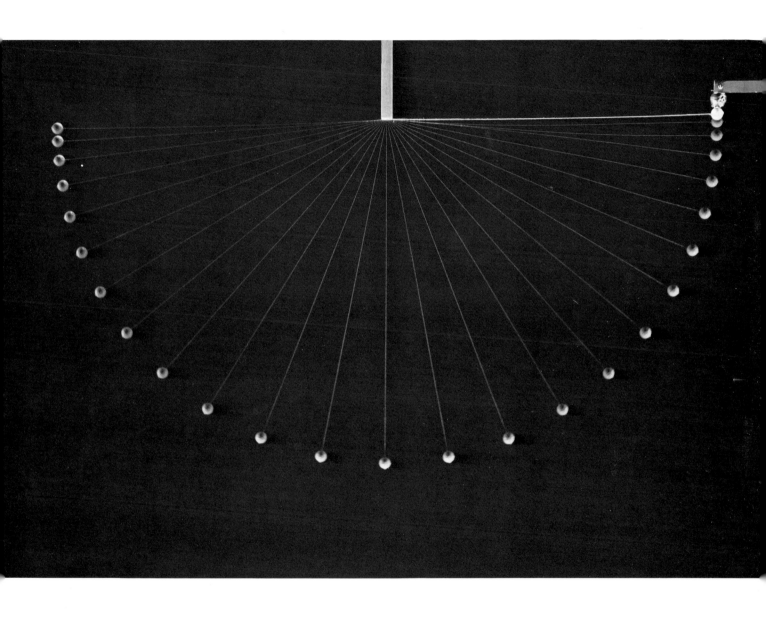

Transformation of energy (above)

The pendulum (left)

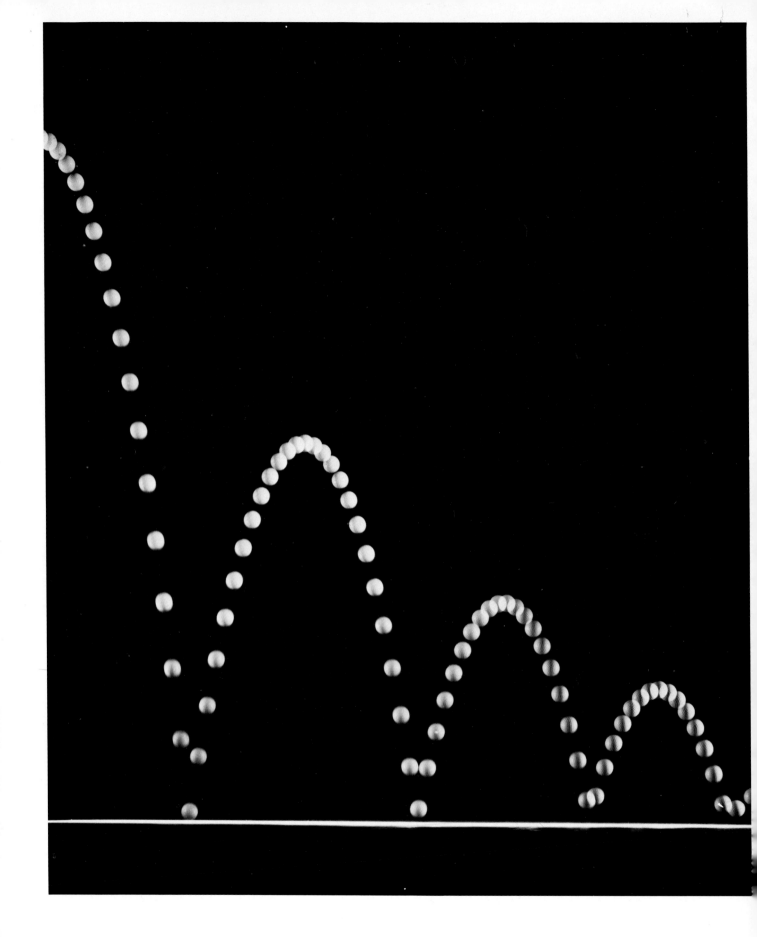

Multiple exposure of a bouncing ball

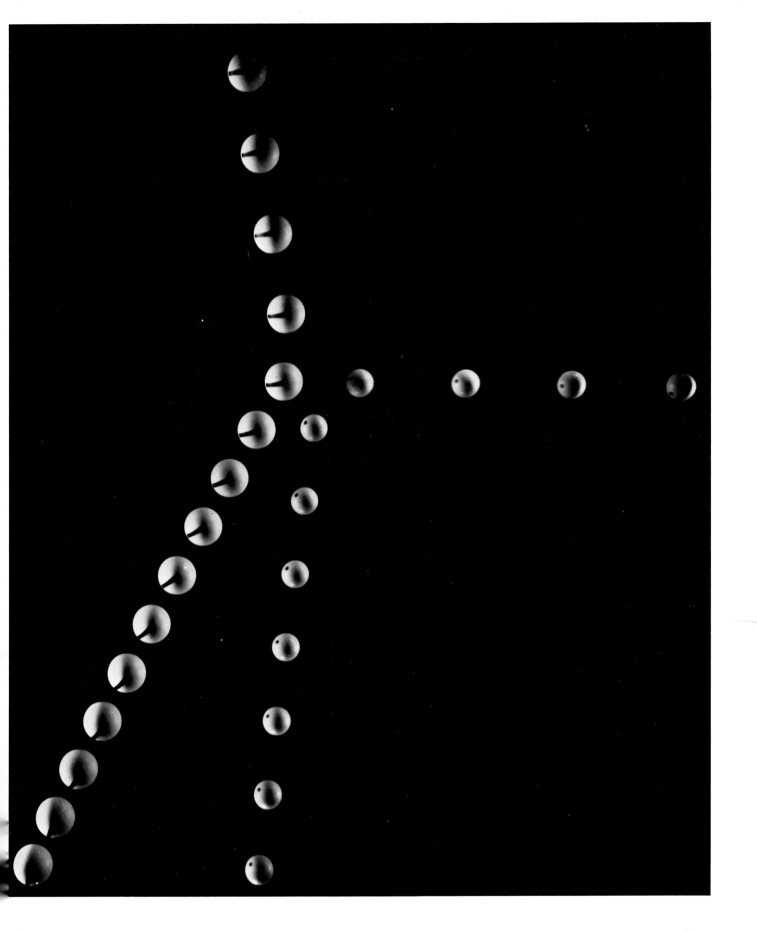

Collision of two balls of unequal mass

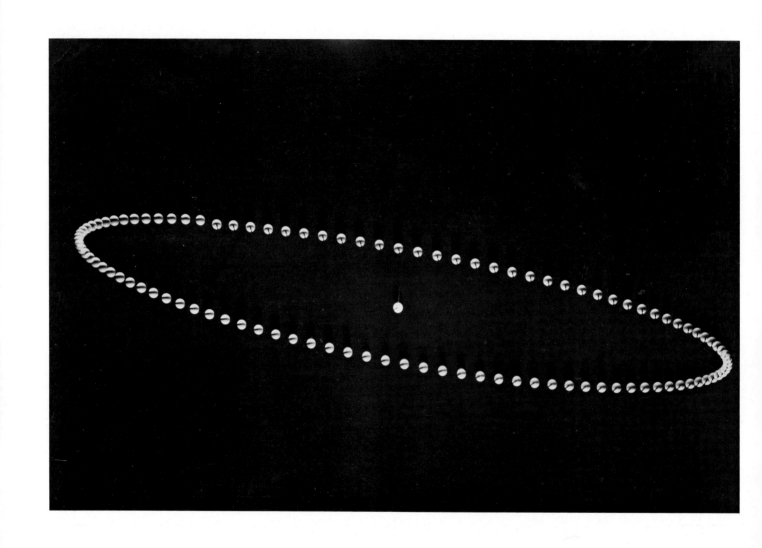

Multiple exposure of a swinging ball

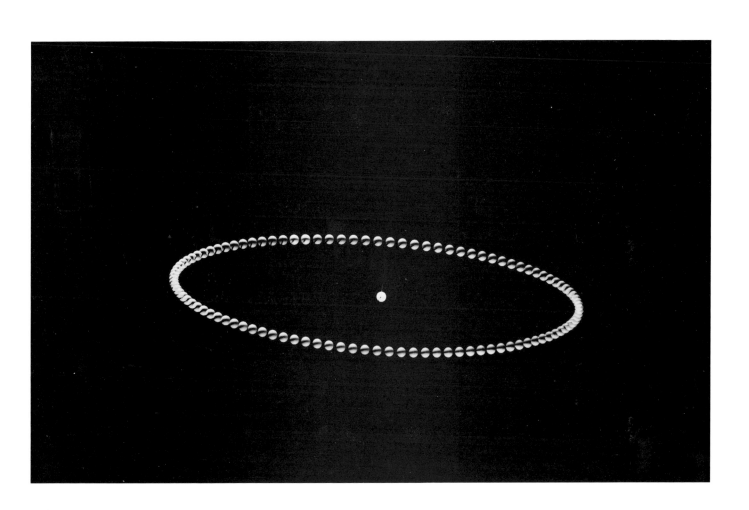

Multiple exposure of a swinging ball in an elliptical orbit.

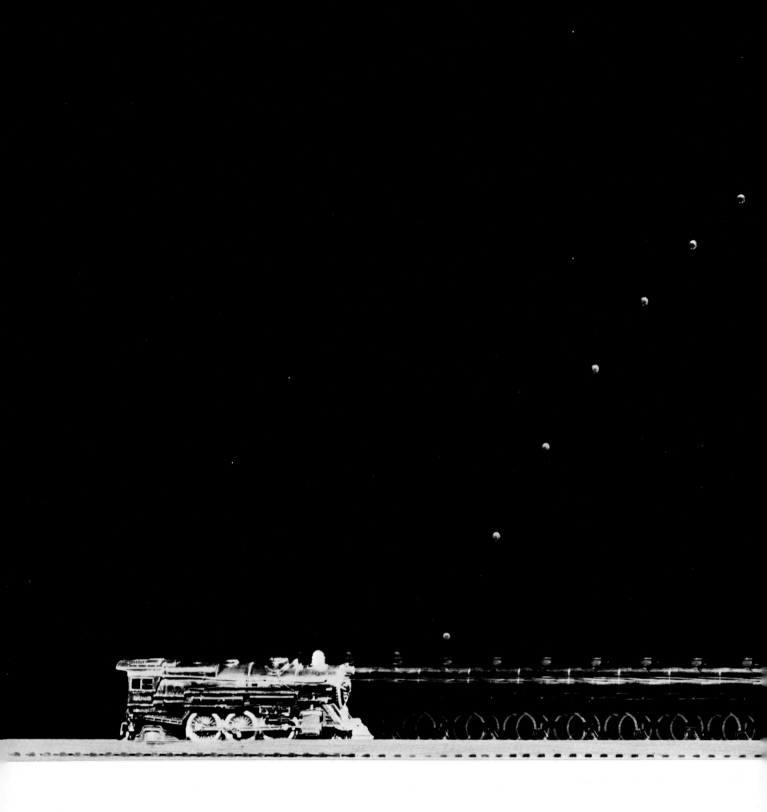

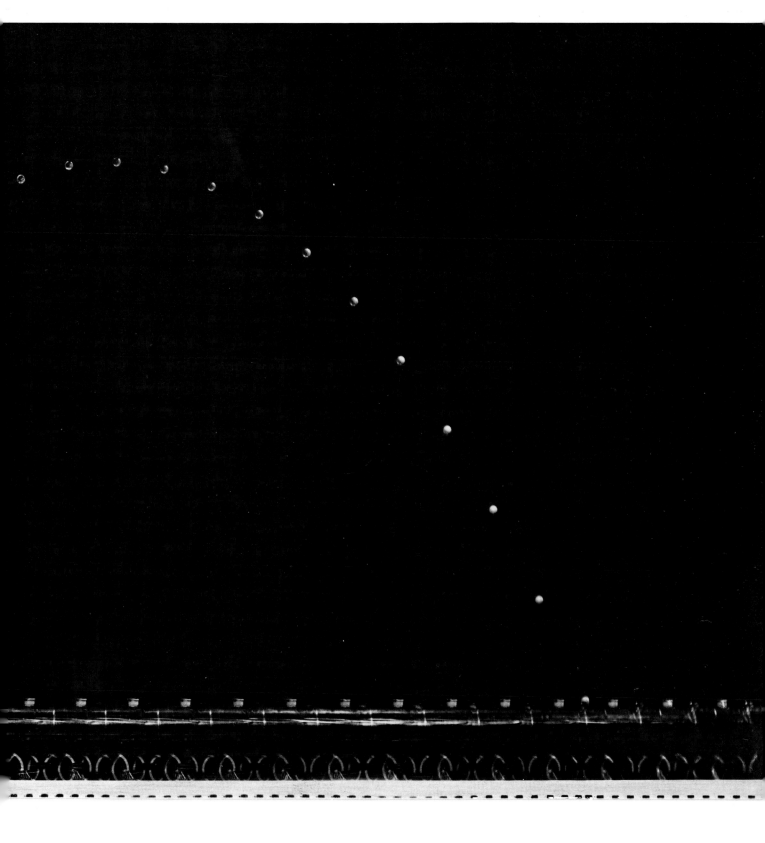

Multiple exposure showing the path of a moving
ball ejected vertically from a moving object

Berenice Abbott

Chronology

1898 Born July 17, Springfield, Ohio.

1917-18 Attended Ohio State University.

1918-21 New York: studied sculpture independently.

1921-23 Europe: first studied sculpture in Paris at the Grande Chamière and with Bourdelle; then in Berlin at the Kunstschule in der Kantstrasse. Shuttled between Paris and Berlin.

1923-25 Paris: worked as assistant to Man Ray. Saw Atget photographs for the first time in 1925 at Man Ray's studio.

1926 Paris: first exhibition of Berenice Abbott photographs, *Portraits Photographiques,* at gallery, *Au Sacre du Printemps.* This exhibit included portraits of Jean Cocteau, André Gide, Marie Laurencin, Sylvia Beach, James Joyce, and others.

1926-29 Paris: professional portrait photography at her studio, 44 rue du Bac.

1927 Paris: August 4, death of Eugène Atget. His photographs were in the custody of André Calmette.

1928 Paris: Berenice Abbott and Man Ray represented by photographs in the first *Avant-Garde* exhibition at the *Salon des Indépendants.*

1928 Paris: autumn; bought Atget's negatives and prints from André Calmette, except for those already owned by *Les Monuments Historiques.*

1929 May; moved from Paris to New York.

1929-68 Lived in New York

1929 New York: assigned by *Fortune* to photograph series of American businessmen. Began independently to document New York City photographically. Photography for many publications and clients in New York began in 1929, continued for years.

1930 New York: arranged for the publication of one of the first books on Atget, *Atget, Photographe de Paris,* with preface by Pierre MacOrlan; published by E. Weyhe, New York—most of the photographs were furnished by Berenice Abbott. Also published in Paris by Henri Jomquière.

1930 Cambridge, Mass.: exhibition at the Contemporary Art Club, Harvard.

1932 Exhibition at Julien Levy Gallery, New York; participated in other shows as follows: *Murals and Photomurals* at the Museum of Modern Art, New York; International Exhibition at the Brooklyn Museum, Brooklyn, N.Y.; *Philadelphia International Salon of Photography*, Philadelphia; at the Ayer Galleries, Philadelphia; and at the Albright Art Gallery, Buffalo, N.Y.

1934-58 New York: taught photography at the New School for Social Research. Exhibition at the New School, 1934.

1935-39 New York: photographed "Changing New York," documentation for Works Progress Administration Federal Art Project.

1936 New York: inclusion in Henry-Russell Hitchcock's exhibition of the architecture of H. H. Richardson at the Museum of Modern Art.

1937 New York: 125 photographs from the Federal Art Project exhibited under title, *Changing New York*, at the Museum of the City of New York.

1939 New York: book, *Changing New York*, with photographs by Berenice Abbott and text by Elizabeth McCausland; published by E. P. Dutton, New York.

1941 New York: book, *A Guide to Better Photography* by Berenice Abbott; published by Crown Publishers, New York.

1947 Paris: exhibition at Galerie de l' Epoque.

1948 Chicago: book, *The View Camera Made Simple* by Berenice Abbott; published by Ziff-Davis, Chicago.

1949 New York: book, *Greenwich Village Today and Yesterday*, photographs by Berenice Abbott, text by H. W. Lanier; published by Harper & Bros., New York.

1951 Aspen, Colorado: took controversial part in Aspen conference on photography. Part of what she said there was published in the article, "It Has to Walk Alone," in *Infinity* magazine, New York. The article was partly reprinted by Nathan Lyons in his book, *Photographers on Photography* (1966).

1953 New York: revised book, *New Guide to Better Photography* by Berenice Abbott; published by Crown Publishers, New York.

1954 Maine: while photographing on her Route One project, she discovered her favorite state, Maine, where she now resides.

1956 New York: printed 100 sets of twenty Atget photographs—2,000 prints in all—under the title, *Eugene Atget Portfolio, Twenty Photographic Prints from his Original Glass Negatives*.

1958-61 Made photographs to illustrate laws and processes of physics for the Physical Science Study Committee of Educational Services, Inc. An exhibition, *The Image of Physics* was circulated nationally by the committee and the Smithsonian Institution.

1963 Furnished original idea and photographs by Atget to Arthur D. Trottenberg leading to the publication of the book, *A Vision of Paris.* Atget's photographs were paired with quotations from Marcel Proust's *Remembrance of Things Past;* edited by Arthur D. Trottenberg; published by The Macmillan Company, New York.

1964 New York: book, *The World of Atget*, photographs by Atget, text and editing by Berenice Abbott; published by Horizon Press, New York.

1964-1969 Cleveland, Ohio: three illustrated books of physics with photographs by Berenice Abbott and texts by E. G. Valens: *Magnet,* 1964; *Motion,* 1965; and *The Attractive Universe* (about gravity), 1969; published by World Publishing Company, Cleveland, Ohio.

1968 Moved from New York to Maine.

1968 New York: sold Atget collection to the Museum of Modern Art.

1968 Maine: book, *A Portrait of Maine,* photographs by Berenice Abbott, text by Chenoweth Hall; published by The Macmillan Company, New York.

1969 Washington, D.C.: *Women, Cameras and Images III*, at Hall of Photography, Smithsonian Institution.

1970 New York: exhibition, Museum of Modern Art; book, *Berenice Abbott: Photographs;* published by Horizon Press, New York.

1973 Awarded honorary doctorate from Smith College.

1981 Received the Association of International Photo Art Dealers award for Outstanding Contribution to the Field of Photography.

1986 Awarded honorary degree from Ohio State University.

1987 Awarded The First International Erice Prize for Photography

1988 Inducted into Order of Arts and Letters by the French Government.

1989 New York: exhibitions, New York Public Library and International Center of Photography; catalog: *Berenice Abbott, Photographer: A Modern Vision*; published by New York Public Library.

Berenice Abbott

Exhibitions

Partial List

1926 Paris: *Portraits Photographiques,* Au Sacre du Printemps

1930 Cambridge, Mass.: Contemporary Art Club, Harvard University

1932 New York City: Julien Levy Gallery

1934 New York City: New School for Social Research

1934 Oakland, Calif.

1934 New Haven, Conn.: *Photographs for Henry-Russell Hitchcock's Urban Vernacular of the Forties, Fifties and Sixties,* Yale University

1934-35 New York City: *Photographs of New York City,* Museum of the City of New York

1935 Hartford, Conn.: Jerome Stavola Gallery

1935 Springfield, Mass.: Springfield Museum of Fine Arts

1935 Cambridge, Mass.: Fine Arts Guild

1935 *Photographs for Hitchcock's Urban Vernacular of the Forties, Fifties and Sixties*, Smith College, Dartmouth College, Princeton University, others

1937 New York City: *Changing New York—125 Photographs*, Museum of the City of New York

1938 New York City: Hudson D. Walker Gallery

1940 San Francisco: *Pageant of Photography*, Golden Gate Exposition

1941 Cambridge, Mass.: Massachusetts Institute of Technology

1947 Paris: Galerie de l'Epoque

1950 Akron, Ohio: Akron Art Institute

1951 Chicago: The Art Institute of Chicago

1953 San Francisco: San Francisco Museum of Modern Art

1953 New York City: Caravan Gallery

1955 Manchester, N.H.: Currier Gallery of Art

1956 Toronto, Ont.: Toronto Art Museum

1959 New York City: *Science Photographs*, New School for Social Research

1959 Cambridge, Mass.: *Science Photographs*, Faculty Club, Massachusetts Institute of Technology

1960 Boston, Mass.: Carl Siembab Gallery

1960 Manchester, N.H.: *Science Photographs*, at Currier Gallery of Art

1960 Washington, D.C.: *Science Photographs*, Smithsonian Institution, and widely circulated

1960 Kalamazoo, Mich.

1969 Washington, D.C.: *Women, Cameras and Images III,* Hall of
Photography, Smithsonian Institution

1970 New York City: Museum of Modern Art

1971 Augusta, Maine: University of Maine

1972 Wellesley, Mass.: Wellesley College; Skowhegan, Maine: Skowhegan
State Fair

1973 New York City: Witkin Gallery; Monson, Maine: Monson Public
Library; Portland, Maine: Westbrook Gallery, Westbrook College;
Northampton, Mass.: Smith College

1974 Keene, N.H.: Louise E. Thorne Memorial Art Gallery

1975 San Francisco: Focus Gallery

1976 New York City: Marlborough Gallery; Washington, D.C.:
Lunn Gallery/Graphics International

1977 Lewiston, Maine: Treat Gallery, Bates College

1978 Bronxville, N.Y.: Sarah Lawrence College

1979 Provincetown, Mass.: Provincetown Fine Arts Workshop;
New Paltz, N.Y.: College Art Gallery, State University College

1980 Cleveland, Ohio: New Gallery for Contemporary Art

1981 New York City: International Center for Photography

1982 Washington, D.C.: Smithsonian Institution; Washington, D.C.: Lunn
Gallery; Springfield, Ohio: Museum of Art; New York City: Witkin Gallery

1989: New York City: New York Public Library; International
Center for Photography

Books by
Berenice Abbott

1939 *Changing New York*; photographs by Berenice Abbott, text by Elizabeth McCausland; E.P. Dutton, New York.

1941 *A Guide to Better Photography*; Crown Publishers, New York.

1948 *The View Camera Made Simple*; Ziff-Davis, Chicago.

1949 *Greenwich Village Today and Yesterday*; photographs by Berenice Abbott, text by Henry Wysham Lanier; Harper & Bros., New York.

1953 *New Guide to Better Photography*; Crown Publishers, New York.

1956 *Eugène Atget Portfolio, Twenty Photographic Prints from his Original Glass Negatives*; edition of 100 portfolios of prints by Berenice Abbott, with introduction.

1964 *The World Of Atget*; text and editing by Berenice Abbott; Horizon Press, New York.

1964 *Magnet*; photographs by Berenice Abbott, text by E.G. Valens; World Publishing Co., Cleveland, Ohio.

1965 *Motion*; photographs by Berenice Abbott, text by E.G. Valens; World Publishing Co., Cleveland, Ohio.

1968 *A Portrait of Maine*; photographs by Berenice Abbott, text by Chenoweth Hall; The Macmillan Co., New York.

1969 *The Attractive Universe*; photographs by Berenice Abbott, text by E.G. Valens; World Publishing Co., Cleveland, Ohio.

1970 Berenice Abbott Photographs; Horizon Press, New York.

1973 *New York in the Thirties*; photographs by Berenice Abbott, text by Elizabeth McCausland; Dover Publications, New York, (Reprint of *Changing New York*).

1979 *Berenice Abbott: The Red River Photographs;* photographs by Berenice Abbott, text by Hank O'Neal; McGraw Hill, New York.

Articles & Reviews
On the Work of
Berenice Abbott

Partial list

1934 *Parnassus*, December.

1935 "The Photography of Berenice Abbott" by Elizabeth McCausland, *Trend*, 3:1, March-April.

1937 "Picture This Career," *Mademoiselle*, August.

1938 "Camera Eye Records . . . Ever 'Changing New York'" by Elizabeth McCausland, *Springfield Sunday Union and Republican*, October 24.

1938 "Berenice Abbott Records Changing New York" by Rosa Reilly, *Popular Photography*, 3:3, September.

1938 "Berenice Abbott Photographs the Face of a Changing City," *Life*, January 13, pp. 40-46.

1939 "Changing New York" by Madeline Ball, *Springfield Sunday Union and Republican*, April 23.

1942 "La Lente Frente a la Vida" by Elizabeth Sacartoff, *Norte*, February.

1942 "Berenice Abbott," by Ralph Steiner, *PM*, April 19.

1944 "Something New Under the Sun," *Minicam Photography*, 7:5.

1948 "Berenice Abbott—Realist" by Elizabeth McCausland, *Photo Arts*, (Spring).

1960 "Berenice Abbott—Pioneer, Past and Present," by Julia Newman, *U.S. Camera*, February.

1962 "Abbott's Non-Abstract Abstracts," *Infinity*.

1980 "Berenice Abbott's Work in the Thirties," by Michael G. Sundell, *Prospects: Annual of American Cultural Studies 5*.

1981 "Berenice Abbott," by Erwin Leiser, *Du*, pp. 35-38, January.

1981 "The Unflinching Eye of Berenice Abbott" by Avis Berman, *ARTnews*, January.

1989 "Photography: A Selective Guide," by Andy Grundberg, *The New York Times*, September 10.

1989 "Landscape Photographs as Envisioned by Woman," by Vivien Raynor, *The New York Times*, September 24.

1989 "Berenice Abbott: Still Feisty and Eager at 91," by Richard F. Shepard, *The New York Times*, October 4.

1989 "Topics of the Times: Berenice Abbott's New York," *The New York Times*, October 8.

1989 "Images of an Optimistic, Self-Assured Past," by Andy Grundberg, *The New York Times*, October 15.

1989 "The Pendulum Swings Away From Cynicism," by Andy Grundberg, *The New York Times*, October 22.

Articles by

Berenice Abbott

Partial list

1929 "Eugène Atget," *Creative Art,* September.

1936 "Photographer as Artist," *Art Front,* Vol. 16.

1937 "Photography 1839-1937," *Art Front,* Vol. 17.

1939 "Eugène Atget," *Creative Art,* Vol. V, pp. 651-56.

1939 "The Art of Photography," transcribed interview on WQXR, January.

1939 "My Ideas on Camera Design," *Popular Photography,* May.

1940 "My Favorite Picture," *Popular Photography,* February.

1940 "Civic Documentary History," in *PHOTOGRAPHY, Profession, Adjunct, Recreation;* Proceedings of Conference, Institute of Women's Professional Relations, Hotel Biltmore, February 9.

1941 "Eugène Atget," *The Complete Photographer,* No. 6 (reprinted in *Encyclopedia of Photography,* Vol. 2, 1963).

1942 "Documenting the City," *The Complete Photographer,* No. 22 (reprinted in *Encyclopedia of Photography,* Vol. 7, 1963).

1943 "Nadar: Master Portraitist," *The Complete Photographer,* No. 51.

1943 "View Cameras," *The Complete Photographer,* No. 53 (reprinted in *Encyclopedia of Photography,* Vol. 20, 1963).

1947 "From a Student's Notebook," *Popular Photography.*

1951 "What the Camera and I See," *ARTnews.*

1951 "It Has to Walk Alone," *Infinity.*

1951 "Photography at the Crossroads," *Universal Photo Almanac,* pp. 42-47.

1959 "The Image of Science," *Art in America,* 47:4.

1975 "Lisette Model," *Camera* (special issue), pp. 4, 21.

1977 *Chansonetta: The Life and Times of Chansonetta Stanley Emmons, 1858-1937,* text by Marius B. Peladeau, introduction by Berenice Abbott, Maine Antique Digest Publications, Waldoboro, Maine.

1979 *Lisette Model;* photographs by Lisette Model, introduction by Berenice Abbott, Millerton.